286-812-TX

1850 293 627 0 369 73

		300			
WEST GRID STAMP					
NN		LJ	8/92	14/1/	
NT		FIT		WO	
NC		FO.		WL	
NH		RD.		WM	
NL		RP.		WT	
NV		RS		WA	
NM		RW		WR	
NB		БV		WS	
NE					
NP					

.

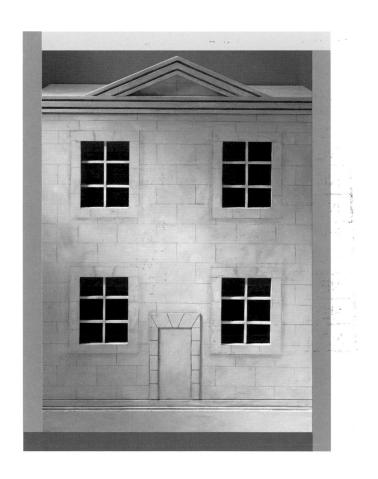

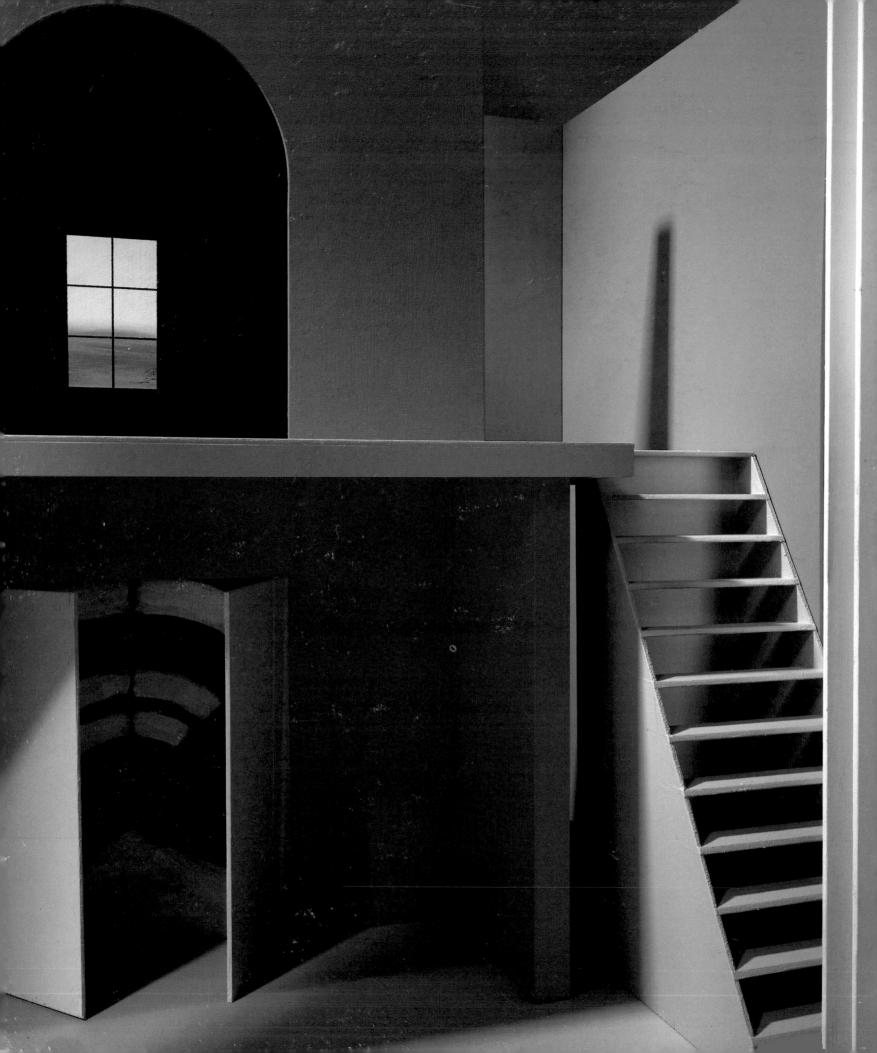

TERENCE CONRAN

TOYS

N D

CHILDREN'S FURNITURE

20 STYLISH DIY PROJECTS
TO MAKE FOR YOUR CHILDREN

CONSULTANT EDITORS

JOHN McGOWAN

& ROGER DUBERN

PROJECT PHOTOGRAPHY
RICHARD FOSTER

CONRAN OCTOPUS

For Sebastian, Jasper, Tom, Sophie, Ned and Sam

First published in 1992 by Conran Octopus Limited 37 Shelton Street, London WC2H 9HN

Copyright © 1992 Conran Octopus Limited

All rights reserved. No part of this book may be reproduced, stored in a retrieval system, or transmitted in any form or by any means, electronic, electrostatic, magnetic tape, mechanical, photocopying, recording or otherwise, without the prior permission in writing of the publisher.

British Library Cataloguing-in-Publication Data A catalogue record for this book is available from the British Library.

ISBN 1 85029 362 7

The designs for the projects on pages 20–5, 26–31, 32–7, 38–41, 52–7, 58–63, 64–73, 74–9, 80–9, 96–104 and 104–9 are copyright © 1992 Sir Terence Conran and may be built for personal use only.

All projects were specially built by SEAN SUTCLIFFE of Benchmark Woodworking Limited

Typeset by Servis Filmsetting Limited, Manchester Printed by Butler & Tanner Limited, Frome and London

Project Editor SIMON WILLIS

Consultant Editors JOHN McGOWAN

and ROGER DUBERN

Copy Editor JACKIE MATTHEWS

Contributing Editor ELIZABETH WILHIDE

Art Editor HELEN LEWIS
Illustrator Paul Bryant
Visualizer JEAN MORLEY

Project Sketches SIR TERENCE CONRAN

Production Manager Sonya Sibbons **Picture Researcher** Nadine Bazar

PROJECT PHOTOGRAPHY

Photography RICHARD FOSTER

Assisted by SIMON ARCHER

Art Direction CLAIRE LLOYD

Assisted by LINDY TROST

Set Building WILF DECORATION

Set Decoration MATTHEW USMAR LAUDER

SPECIAL NOTE

Before embarking on any of the projects in this book, you must check the law concerning building regulations and planning. It is also important that you obtain specialist advice on plumbing and electricity before attempting any alterations to these services yourself.

Whilst every effort has been made to ensure that the information contained in this book is correct, the publisher cannot be held responsible for any loss, damage or injury caused by reliance upon the accuracy of such information.

DIMENSIONS

Exact dimensions are given in metric followed by an approximate conversion to imperial. Never mix metric and imperial dimensions when making a calculation or building a project.

SAFETY

The publisher would like to thank the ROYAL SOCIETY FOR THE PREVENTION OF ACCIDENTS for reading through and checking the project instructions; their recommendations have been incorporated into the text.

Additionally, on page 125 there is a summary of the most important points relating to DIY safety and the design and construction of toys and children's furniture. It is strongly recommended that you read this summary before making any of the projects in this book.

CONTENTS

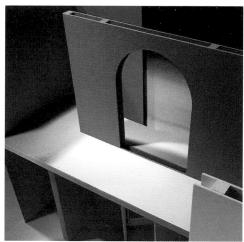

INTRODUCTION 6

Part 1
BEDROOMS 10

Projects

CRIB 20

ROCKING CHAIR 26
STORAGE HOUSE 32
SHELF, RAIL AND PEG STORAGE 38
CHILD'S FOUR-POSTER BED 42
LOW-LEVEL SHELVES 43

Part 2

PLAYROOMS 44

Projects

DOLL'S HOUSE 52
PAINTING TABLE 58
SWING-DOOR WARDROBE 64
ROCKING HORSE 74
PUPPET THEATRE 80
BLACKBOARD SCREEN 90
TRUCK DESK 91

Part 3
OUTDOORS 92

Projects

CLIMBING FRAME 96
CART 104
ROUND-THE-HOUSES GOLF 112
WEATHER VANE 113

Part 4

TOOLS, MATERIALS AND
TECHNIQUES 114
TOOLS 114
MATERIALS 116
TECHNIQUES 118

SAFETY 125

INDEX 126

ACKNOWLEDGMENTS 128

INTRODUCTION

A child's room is a world in microcosm. There is no doubt that many of our first impressions of colour, texture, design and pattern are formed here, surrounded by the familiar everyday objects of the nursery. Most of us can vividly recall the rooms we grew up in; and we may well remember a favourite chair or a desk with as much affection as a beloved train set, doll's house or teddy bear.

Although few people would dispute the importance of these early experiences, the design and furnishing of children's rooms and play spaces do not always bear witness to this fact. Children, of course, grow up and grow out of rooms as quickly as they grow out of clothes. A baby's nursery cannot contain an active, exploring two-year-old, and what is fun

and appealing at five years old is babyish and boring at ten. For some parents this is reason enough not to devote the same degree of care and finish to a child's room as they would to other rooms in the house. And many people believe that young children are so innately destructive and chaotic that good furniture and decoration would be wasted on them.

I hope that this book will help to overturn both of these misconceptions. The changing needs of the growing child present the biggest challenge to anyone designing or equipping a child's room. But, as many of the projects in this book demonstrate, with a little imagination and ingenuity it is possible to build in enough flexibility to allow a room to change with the child.

The second common belief, that children are too careless to look after things properly, is often why so many children's rooms are bland or furnished with mismatched pieces of furniture. But I believe that children only learn to look after things if they are given items that are worth looking after.

Making the furnishings yourself enables you to respond to particular requirements and is economical.

There are also more fundamental rewards: there is no better way to demonstrate your love for your children, and they will never forget the things you have made for them. If your children wonder at your creativity, so much the better: as they grow they will be more confident about developing their own skills!

Tirence Couran.

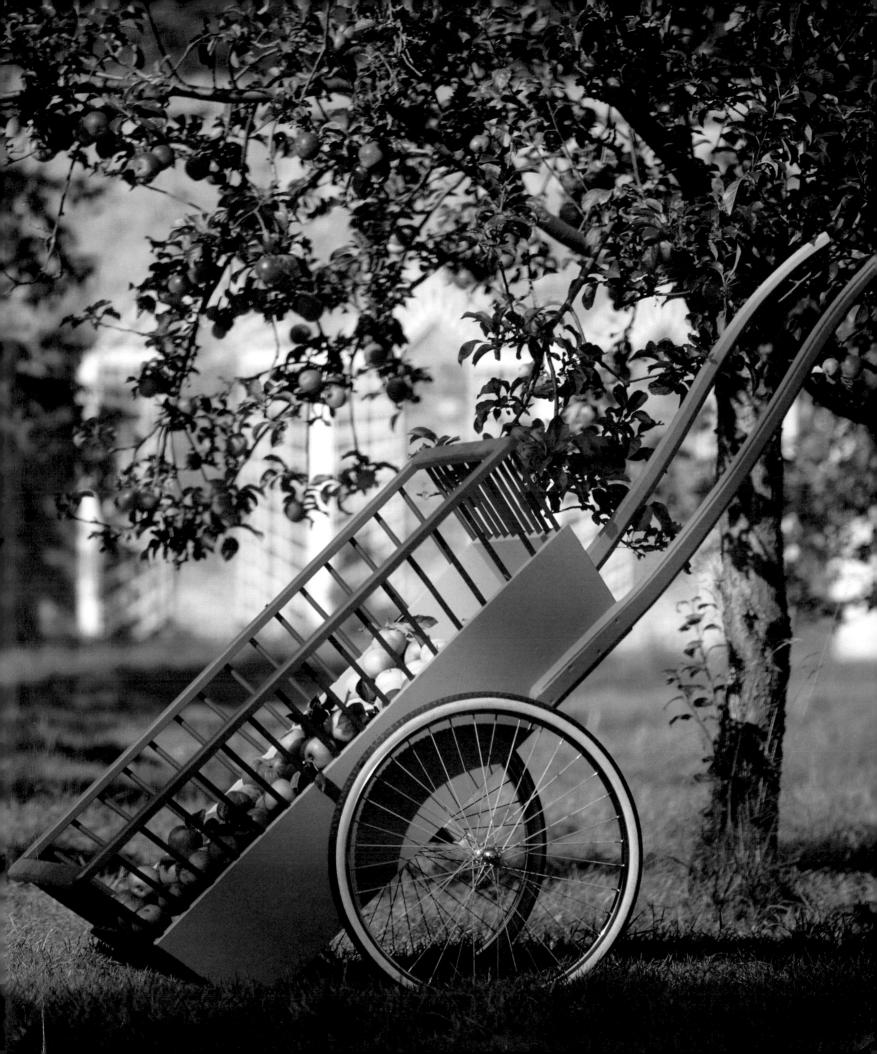

INTRODUCTION

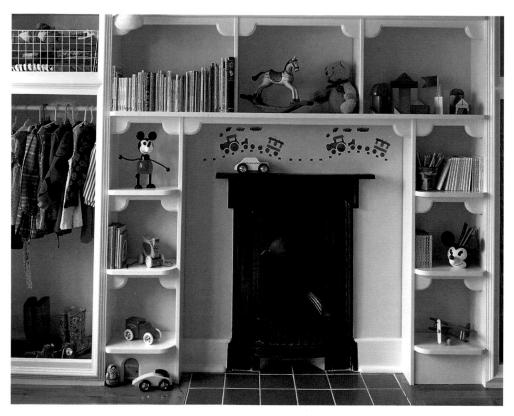

PLANNING FOR CHANGE

This book is intended to apply to children from birth to around 12 years of age. Within this short space of a dozen years, children grow and change rapidly. When planning a child's room, you should allow for at least three distinct phases. From birth to the toddling stage, the room should allow for a baby's daily needs to be easily met; as the child becomes mobile and toys proliferate, storage and safety are prime considerations; later, as the child develops interests and hobbies, there must be space for selfexpression. Since your family may also increase, you may have to reconcile the needs of two children at different stages of development within the same area.

Early on – perhaps even before the baby has arrived – many parents lovingly equip and decorate a nursery down to the last detail. But while this is a natural

impulse, it is wise to remember that babyhood is of comparitively short duration and any equipment or furniture which is too specifically geared to a particular point in a baby's or a child's development will quickly be outgrown. There is obviously less wasted time, effort and money if you invest in furniture that is versatile enough to be used in different ways. A good chest of drawers can provide a surface for changing a baby, with linen storage below, and can later be given over to clothes storage. A chest or blanket box can provide space for bedding or nappies, then later be used as a toy box, and finally store objects such as sports equipment, tapes or magazines.

Versatility is intrinsic to many modern storage systems. At the simplest level, shelving arrangements of the metal track and bracket variety can be spaced according to the height and reach of the child

NOOKS AND CRANNIES

Built around a small bedroom fireplace, this wall of storage provides hanging space at child height, together with intriguing niches and compartments for toys, books, games and puzzles (left).

Dressing-up Box

An old tin trunk or wooden blanket box makes the perfect home for dressing-up clothes and theatrical props (below).

and the size and shape of what is being stored. Hanging rails can be set low down at first and later moved up. A pegged rail for hanging everything from clothes to toys, Shaker style, is perhaps the simplest and most flexible arrangement of all. Each one of these adjustable systems enables you to keep the environment in the room scaled to the child without building in too much at low level which will need to be remade as the child grows.

Elements which can be changed quickly and easily are essentially decorative – a change of paint finish, curtains or blinds can give the room a different atmosphere to suit a new stage in the child's growth. The soft pastel shades of a baby's room, for example, might give way to brighter paintbox colours for a school-age child. Children enjoy being involved in these decisions and making a contribution to the way their room looks.

Bedrooms 10

Shelf, rail and peg storage 38

Safety 125

INTRODUCTION Planning for change 8/9

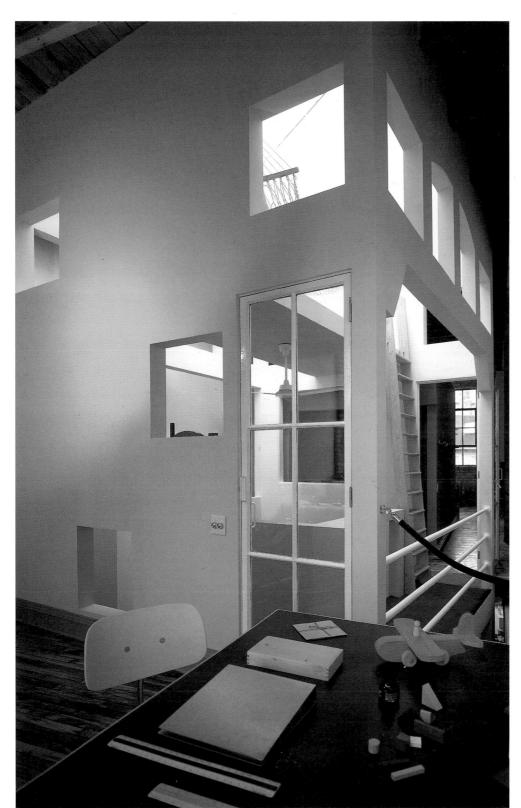

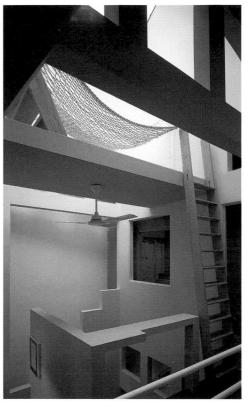

SPACE PLANNING

This architect-designed warehouse conversion offered the opportunity to create new and exciting children's spaces. Within a largely open-plan layout, a more enclosed area, linked to the ground floor with a ladder, accommodates two bedrooms with internal views down into the main living room (left). Beneath the bedrooms are play spaces equipped with chairs and tables for hobbies and schoolwork (above). While such a radical restructuring of existing space may not always be possible, it is worth bearing in mind that children appreciate and enjoy unusual spaces in which to play and live.

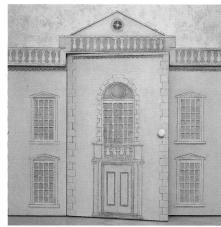

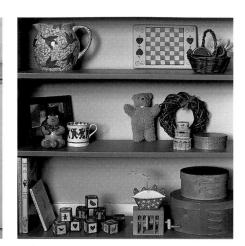

Compared to an adult's requirements, young children make very high demands on a bedroom and spend much more of their time there. If space in the child's bedroom is restricted, toys, belongings and noisy games quickly overrun the rest of the house. Giving the children a room which can also serve as a playroom will have a beneficial effect on the whole household. A good children's room is good for parents, too.

By the time children reach school age, they will see their bedrooms as much more than just a place to sleep in. It is a place for play, to bring friends to after school, a place in which to read and study and be surrounded by favourite things. These varied activities, together with the changes in emphasis as the child grows, call for sensitive planning and decorating.

One basic decision is which room, or rooms, of your home you allocate to the children. Children are often given the smaller bedrooms, but there is good argument, in their early years at least, for devoting a large room to the children, especially if two are sharing it; later on, when siblings need their own private space, the distribution of bedrooms can be reconsidered.

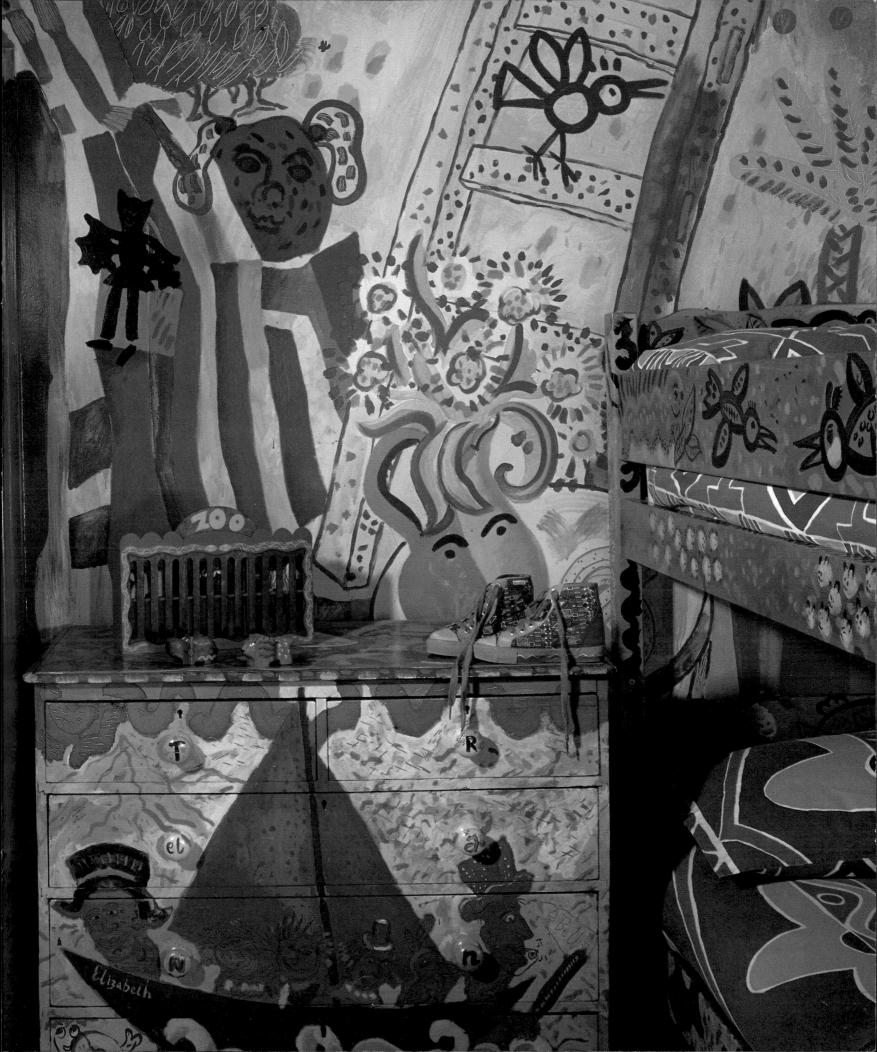

BEDS

As in any bedroom, the bed and how it is positioned is a key element in a child's room. To most children, bed is a very important place, a refuge and a source of comfort, a piece of territory which is truly their own. Although children may heartily resist being sent there at the end of the day, bed nevertheless represents a fixed point in their lives.

Whatever else changes in a child's room, it is hard to avoid two, three or even four different types of sleeping arrangement. Although a baby isn't concerned about where it sleeps as long as it is warm and comfortable, and would probably rather be sleeping with you, it is only natural to devote a great deal of thought and care to choosing your baby's first bed. Light and portable, Moses baskets are a popular choice for the first few months and can be simply lined and trimmed in a fabric that complements the nursery decoration. A carrycot, also suitable for the first few months, is rather more versatile. It can be set on a stand, clipped to a wheeled frame for use as a pram, or strapped into the back of a car. Perhaps less practical but rather more appealing are cradles and cribs, lovingly detailed, and worth handing down from child to child. Whatever you choose, position it away from draughts and direct heat, on a stable, dust-free surface.

Your baby will outgrow its first bed fairly quickly. At this stage it is wise to invest in a strong, well-designed cot that will protect the child from accidental tumbles as its mobility increases. There is a wide variety of cots available, made from metal or wood, with solid or railed sides, decorated or plain. Many have a 'dropside' mechanism which enables the side of the cot to be lowered, making it easier to lift the baby in and out.

Research suggests that babies can see, understand and recognize far more and at a far earlier stage than is commonly believed, which is good reason for providing them with bright and attractive shapes and colours to which they can respond. In its first year, a baby spends a significant amount of time in the cot. Suspending mobiles above the cot in the baby's field of vision, attaching soft, babies' toys where the baby can knock them and make them move are all ways of giving a very young child the chance to explore the sights and sounds of a new world. Take care, however, not to overstimulate your baby. A cot full of noisy, jangling toys is not peaceful or relaxing, and you may run the risk of confusing and tiring your baby rather than developing its emergent senses.

A first real bed is a landmark and usually a source of some pride to a child. Making the transition from cot to bed often calls for an element of rearrangement and reorganization in the room and can also be the time to signal a move away from nursery furnishings. Buying an intermediate 'cotbed' is often a false economy; instead choose a good-quality single bed with a firm mattress that will last for many years. Divan beds with storage drawers in the base are a practical idea and, with the addition of a tailored covering and cushions, can provide additional seating when the child is older and has friends to visit.

High sleepers – platform beds with built-in worksurfaces – appeal to a child's sense of adventure, as do bunk beds, which tend to become the focus of hours of imaginative play. Beds raised up off the floor in this fashion are potentially less safe than are conventional beds; consider installing such an arrangement only when younger siblings are well past the age when accidents are most likely to occur.

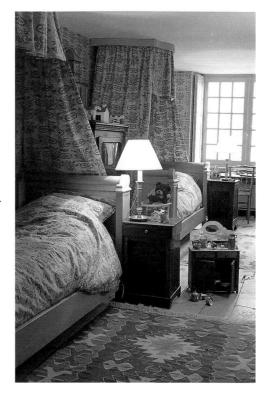

FURNISHING WITH FABRIC

Many children have to share a room at some point with a sibling. Adopting some means of dividing the room can help to ease the inevitable territorial squabbles. If you don't want to construct a permanent barrier, curtains can be an effective way of distinguishing sleeping areas from the common playing spaces (above). Fabric is a good way of dressing up a room. Cheerful red-and-yellow striped curtains are suspended from a rail by 'epaulette'-style loops (right. above). A theatrical pelmet makes a grand entrance to a bedroom alcove (right, below). Twists of plain white muslin are a cheap but highly effective way of transforming a plain iron bedstead (far right).

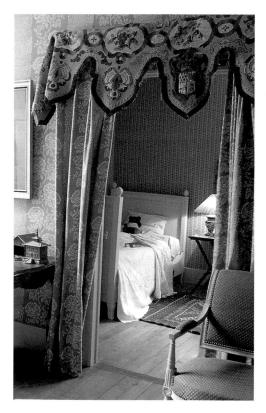

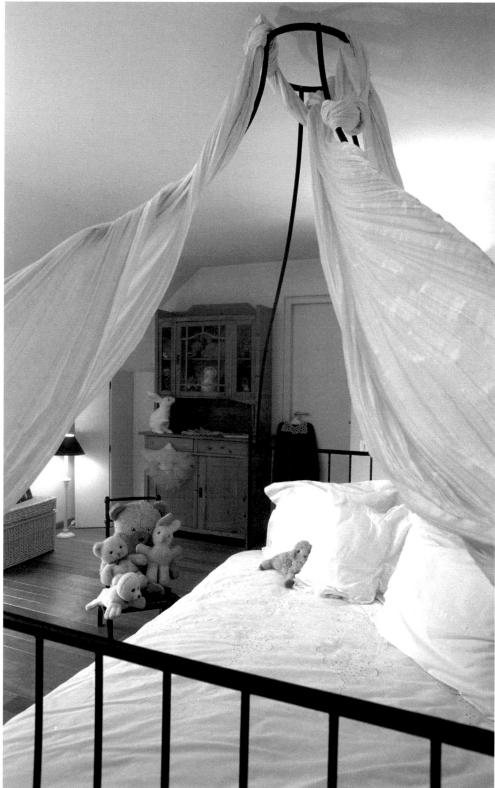

UP THE WALL

Wall space is put to stylish storage use in this arrangement of pegs set around the perimeter of the room, paired with a deep shelf at picture-rail height for propping up photographs and mementoes (above).

ENQUIRING MIND

From an early age, most children display a deep curiosity about the world. Surround them with provocative and stimulating objects to keep their interest alive. Here a world map papers the wall, providing a background for a planet mobile and a mantelshelf array of wonderfully eclectic things to ask questions about (opposite).

STORAGE

Getting the storage arrangements right is a large part of what makes a child's room successful. In the very early days, storage should be tailored to the needs of adults using the room, making a practical and comfortable place to change, dress and look after the baby. But, as the child grows, whatever storage you devise should allow and indeed encourage the child to participate in the process of clearing up and taking care of possessions.

In the nursery, the greatest need is for places to store changes of bedding, nappies and toiletries, while a drawer or simple hanging rail will usually suffice for a baby's entire wardrobe. Even so, consider buying one or two good pieces of storage furniture or setting up a flexible storage system that can see the child

through several stages of development. A chest of drawers, a bookcase, a set of adjustable shelves built into an alcove, a blanket box or stacking crates can all satisfy a range of storage applications. Similarly, a hanging rail fixed at a level the child can reach, and moved up the wall as the child grows, is often more practical than a child-sized wardrobe.

DECORATION AND FURNISHING

Surfaces and finishes do need to be fairly hard-wearing in a child's room, but there is no need for them to be boring or unattractive. Practical considerations probably apply most strongly to flooring, which cannot be replaced or renovated as quickly and cheaply as wall decoration.

Pile carpeting is not a good choice, since it will inevitably become a patchwork of ugly spills and stains. Flatweave or rugged cord carpet is a better idea, while a wood floor — sanded boards or new hardwood — is warm, good-looking and practical. A large bright rag-rug or dhurrie is an economical way of adding colour and pattern, but make sure it is laid over a non-slip mat to prevent falls.

For windows, blinds are neat and unobtrusive. Plain, checked or striped curtains are also appropriate. You can match these to other soft furnishings – if there is space it's a good idea to have a chair where you can sit and read your child a bedtime story. Floor cushions, an old sofa dressed up with a bedspread and a bedside table for an older child are also useful, if there is enough room.

Lighting should be kept simple and safe. Most small children appreciate the comforting glow of a nightlight; a new reader will welcome a bedside light. Avoid standard lamps and large table lamps which can be easily knocked over. A simple overhead fitting or a system of angled spotlights are better options.

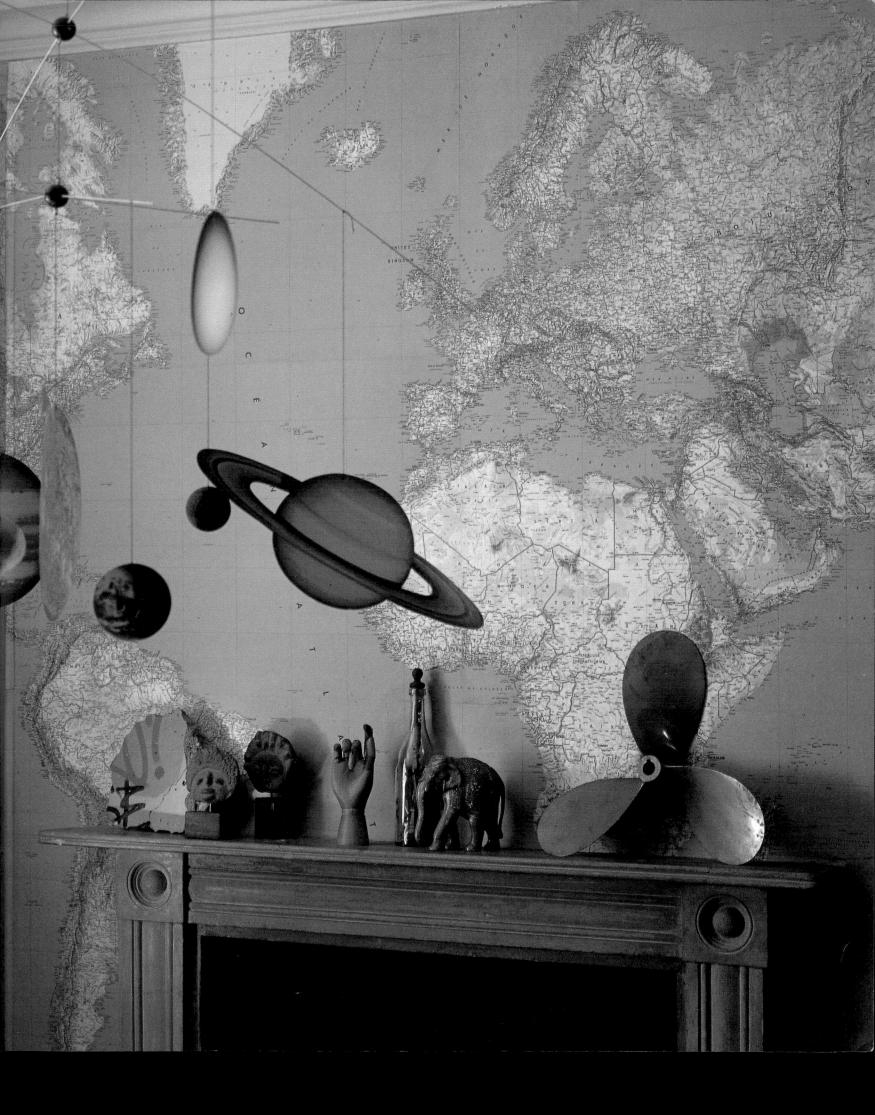

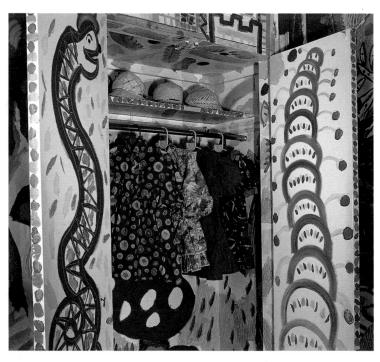

PAINTED DECOR

Children's rooms lend themselves to painted decoration: it is easy, quick and cheap to achieve, can be brightly coloured and changed with little trouble as the child grows into the next phase. Although the paint effects illustrated here are the results of many hours' work, you don't have to be a fine artist to produce lively effects - stylized patterns, 'naive' representations of animals and simple stencilling are all quick and easy to do. A snake and a caterpillar enliven cupboard doors in a brilliantly painted room (above left), while Caribbean-style scenes dress up a plain wooden wardrobe (below centre). A step beyond painted surfaces are pieces of furniture in animal shapes with painted detail, such as the enchantingly anthropormorphic work of the French artist, Gérard Rigot (above right and opposite).

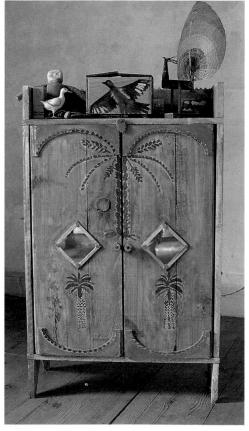

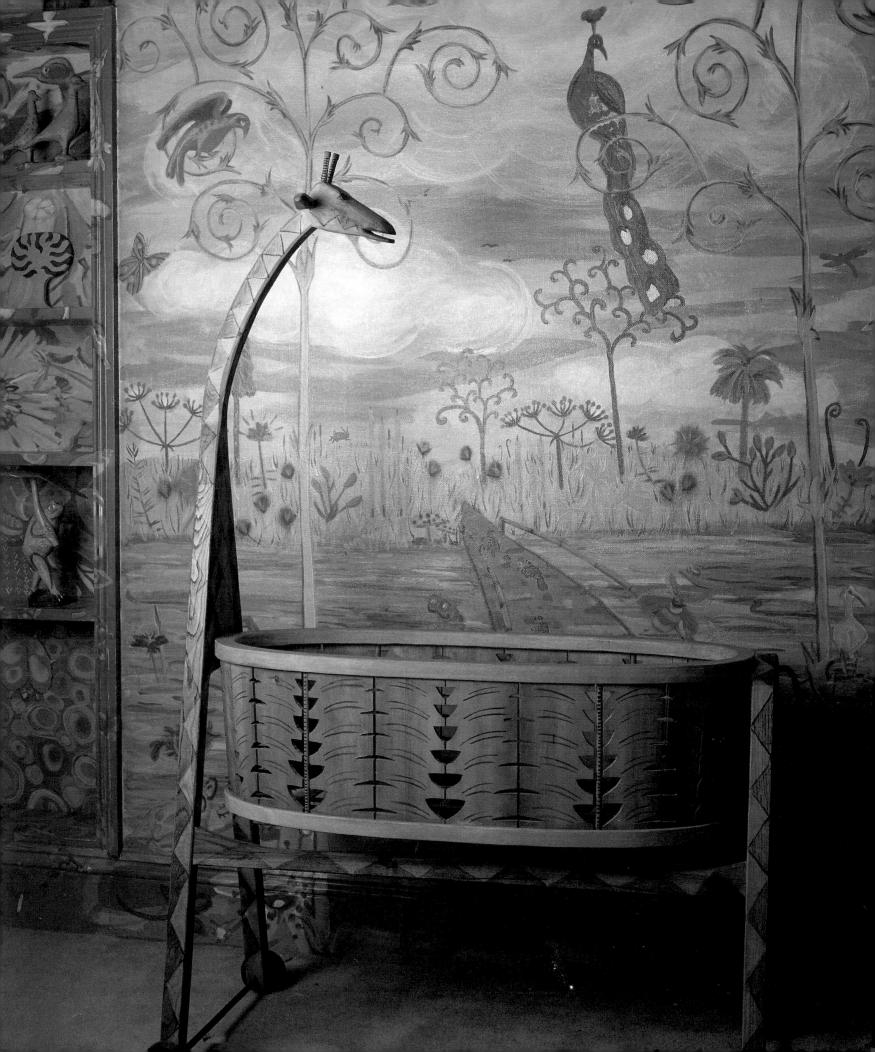

CRIB

A baby's crib has great sentimental value. Before the baby is born, making or trimming a crib or basket is often a way for parents to express all their hopes and feelings for the future. Fathers, in particular, may take pride in fashioning their child's first bed, making their own contribution at a time when they can otherwise feel somewhat left out. And the significance of the crib will outlast its usefulness. Later in life, the child will see the crib as proof of the parents' concern and love and it may become a family heirloom.

A rocking cradle or crib is a traditional bed for a newborn baby, the gentle lulling motion soothing and reassuring a baby unaccustomed to perfect stillness. The rockers are the most complicated part of the construction, albeit an interesting woodworking exercise. They are fashioned by gluing and cramping strips of plywood together around a former to build up into curves. Holes drilled in the end panels are primarily decorative, but could also be used for suspending a soft toy or rattle.

The basic design of the crib shown here consists of a simple pine frame, with dowels at the sides. A little care is needed to ensure that the angles are correct for insetting the plywood end panels.

The crib is very much scaled to the first few months of a baby's life – a sense of enclosure seems to be important to a baby in its early days. But although the crib is soon outgrown, it will find a new use when the next baby comes along. The dimensions of the crib accommodate a standard-sized baby's mattress.

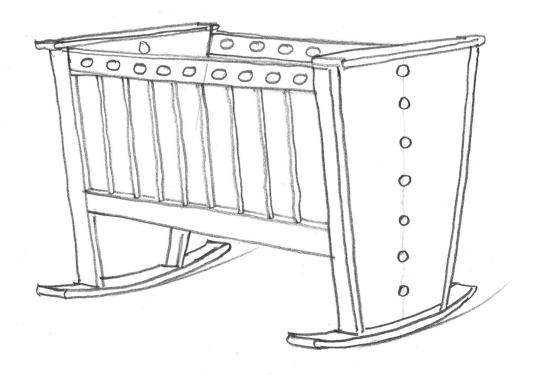

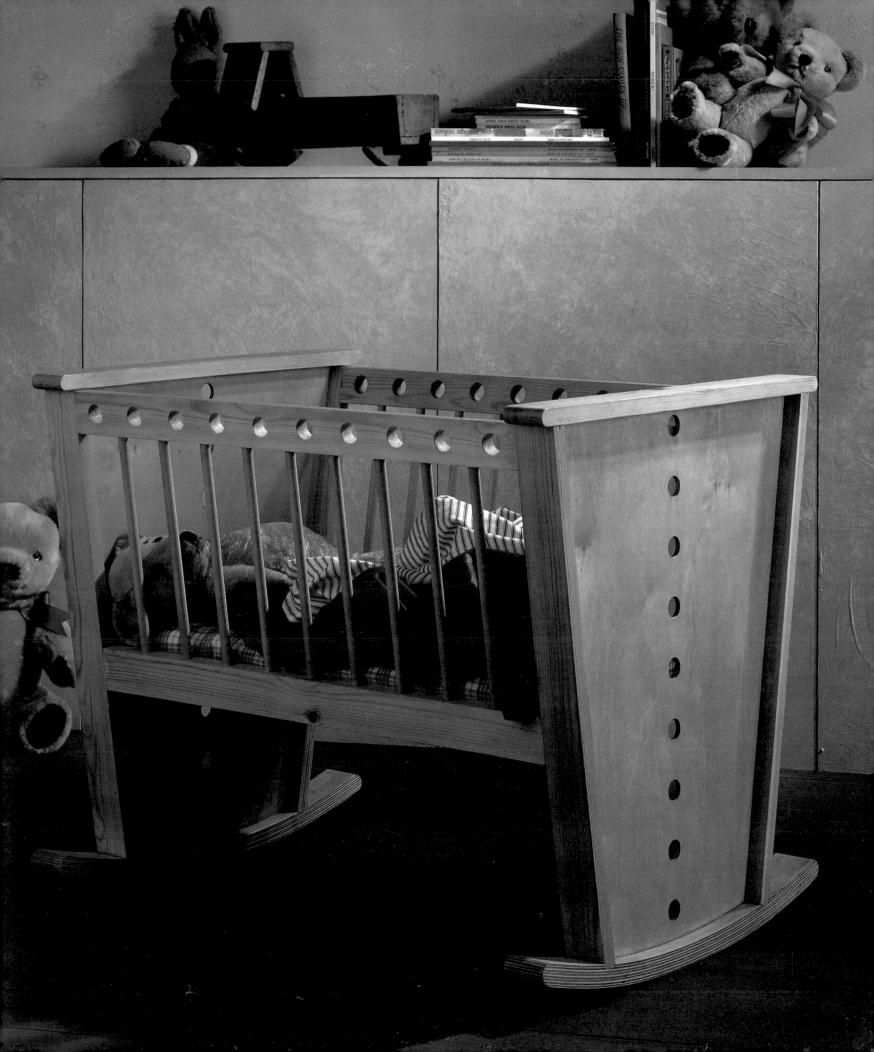

CRIB

A new baby can easily get 'lost' in a cot, and for those important first few months a crib is a must. Our crib is equipped with curved rockers that allow it to be rocked from side to side to lull a baby to sleep. Proprietary crib mattresses are available from baby shops, and our design is based around a mattress measuring 730×350 mm ($28\frac{3}{4} \times 13\frac{3}{4}$ in).

For safety's sake, do not attempt to modify or alter the design. The size of the rockers, and the height of the mattress base from the ground,

Tools
WORKBENCH (fixed or portable)
TRIMMING KNIFE
STEEL MEASURING TAPE
STEEL RULE
TRY SQUARE
PANEL SAW
CIRCULAR POWER SAW
TENON SAW
JIGSAW
MARKING GAUGE
POWER DRILL
DRILL STAND (optional)
DRILL BIT -3 mm ($\frac{1}{8}$ in)
DOWEL BIT – 10mm (3in)
COUNTERSINK BIT
FLAT BITS – 25mm (1in) and 12mm ($\frac{1}{2}$ in)
DOWELLING JIG
2 G-CRAMPS or WEBBING CRAMP
SMOOTHING PLANE (hand or power)
POWER ROUTER and 6mm (\frac{1}{4}in) STRAIGHT BIT
SET OF CHISELS
MALLET

POWER FINISHING SANDER or

HAND SANDING BLOCK

MATERIALS			
Part	Quantity	Material	Length
UPRIGHT	4	75×25 mm (3 × 1in) PAR softwood, reduced to 55mm ($2\frac{3}{16}$ in) wide	625mm (24 ⁵ / ₈ in)
RAIL	4	As above	700mm (27½in)
CAPPING BOARD	2	As above	580mm (about 23in)
SLAT	18	12mm (½in) hardwood dowel	300mm (12in)
END PANEL	2	6mm (‡in) plywood	640mm ($25\frac{1}{4}$ in) high × 512mm ($20\frac{3}{16}$ in) wide at the top × 312mm ($12\frac{1}{4}$ in) wide at the bottom
ROCKER	2	Each formed from 4 pieces of 6mm (4in) laminated plywood	Cut from a sheet approx. 650 \times 58mm (25 $\frac{5}{8}$ \times 2 $\frac{1}{4}$ in)
BASE	1	6mm (¼in) plywood	Cut to fit (approx. 750×385 mm $[29\frac{1}{2} \times 15\frac{1}{4}$ in])
BASE-SUPPORT BATTEN	2	25 x 25mm (1 x 1in) PAR softwood	Cut to fit (approx. 750mm [29½in])
DOWEL (for joints)	24	10mm (3in) diameter	
Also required: 18mm (3in) ch	nipboard, to m	nake former for rockers	

have been carefully worked out to ensure stability. And the spacing between the dowels which form the sides of the crib ensures that a baby's head, hands and feet cannot become trapped. Similarly, the holes in the end panels and along the top side rails must be 25mm (1in) in diameter to ensure that little fingers cannot become caught in them.

The main frame of the crib is made from $55 \times 25 \text{mm}$ ($2\frac{3}{16} \times 1 \text{in}$) PAR (planed all round) softwood. You will not be able to buy this size 'off the shelf', so buy $75 \times 25 \text{mm}$ ($3 \times 1 \text{in}$) softwood and cut this stock down to size using a circular saw, or ask the supplier to do this for you. The newly sawn edge will need to be planed smooth.

The sides are formed using 12mm $(\frac{1}{2}in)$ hardwood dowels, and the end panels and crib base are cut from 6mm $(\frac{1}{4}in)$ plywood. Choose the plywood carefully, especially if the crib is to be given a clear finish (for this you will need a 'faced' or veneered plywood). Stops could be fitted beneath the rockers to prevent any risk of tipping.

CONSTRUCTION

Cut down the softwood framing timbers and plane to finish 55mm $(2\frac{3}{16}\text{in})$ wide. Then cut all the main components (that is, the uprights, rails and slats) to length.

SIDE FRAMES

Each side of the crib is constructed from nine slats of dowelling fixed vertically between two horizontal rails (fig 1). Along the centre line of a narrow edge of one rail mark positions for nine holes, spaced equally at 70mm ($2\frac{3}{4}$ in) centres. Cramp all four rails together side by side and transfer the marks from the first rail to the other three rails.

Fit a 12mm $(\frac{1}{2}in)$ dowel bit in an electric drill, and drill a hole at each mark on the rails to a depth of 10mm $(\frac{3}{8}in)$. This is best done with the drill held upright in a drill stand. Alternatively, you can cramp the four rails firmly to a workbench.

Apply a little adhesive to each hole and assemble the two sides. Fit the dowels between two rails and tap them together with a mallet, using scrap wood to protect the surface of the rails from the mallet blows. Lay the side frames on a flat surface for about six hours until the adhesive has firmly set.

Making the Side Frames Nine holes spaced at 70mm (2¾in) centres are drilled along top and bottom rails to take dowel 'slats'.

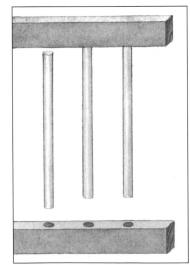

Marking	square	118
Sawing	118	
Planing	119	
Drilling	120	

BEDROOMS
Crib
22/23

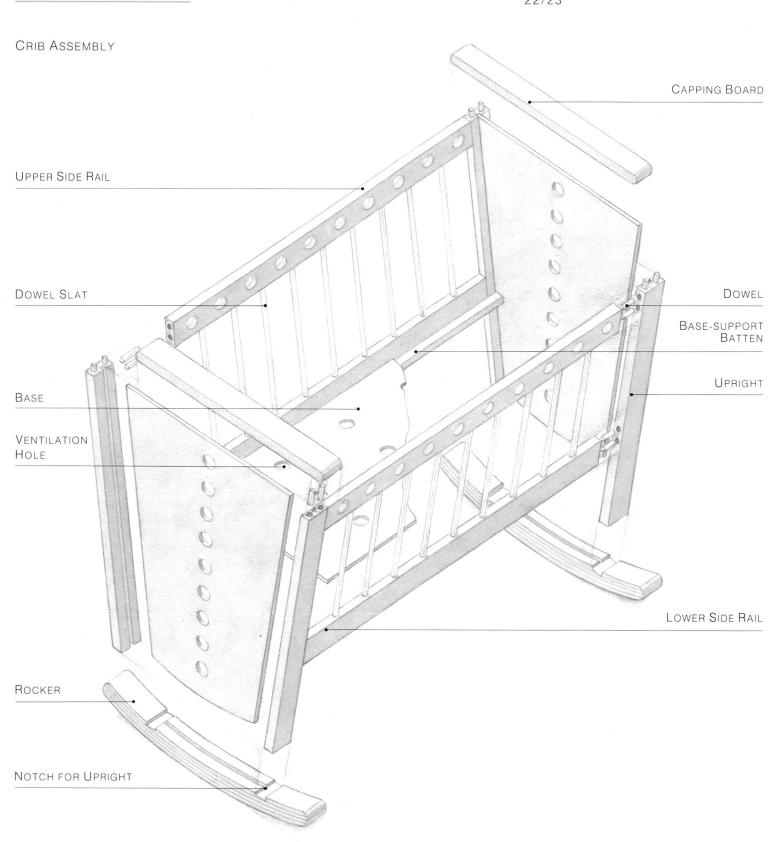

CRIB

UPRIGHTS

Down the length of the centre of the inside face of each upright rout a 6×6 mm ($\frac{1}{4} \times \frac{1}{4}$ in) groove.

The four uprights are joined to the rails of the assembled side frames using two dowels at each joint (fig 1). Lay the side panels flat on the bench with an upright at each end and mark the four joint positions for each panel - the tops of the uprights must be flush with the tops of the upper side rails. Using a dowelling jig, drill out two holes for 10mm (3in) dowels in the end of each rail and in matching positions in the uprights. Dry assemble to test the fit. Then apply a little adhesive to the holes of the joints, insert the dowels and tap the uprights in place with a mallet, using a piece of scrap wood to protect the surfaces (fig 2).

MAKING THE ROCKERS

The rockers are each made by laminating four strips of plywood bent around a chipboard former – offcuts of any $18mm \left(\frac{3}{4} n \right)$ board will do – to make the curve (fig 3).

Joining Sides to Uprights

Mark the side rail positions on the
sides of the uprights. Drill and dowel
ends of rails to uprights.

The radius for the arc of the rocker former is 960mm (approximately 38in). The best way to mark this curve is to use a pencil tied to a suitable length of string attached to a nail at a central point. Mark the arc on to a piece of 18mm (¾n) chipboard measuring approximately 700 × 300mm (28 × 12in), and cut around this curve using a jigsaw.

Build up the thickness of the former at the curved edge using two extra pieces of board (about 700×150 mm [28×6 in]) to bring the thickness of the curve to 54mm ($2\frac{1}{8}$ in). Screw the three pieces together (fig 3, below).

From the 6mm ($\frac{1}{4}$ in) plywood cut the eight strips, each 650mm ($25\frac{5}{8}$ in) long, to form the rockers. Cutting these to 58mm ($2\frac{5}{16}$ in) wide allows a little extra for finishing to 55mm ($2\frac{3}{16}$ in) which is the width of the stock used for the uprights.

Glue together the four strips to form each rocker using a non-flexible powdered resin wood glue such as Cascamite (not the ready-to-use PVA type). This gives a rigid setting. Form one rocker at a time,

Finished Side Assembly Note 6×6 mm $(\frac{1}{4} \times \frac{1}{4}$ in) groove down centre line of inside face of each upright to accept end panel.

cramping one set around the former (fig 3) and holding with G-cramps or a webbing cramp until the adhesive sets (about 8 hours). Then repeat for the second rocker.

END PANELS

Mark out end panels on 6mm ($\frac{1}{4}$ in) plywood so they are 640mm ($25\frac{1}{4}$ in) high, 512mm ($20\frac{3}{16}$ in) wide at the top and 312mm ($12\frac{1}{4}$ in) wide at the bottom. Check that they taper equally each side of the centre line. Cut out the panels.

Line up a rocker to the bottom edge of an end panel, align the centres and mark round the curve on to the bottom edge of the panel. Trim the panel to shape using a jigsaw. Transfer the curve on to the other panel and cut this one out.

Dry assemble the end panels on to the side frames and turn the whole unit upside down.

Place one of the rockers in position alongside the end panel. Make sure the centre line of the rocker lines up with the centre line of the end panel. Mark on the rockers where the uprights will sit.

Using a try square, extend the marks of the upright positions across the rockers. Saw down these lines with a tenon saw, and chop out the notches with a chisel (see Crib Assembly, page 23).

Using a router, rout a 6mm ($\frac{1}{4}$ in) wide groove, 10mm (about $\frac{3}{8}$ in) deep, centrally on each rocker

between the notches to accept the bottom edge of the end panel.

From the underside, drill and countersink through the rockers at an angle into the uprights (fig 4) and fix with 64mm ($2\frac{1}{2}$ in) No 10 woodscrews, two to each upright. Dry assemble to check the fit.

ASSEMBLING THE BASE

Cut two base-support battens from 25×25 mm (1×1 in) PAR softwood, to the internal length between the end panels at the height of the lower side rail.

Plane a bevel along one length of each batten so the top edge will be horizontal to the base (fig 5). Glue and screw the battens flush with the bottom of the lower side rail. Use $1\frac{1}{2}$ in (38mm) No 8 woodscrews.

Forming the Crib Rockers

Each rocker is made from four strips of 6mm $\binom{1}{4}$ in) plywood, which are bent around a purpose-made chipboard former with a radius of 960mm (38in). The plywood strips are then glued and cramped together until the adhesive sets.

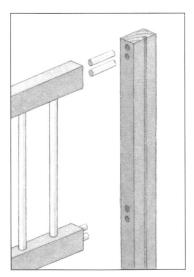

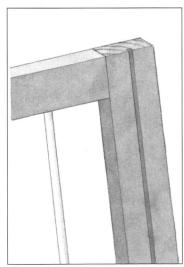

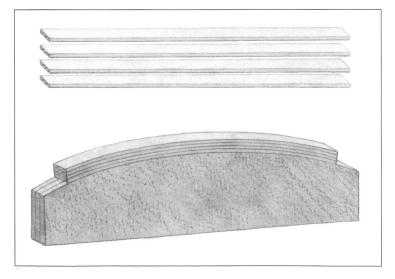

Cutting a circle 118

Marking square 118

Sawing 118

Cutting curves 119

Planing 119
Drilling 120
Screwing 120
Dowel joint 124

BEDROOMS
Crib
24/25

Check that the diagonals are equal to ensure the crib is square, pulling it to adjust if necessary. Then take the internal measurements of the crib, and cut the plywood base panel to fit. Once in place, the base will hold the crib square.

CAPPING BOARDS

Remove the end panels and plane the top edges of the side frames so they are horizontal. Plane from the ends towards the middle to avoid splintering the outside edges of the uprights. Replace the end panels.

Cut the two capping boards to length. At the ends these will be dowel jointed to the uprights (fig 6), but between these dowel positions a 6×6 mm ($\frac{1}{4}\times\frac{1}{4}$ in) groove, 512mm ($20\frac{3}{16}$ in) long, will be required centrally along the underside of each capping board to take the top edge of the end panel.

Drill down into the uprights and up into the underside of the capping boards to take the dowels and dry assemble with 10mm ($\frac{3}{8}$ in) dowels, two to each upright. A dowelling jig may make drilling more accurate.

DECORATIVE HOLES

Take the crib apart, and with the relevant parts held on scrap wood, drill 25mm (1in) diameter holes centrally down the end panels at 70mm ($2\frac{3}{4}$ in) centres.

Drill 25mm (1in) holes through the top rails, spacing these centrally between the dowel slats (see Crib Assembly, page 23). Do not hang toys etc. between the holes as there is a risk of strangulation.

In the base panel drill 12 ventilation holes (four rows of three holes), again to a diameter of 25mm (1in).

FINAL ASSEMBLY

With a sanding block or finishing sander, round off the ends of the rockers and capping boards.

Glue up the crib in the following order: (i) end panels to side frames; (ii) rockers to base of end panels; (iii) capping boards to top of end panels. Finally, simply drop the base panel into place.

Before applying your finish, make sure all edges and holes are rounded and sanded smooth.

Fitting the Capping Board Rout underside of capping board to accept top of end panel. Dowel capping board ends to uprights.

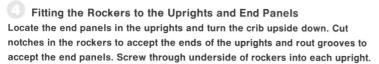

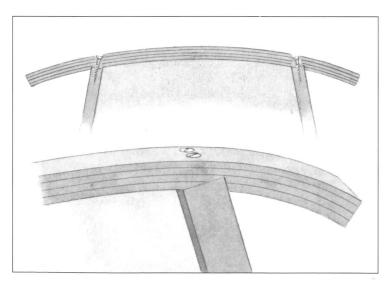

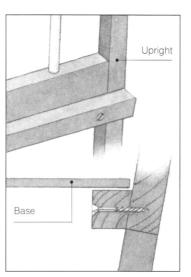

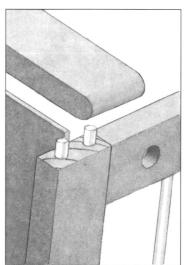

ROCKING CHAIR

A rocking chair is a classic item of nursery furniture. An adult-sized rocker is an ideal place for reading a bedtime story to a sleepy child. But a small, specially made rocking chair, such as the one shown here, has much more personal meaning and appeal for the child itself. Having a chair of one's own is something to be proud of, a symbol of childhood that is accorded special significance and often cherished for many years to come.

The design and construction of this rocking chair are fairly straightforward. The most complicated part of making it consists of shaping the rockers which are built up from strips of plywood. The rest of the chair is also made of plywood, jigsawed into the appropriate shapes. The plywood provides an easy surface to decorate. The chair could be painted a colour to complement the room, and you might add a cushion for extra comfort.

Wit and humour are important elements that should not be overlooked in designs for children's furniture. The rounded wings of the rocker, which resemble great Mickey Mouse ears, are vaguely anthropomorphic, a quality accentuated further by the two 'eyeholes' drilled through the back. Chairs which wrap around and encircle a child in this way make a cosy place to sit and offer a pleasing sense of security.

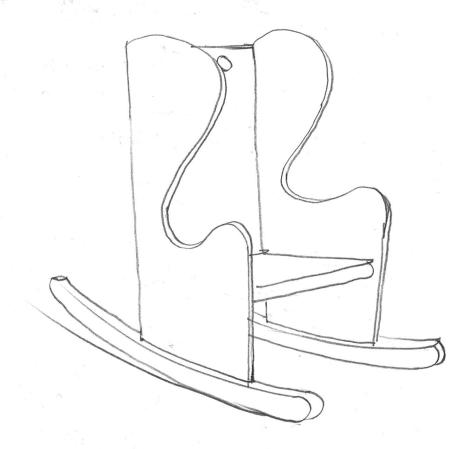

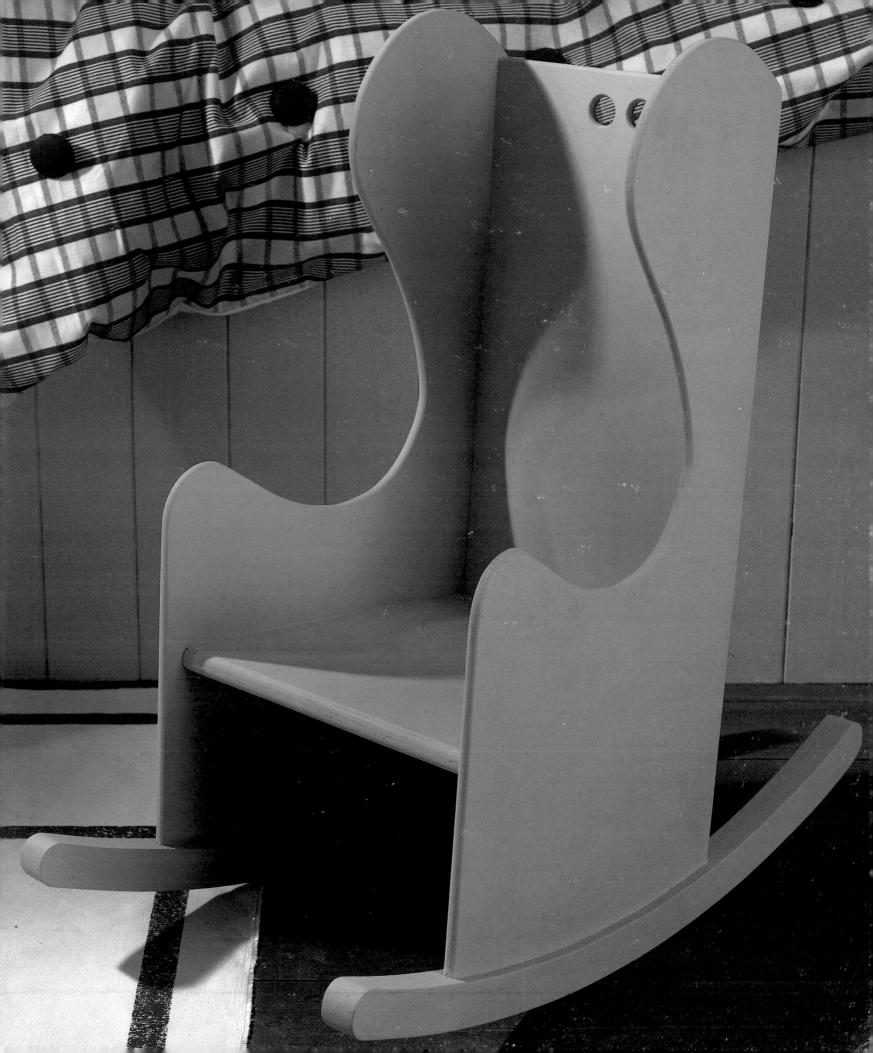

ROCKING CHAIR

Even small children eventually stop running around to take a breather and when they do it is a good idea for them to have their own comfortable chair where they can rest and relax, read, or watch television. The child's rocking chair made here is ideal. The chair is about 700mm (27½in) high overall, and it is perfect for children aged about four years old. The entire chair is made from 9mm (3in) plywood. You only need a sheet measuring 1400 × 910mm (about 5 × 3ft), but you will probably end up having to buy a sheet measuring 1800×910 mm (6×3 ft), which is a stock size. This will result in some waste but the offcuts may be useful for some other project.

TOOLS

WORKBENCH (fixed or portable)

TRIMMING KNIFE

STEEL MEASURING TAPE

STEEL RULE

TRY SQUARE

MARKING GAUGE

PANEL SAW or CIRCULAR POWER SAW

POWER DRILL

FLAT BIT -25mm (1in), to cut holes in back panel

2 G-CRAMPS

2 SASH CRAMPS or WEBBING CRAMP

SMOOTHING PLANE

POWER ROUTER and 6mm $(\frac{1}{4}in)$ STRAIGHT-CUTTING BIT

ROUNDING-OVER CUTTER for router (or plane, Surform tool or

sanding block)
POWER FINISHING SANDER or

HAND SANDING BLOCK

JIGSAW or SURFORM TOOL

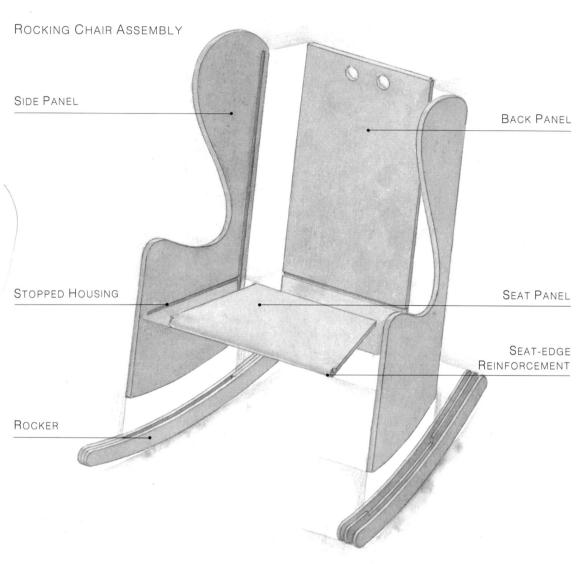

MATERIALS

Part	Quantity	Material	Length
SIDE PANEL	2	9mm (3in) plywood	Cut from 700 × 320mm (27½ × 13in)*
BACK PANEL	1	As above	600 × 260mm (23 ⁵ ₈ × 10 ¹ ₄ in)
SEAT PANEL	1	As above	296mm (115/8in) deep × 310mm (124/1n) wide (tapering to 260mm [104/1n] at the back)
SEAT-EDGE REINFORCEMENT	1	As above	310 × 50mm (12½ × 2in)
ROCKER	2	Each formed from 3 pieces of 9mm (3in) plywood	Cut from 660 × 400mm (26 × 153in)*
Cut from grid pattern	provided on pa	age 29	

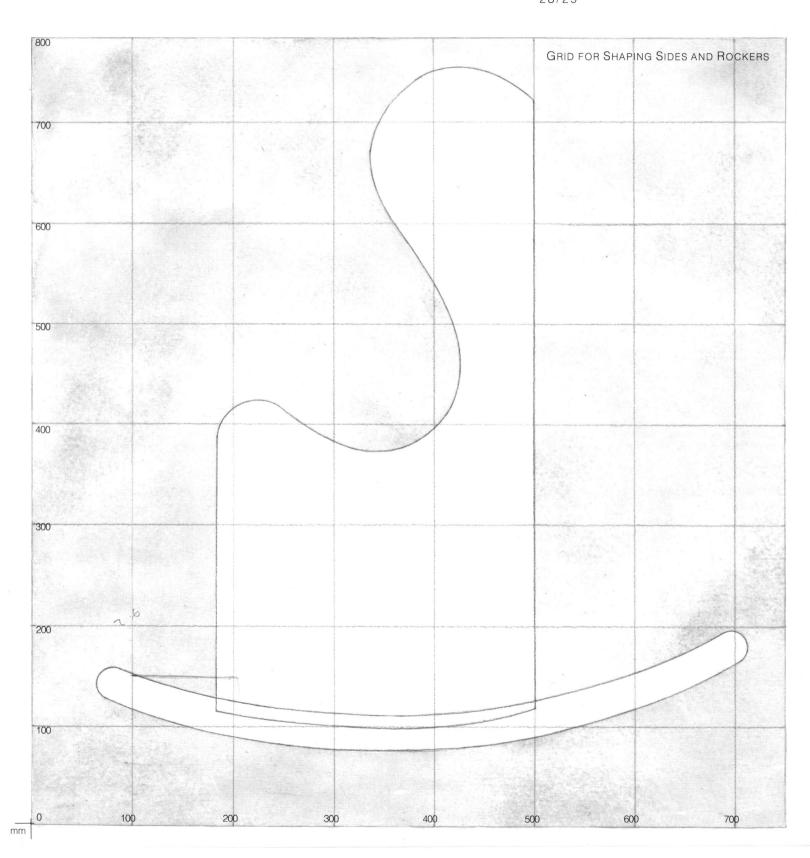

ROCKING CHAIR

CONSTRUCTION

Mark out the main pieces for the sides, back and seat on the 9mm ($\frac{3}{8}$ in) plywood sheet. Double check the measurements are accurate, then cut out the pieces using a jigsaw or a circular power saw.

SHAPING THE SEAT

Mark out the front of the seat so that it measures 310mm ($12\frac{1}{4}$ in) wide at the front, narrowing evenly at each side to 260mm ($10\frac{1}{4}$ in) wide at the back. The front-to-back measurement is 296mm ($11\frac{5}{8}$ in). When you are sure that the seat is a regular shape, cut it out using a jigsaw or a circular power saw.

SHAPING THE SIDES

Using the grid (page 29), transfer the shape of the side panel and rocker on to a large sheet of paper. Brown paper is ideal for the pattern, but newspaper will do.

Once you are satisfied with the shape of the side (it doesn't have to be *exactly* as shown here), transfer

Forming the Rockers
Each rocker is made from three
pieces of plywood; notch central
piece to accept chair side panel.

the outline to one of the plywood side panels. The easiest way to do this is first to trace over the drawn outline on the *reverse* side of the paper using a soft pencil, then lay the paper pattern on to the plywood panel the right way up and secure it down at the sides and corners with adhesive tape. Now go over the outline again, pressing hard with the pencil. The outline will be transferred on to the wood.

Cut out the shape using a jigsaw, and sand the edges smooth. Lay this shaped piece on top of the plywood for the second side panel, draw around it and cut out and smooth as before.

SHAPING THE ROCKERS

Each rocker is made from three thicknesses of plywood, so you have to cut out six shapes in total. Following the method described above for the side panel, transfer the pattern of the rocker on to the plywood sheet set aside for the rockers and cut out the first rocker piece using a jigsaw. Sand or plane this accurately to shape as shown on the grid (page

Housing and Rebate Detail The main chair parts are joined using 6×5 mm ($\frac{1}{4} \times \frac{3}{16}$ in) housings and matching rebates as shown.

the rocker can be shaped using either a jigsaw or a Surform tool.

Use this first rocker section as a template to mark out the other five

29). The concave (upper) edge of

Use this first rocker section as a template to mark out the other five pieces on the plywood panel. Cut all of these out with a jigsaw and sand all the edges smooth.

MAKING THE ROCKERS

The rockers are made by laminating three shaped pieces of plywood together. Before this is done, the two central pieces are notched to create slots to take the side panels (fig 1). To mark out on the central pieces, hold one of the shaped pieces against a side panel, referring to the grid to position it correctly. The rocker should protrude about $120 \text{mm} \left(4\frac{3}{4} \text{in} \right)$ in front of the panel and $220 \text{mm} \left(8\frac{5}{2} \text{in} \right)$ behind it.

Mark off the width of the side panel on to the concave edge of a rocker strip. Cut out a 12mm (½n) deep section across the full thickness between these marks, following the curve of the bottom edge of the side panel. Repeat the process on another rocker strip.

Back and Side Panels
Rout housing to accept back panel
rebate 15mm (§in) from and parallel
with back of side panel.

Glue up each set of three strips, with one whole rocker on each side of the slotted rocker (fig 1, below). Cramp together and, when the adhesive has set, round off the ends and sand the surfaces flush. Stops could be added to prevent tipping.

MAKING THE HOUSINGS FOR THE BACK PANEL

The back and seat panels fit into housings (slots) which must be cut in the inside faces of the side panels. A typical section of this, with dimensions marked, is shown (fig 2). Both the back panel and the seat panel are rebated along their sides to fit snugly into the housings.

To mark out the back housing on the side panel, measure and draw a line 15mm ($\frac{5}{8}$ in) in from the back edge of the panel (fig 3). This marks the front edge of the housing. Mark a parallel line 6mm ($\frac{1}{4}$ in) towards the back edge using a marking gauge. This second line marks the width of the housing for the back panel.

To determine the length of the housing, place a side panel into a rocker and offer up the back panel

O Seat and Back Panels

Rout a housing 150mm (6in) up from bottom of back panel to accept rebate in back edge of seat panel.

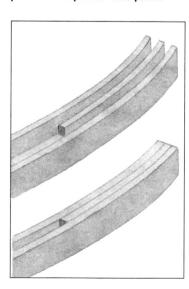

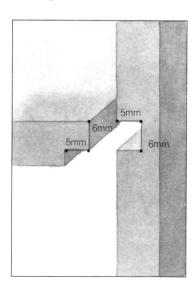

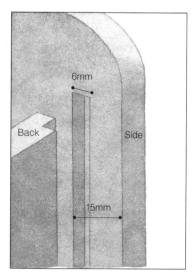

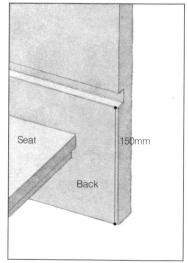

Finishes 117	
Cutting curves	119
Planing 119	

Drilling 120	
Housing join	t 123
Rebates 12	3

Rocking Chair

30/31

so that it comes just above the rocker. Mark off the top and bottom of the back panel across the marked lines to indicate the length of the housing.

Make corresponding marks for the housing on the other side panel. (Remember they are 'handed' left to right, so will be mirror images.)

CUTTING THE HOUSINGS FOR THE SEAT

Measure 150mm (6in) up from the bottom edge of the back panel and, using a marking gauge, mark off a 6mm ($\frac{1}{4}$ in) wide housing for where the seat panel will be rebated to join the back panel (fig 4).

Offer up the back panel to each of the side panels and transfer marks for the height of the seat panel on to the side panels. Offer up the seat panel to each side panel at this height, positioned at 90 degrees to the housing marks for the back panel (fig 5), and measure for the length of the seat housing on the side panel so that, when it is cut, a 6mm ($\frac{1}{4}$ in) stopped shoulder will be left at the front of the seat (fig 6).

Coat and Cidc Pancls Mark back panel housing position on side panels. Rout housings for seat at right angles to marked points.

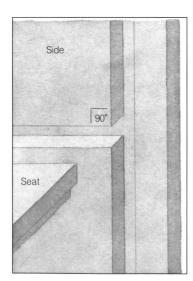

Mark the housing for the seat on the inside face of the other side panel in the same way.

Cut out all the housings using a router fitted with a 6mm ($\frac{1}{4}$ in) wide straight-cutting bit set to cut to a depth of 5mm ($\frac{3}{48}$ in).

CUTTING THE REBATES IN THE SEAT AND BACK PANELS

To fit into the housings, the tongues in the seat and back panels must be 6mm $(\frac{1}{4}in)$ wide and 5mm $(\frac{3}{16}in)$ deep. To ensure the panels are a tight fit you will need to rout rebates 5mm $(\frac{3}{16}$ in) wide and to a depth so that they leave 6mm (in) of fixed tongue to fit into the housing. Practise the routing technique first on plywood offcuts to get the fit right, then rout round the back and sides of the seat panel underside remembering to leave the 6mm $(\frac{1}{4}in)$ stopped shoulder at the front of the seat (fig 6). Also rout a rebate down the reverse side of the long edges of the back panel (that is, the side that does not have any seat housing cut into it) (fig 3).

Coat Panel Rebates Rout 6×5 mm ($\frac{1}{4} \times \frac{3}{16}$ in) rebates along back and side edges. Rebates at sides are stopped 6mm ($\frac{1}{4}$ in) short.

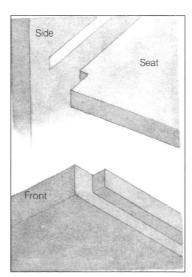

FINISHING OFF

Drill two 25mm (1in) diameter holes through the back panel, about 35mm (13in) down from the top edge to the centres of the holes and about 35mm (13in) apart, centre to centre. These holes are decorative and are useful for lifting the chair.

Rub down all the panels with abrasive paper until smooth. Dry assemble them to check the fit.

For aesthetic reasons, glue and pin a strip of 50mm (2in) wide plywood offcut to the underside of the front of the seat panel (fig 7).

Using a rounding-over cutter fitted in a router, or Surform tool or sanding block, round off the front edge of the seat, the edges of the seat-reinforcing strip, the top and bottom edges of the back panel, all around the shaped side panels and the inside of the holes, so that all exposed edges are smooth.

Apply adhesive to the housings and assemble all the components, holding the seat together with sash cramps or a webbing cramp.

Finish the chair as required.

Seal-edge reinforcement Glue and pin an offcut to underside of seat panel, flush with front edge. Round over front edge to finish off.

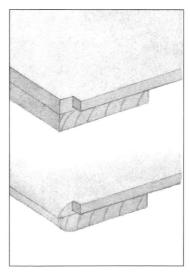

STORAGE HOUSE

Play and practicality come together in this witty 'doll's house' storage structure, designed to encourage children to participate in tidying up and taking care of their own things, whilst helping to make a game of it. Attractive, interesting and amusing storage like this not only enlivens a bedroom but is fun to use, and this house, with its opening windows and doors, helps to teach children to put back their toys and other belongings literally 'where they live'.

The construction demands only the most basic DIY skills. There are only a few angles or curves, and the main framework consists of straight panels made of MDF, a good surface on which to decorate. The house here fits into a recess but it could equally be free-standing or set against a wall without being retained on either side. Down the centre of the house, the arches over the windows are cut out to make handles to open either doors or drawers, whichever you choose.

The house can be decorated entirely to your own architectural preferences. If you aren't confident about your painting skills, you can make a window stencil and a door stencil and use these as templates to ensure uniformity of design, or you could cut out squares of paper and glue these on top to make window panes or door shapes, varnishing over the top so they don't peel away. Inside, storage spaces can be left plain or painted or papered to take the doll's house illusion a stage further.

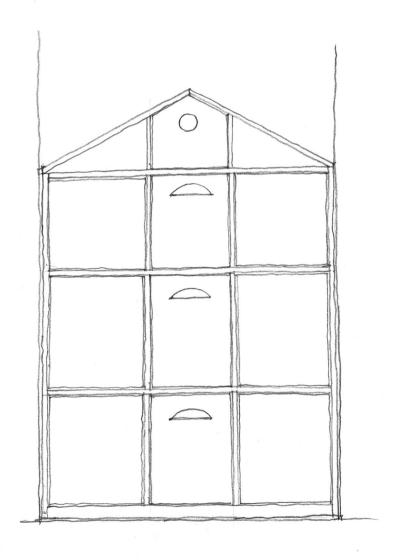

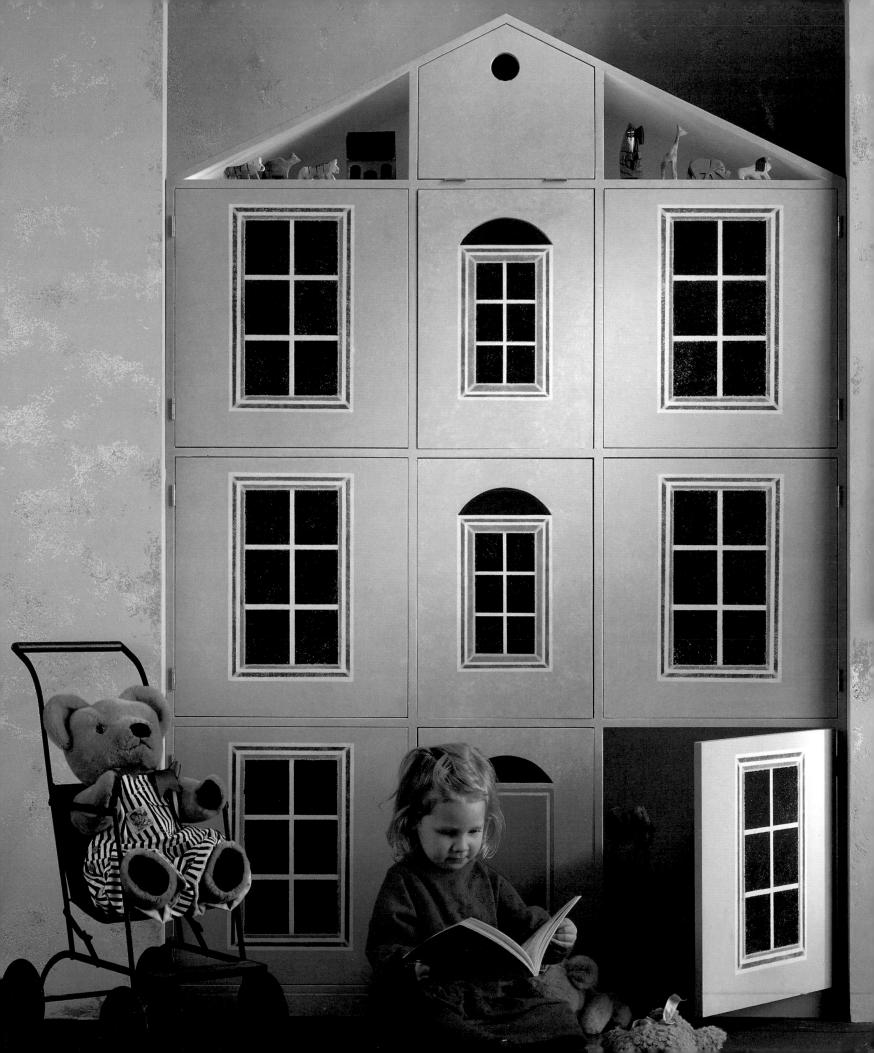

Storage House

Here is a free-standing storage unit with a difference – it is built in the shape of a town house. The storage is divided into compartments which have either conventional side-hinged doors, bottom-hinged flap-down doors, toy boxes to slide in and out, or they can be left as open shelves. For safety's sake, you should only fit toy boxes along the bottom row because these can be heavy when full.

The dimensions given are easily modified if you want a larger or smaller unit, or if it is to fit into an alcove. If it is free-standing, the storage house must be screwed to the wall through the back panel to ensure it is absolutely secure.

The cupboard is made from four 2440×1220 mm (8×4 ft) sheets of 15mm ($\frac{5}{8}$ in) MDF (medium density fibreboard); alternatively, 15mm ($\frac{5}{8}$ in) blockboard can be used.

Tools
WORKBENCH (fixed or portable)
STEEL MEASURING TAPE
STEEL RULE
TRY SQUARE or COMBINATION SQUARE
SLIDING BEVEL
JIGSAW or CIRCULAR POWER SAW – for cutting out panels
POWER DRILL
DRILL BIT - 3mm (lin)
COUNTERSINK BIT
HOLE SAW - 50mm (2in) diameter
SCREWDRIVER
CLAW HAMMER
SMOOTHING PLANE
ROUTER
STRAIGHT BIT - 15mm (5in)
G-CRAMPS

POWER SANDER or HAND

SANDING BLOCK

Part	Quantity	Material	Length
SIDE PANEL	2	15mm (şin) MDF	1460 × 380mm (57½ × 15in)
TOP PANEL	1	As above	1200 × 380mm (47½ × 15in)
BOTTOM PANEL	1	As above	As above
CENTRAL DIVIDER	2	As above	1438 × 365mm (56 ⁵ ₈ × 14 ³ ₈ in)
OUTER SHELF	4	As above	428×365 mm ($16\frac{3}{4} \times 14\frac{3}{8}$ in)
INNER SHELF	2	As above	326×365 mm ($12\frac{7}{8} \times 14\frac{3}{8}$ in)
BACK PANEL	1	As above	1440 × 1200mm (56 ³ / ₄ × 47 ¹ / ₄ in)
ROOF PANEL	2	As above	780 × 380mm (30 ³ ₄ × 15in)
ROOF DIVIDER	2	As above	Cut from 365×310 mm ($12\frac{1}{4} \times 14\frac{3}{8}$ in)
ROOF BACK PANEL	1	As above	Cut from 1200×300 mm ($47\frac{1}{4} \times 11\frac{7}{8}$ in)
ROOF FIXING BLOCK	1	Softwood offcut	380 × 50mm (15 × 2in)
PLINTH FRONT	1	15mm (§in) MDF	1220 × 40mm (48 × 1 ⁹ / ₁₆ in)
PLINTH BACK	1	As above	As above
PLINTH SIDE	2	As above	350×40 mm ($13\frac{3}{4} \times 1\frac{9}{16}$ in)
OUTER DOOR	As required	As above	470×420 mm ($18\frac{1}{2} \times 16\frac{1}{2}$ in)*
INNER DOOR	As required	As above	470 × 320mm (18½ × 125in)*
TOY BOX FRONT	1 per box	As above	470 × 320mm (18½ × 125in)*
TOY BOX BACK	1 per box	As above	As above
TOY BOX SIDE	2 per box	As above	470 × 345mm (18½ × 13½ in)*
TOY BOX BASE	1 per box	As above	335×310 mm ($13\frac{1}{4} \times 12\frac{1}{4}$ in)*

^{*} Door and toy box sizes are approximate; pieces should be cut to fit as required to give a 1.5mm $(\frac{1}{16}in)$ clearance all round; the topmost inner door will need to be shaped to follow apex of roof

CARCASS

Mark and cut out all of the components for the carcass – that is, the top, bottom, two sides and two central dividers.

SIDE PANELS

Mark and cut a 15mm (§in) deep rebate into the top and bottom edges of each side panel (fig 1, page 36), using a router fitted with a 15mm (§in) straight cutter bit.

Divide each side panel into three equal sections, then mark 15mm ($\frac{5}{8}$ in) wide housings centrally at these heights, across the inside face of each panel. Rout the housings to a depth of 5mm ($\frac{1}{4}$ in).

TOP AND BOTTOM PANELS

Mark off positions for the 15mm ($\frac{5}{8}$ in) wide housings on the inside faces of the top and bottom panels so that there is a central section with an internal dimension of 320mm ($12\frac{5}{8}$ in) wide. This leaves an internal dimension of 420mm ($16\frac{1}{2}$ in) for the two outer sections.

Cut the two housings $15 \text{mm} \left(\frac{5}{8} \text{in} \right)$ wide and $5 \text{mm} \left(\frac{1}{4} \text{in} \right)$ deep across the inside face of the bottom panel (fig 2, page 36). The top panel will be housed on both sides, so mark around for the upper housing, but this time cut the housings to a depth of $3 \text{mm} \left(\frac{1}{8} \text{in} \right)$ only, so the panel will not be too thin at the point where the housings have been cut.

CENTRAL DIVIDERS

These are 22mm ($\frac{7}{8}$ in) shorter than the side panels. Offer one of the central dividers up to the side panel so the side panel overlaps by 10mm ($\frac{3}{8}$ in) at the bottom and by 12mm ($\frac{1}{2}$ in) at the top, and mark off the housings for the shelves (fig 3, page 36). Square around to the sides. Mark off on to the other central divider. Cut the housings on the central dividers 15mm ($\frac{5}{8}$ in) wide and 3mm ($\frac{1}{8}$ in) deep.

BACK PANEL REBATING

Cut a rebate 15mm ($\frac{1}{8}$ n) wide and 5mm ($\frac{1}{4}$ in) deep around the back inside faces of both side panels and the top and bottom panels.

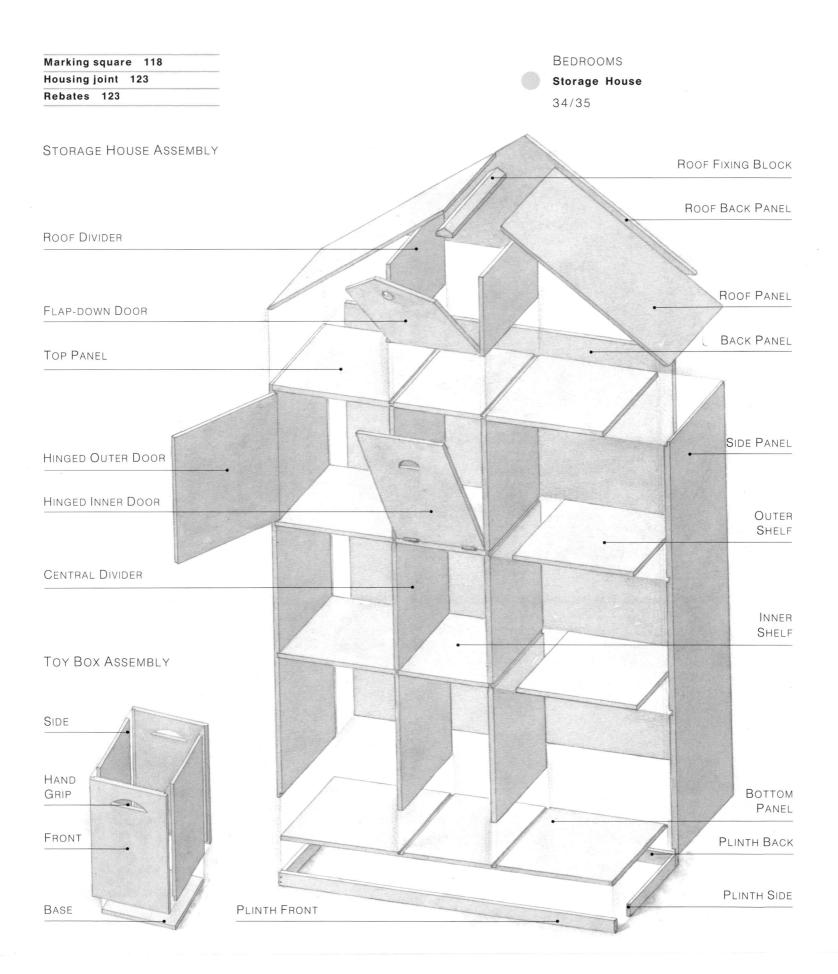

Storage House

ASSEMBLY

Drill and countersink 3mm ($\frac{1}{6}$ in) holes in three places through the centre line of all the rebates on the top, bottom and side panels. Make sure the central dividers are flush at the front. Glue and screw the carcass together – top, bottom, sides and central dividers – using 32mm ($\frac{1}{4}$ in) No 8 woodscrews.

Check that the diagonals are equal to ensure that the carcass is absolutely square. Nail temporary battens diagonally across the front and back, to hold the carcass square while the adhesive dries.

BACK PANEL

Check the dimensions of the back panel from the assembled carcass, then cut out the back panel ensuring it is square.

Offer the back panel in place and mark off the positions of the central dividers from the inside to give the fixing line. Drill through the back panel from the inside, down the centre of these lines in about six places spaced equally. Countersink the holes from the outside.

Drill and countersink from the outside of the back panel into the top, bottom and sides along the centre line of the back panel rebate width in six places to fix the back panel to the carcass.

Glue and screw the back panel in place through the top, bottom and side panels into the back, and through the back panel into the central dividers.

SHELVES

Check the internal dimensions of the assembled carcass and cut out the inner and outer shelves. Check the fit, then apply adhesive to the rebates, and slide the shelves into position to line up flush with the front. Drill, countersink and screw through the side panels into the outer shelves (fig 4).

PLINTH

Cut out the plinth components and glue and screw the side pieces between the front and back pieces with the corners flush (see Storage House Assembly, page 35).

Lay the assembled carcass on its back and fit the plinth using glue blocks (offcuts) glued and screwed in several places all round.

ROOF

ROOF PANELS

Cut out the two roof panels to the correct width, but leave them slightly overlength for the time being. Set a sliding bevel to 63 degrees and chamfer the apex ends of the panels to this angle, either with a circular saw or a jigsaw set to this angle, or plane the bevel by hand (fig 5).

At the eaves level, set the bevel to 27 degrees and mark off and cut the angles of the two panels.

Temporarily pin the eaves edges down into the top panel and check that the apex comes together neatly.

Rebating the Side Panels Cut 15 \times 5mm ($\frac{s}{e} \times \frac{1}{4}$ in) rebates across the top and bottom inside edges of the side panels.

ROOF DIVIDERS

Take the roof dividers and offer them up to the rebates in the top panel, holding them at right angles to the top panel. Mark off the required length and the angle at which to cut each roof divider at the top using a sliding bevel (fig 6). Cut both dividers to length and carefully angle the top edges.

Remove the roof panels and drill and countersink at the eaves in three places at an angle (fig 5). Next, drill and countersink vertically through the roof into the roof dividers in three places, making sure the dividers are flush at the front (fig 6). Dry assemble the roof structure to the main carcass.

FIXING BLOCK

Cut the roof fixing block to length, offer it up to the apex of the roof, and mark and plane off the angles of the top surfaces so the block fits neatly against the underside of the apex. Dry assemble, screwing the block up so that it is square to the roof panels (fig 5, below).

Top and Bottom Housings

Above Rout 3mm (\frac{1}{6}in) housings in
both faces of top panel. Below Rout

5mm (\frac{1}{2}in) housings for bottom panel.

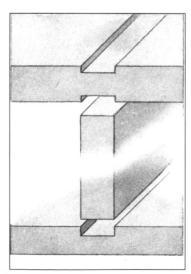

ROOF BACK PANEL

Take the roof back panel and offer it up to the roof section, lining up the bottom edge with the top of the main back panel. Mark off the roof angles from the inside. Remove the roof back panel and cut to the marked lines so that it fits inside the roof with the back flush (see Storage House Assembly, page 35).

With the roof back panel in position, mark off the positions of the roof dividers from the inside to give a fixing line. Remove the panel, drill through from the inside in two places on each of the centre lines of the dividers' positions. Countersink these holes from the back. Dry assemble the dividers.

Drill and countersink down square to the roof through the centre line of the back panel thickness in four places in the top of each roof panel.

Dismantle the roof structure, glue up all the joints and reassemble, gluing, screwing and countersinking the back panel in place. Leave the roof structure to dry.

Cutting the Central Dividers
Hold central divider 12mm (½in) short
of top of side panel; transfer shelf
housing positions to divider.

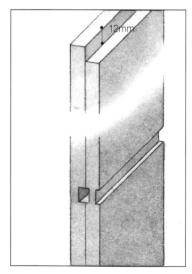

Cutting a circle 118
Planing 119
Drilling 120

Screwing 120
Hinges and catches 122
Rebates 123

BEDROOMS
Storage House

36/37

DOORS

SIDE DOORS

Measure the aperture and reduce the size by 3mm ($\frac{1}{8}$ in) each way to give a gap of 1.5mm ($\frac{1}{16}$ in) all round. Cut out a door, wedge it in place so that it is perfectly square in the opening and hinge it in position with two flush hinges so it is flush with the front. Fix a magnetic touch-latch so the door will not need a handle.

Make and fix as many sidehinged doors as required.

FLAP-DOWN DOORS

Cut out and install the flap-down doors in the same way as the side-hinged doors, but fit the hinges on the bottom edge. Make cut-outs as handholds using a jigsaw.

SHAPED FLAP-DOWN

This is shaped to fit the apex of the roof. Fit flush hinges along the bottom edge and a magnetic touchlatch to the underside of the roof fixing block. For a handhold, cut a 50mm (2in) diameter circle.

Above Glue shelves into housings in central dividers. Below Screw shelves into side panel housings.

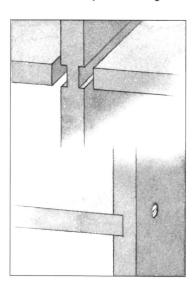

Toy Box

The toy box simply slides in and out of the central lower or outer lower compartments. Measure the aperture, and reduce the size by 3mm ($\frac{1}{8}$ in) each way. Cut out the front and back panels to these dimensions. Cut 15×5 mm ($\frac{5}{8} \times \frac{1}{4}$ in) rebates down the long inside edges of the front and back panels (see Toy Box Assembly, page 35). Cut out the sides to the internal depth of the compartments, less 20mm ($\frac{3}{8}$ in).

Cut 15×5 mm $\left(\frac{5}{8} \times \frac{1}{2} in\right)$ rebates along the bottom inner edges of the front, back and side panels. Drill and countersink through the front and back panels in four places on the centre line of the side panel thickness. Glue and screw the box carcass together.

Cut the base to fit in the rebates of the bottom of the box. Drill and countersink in three places through the side, front and back panels to the centre line of the base thickness. Glue and screw together.

Cut out the handholds in the front and back panels using a jigsaw.

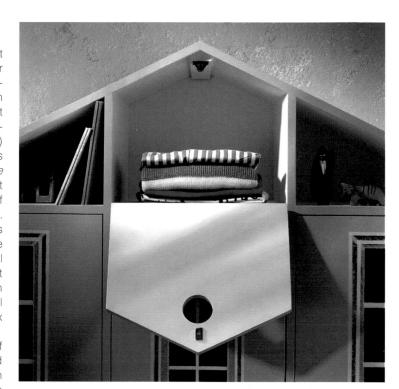

FLAP-DOWN DOORS

The flap-down door at the apex of the storage house is shaped to fit the apex of the roof. A circular cut-out provides a finger-grip opening, while the magnetic latch 'invisibly' holds the door shut when it's closed.

Adding the Roof

Left above Angle apex end of roof panel at 63 degrees and other end at 27 degrees. Right Pin roof in place to check the fit. Left below Angle roof fixing block to fit flush with apex; screw up through block into roof panels.

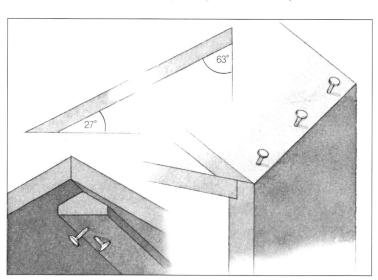

Roof Dividers

Angle top edges of roof dividers to sit flush with roof panel and screw in place, flush with front of house.

SHELF, RAIL AND PEG STORAGE

Where it may not make sense to children to put things away, they can usually see the point of hanging things up. Children like to see their possessions about them and a wall of pegs or shelves serves as both display and storage for all those belongings that would otherwise litter the floor.

The basic design owes something to Shaker pegboards, horizontal rails for hanging things off the floor, usually applied around the perimeter of the room at picture-rail height. In this case, how-

ever, the pegs are arranged vertically; a series could be lined up to make a wall of storage, one of the simplest and most economical ways of bringing order out of chaos. And the simple rhythmic arrangement of verticals and crossbars is attractive enough in its own right, even without anything thrown over it.

Made of dowelling and lengths of pine, the pegboards are very easy to make. The shelves are a variation on the same basic construction; alternatively, pegs and shelves could be combined along the same length. The pegs are angled so that they are longer at the top, shorter at the bottom, allowing each successive layer to hang free of the next.

The pegs can be mounted fairly high up the wall if you are worried that the children may try to climb up them. In any event, it is important to ensure that the screws at the top and bottom are located securely into wall plugs so that the boards are anchored to the wall.

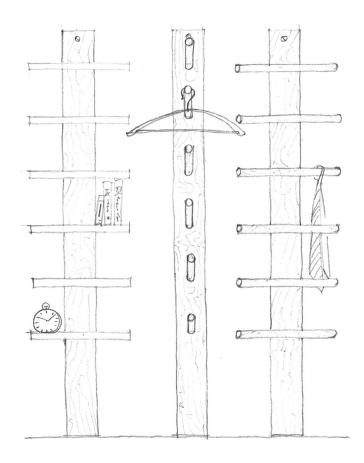

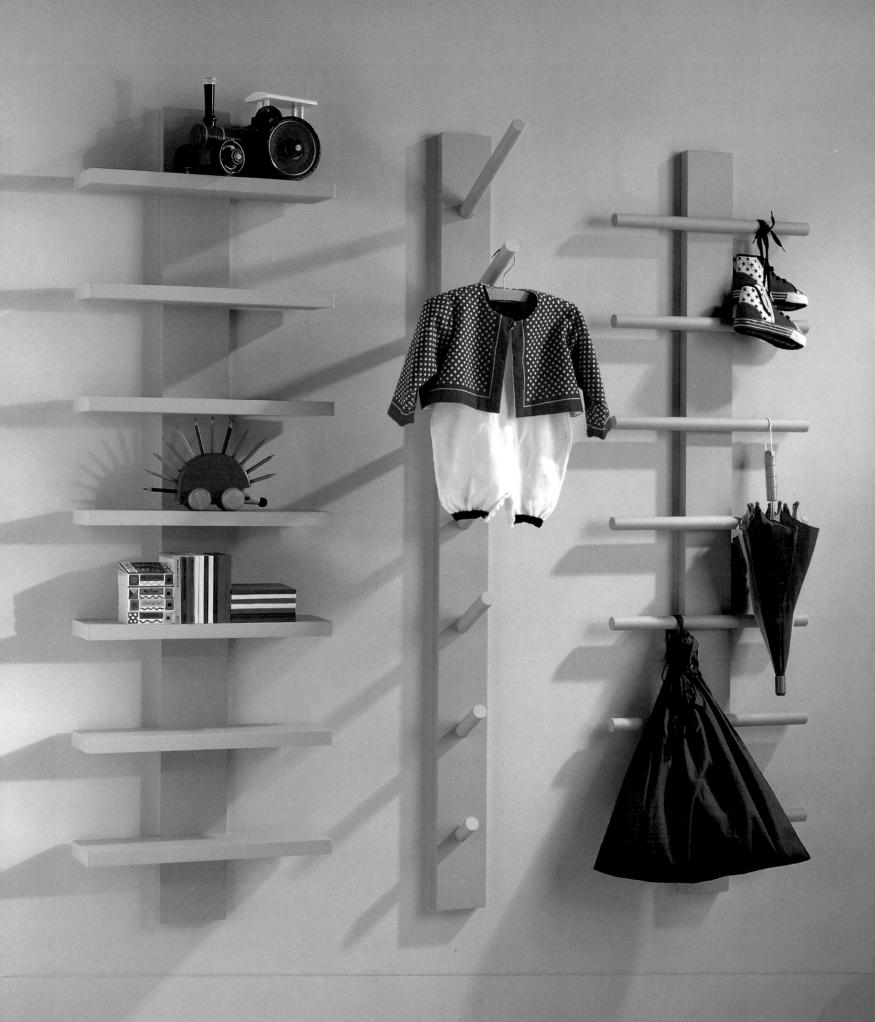

SHELF, RAIL AND PEG STORAGE

Children tend to leave belongings, especially clothes, shoes and toys, scattered about the floors of their rooms; but a simple and easy-to-use storage system might encourage them to be a bit more tidy. These shelves, rails and pegs fit the bill: all are based on the same principle, and consist of a simple backboard with seven shelves, pegs or rails down its length.

There is a risk that children will climb on these projects. You must, therefore, screw and anchor the backboards securely to the wall, and make sure that they are placed high enough up to deter children from climbing on them, or running into the projecting pegs.

Quantity	Material	Length
1	140×32 mm ($5\frac{1}{2} \times 1\frac{1}{4}$ in) PAR softwood	1500mm (59in)
7	As above	450mm (17¾in)
1	115×32 mm ($4\frac{1}{2} \times 1\frac{1}{4}$ in) PAR softwood	1500mm (59in)
7	25mm (1in) hardwood dowel	450mm (17¾in)
1	115×32 mm ($4\frac{1}{2} \times 1\frac{1}{4}$ in) PAR softwood	1500mm (59in)
7	25mm (1in) hardwood dowel	Varying lengths cut from 1350mm (53in) overall
	1 7 1 7	1 140 × 32mm (5½ × 1¼in) PAR softwood 7 As above 1 115 × 32mm (4½ × 1¼in) PAR softwood 7 25mm (1in) hardwood dowel 1 115 × 32mm (4½ × 1¼in) PAR softwood

TOOLS

WORKBENCH (fixed or portable) TRIMMING KNIFE STEEL MEASURING TAPE STEEL RULE TRY SQUARE PANEL SAW or CIRCULAR POWER SAW POWER DRILL DRILL BIT $-3mm(\frac{1}{8}in)$ COUNTERSINK BIT SCREWDRIVER POWER FINISHING SANDER or HAND SANDING BLOCK ROUTER STRAIGHT ROUTER BIT - 6mm $(\frac{1}{4}in)$ and 32mm $(1\frac{1}{4}in)$ V-CUTTING ROUTER BIT MARKING GAUGE DRILL STAND DOWEL BIT -10mm ($\frac{3}{8}$ in)

FLAT BIT - 25mm (1in)

SMOOTHING PLANE

SHELVES

MATERIALS

Mark off the shelf spacings at 200mm (8in) centres down the backboard (fig 1). Mark horizontal lines across the width of the board at these points.

Using a router and a straight bit, rout a housing at each marked position $10\text{mm}\left(\frac{3}{8}\text{in}\right)$ deep and to the thickness of the shelf (fig 2, above). Alternatively, cut the housings for the shelves using a tenon saw, and remove the waste with a chisel.

Cut the shelves to length, sand smooth and round over the corners. Fit each shelf in position, centring it, and drill and countersink from the back of the backboard. Apply adhesive to the first groove, replace the shelf and attach with three 38mm (1½in) No 8 woodscrews (fig 2, below). Repeat for the other shelves. Paint or finish as required.

RAILS

Mark off the rail spacings at 200mm (8in) centres down the backboard (fig 1). Mark across the width of the board. At these positions, rout across the board using a V-cutting

bit or cut with a tenon saw (fig 3, above). The grooves allow the rails to locate into the backboard.

Cut the dowels to length. Drill and countersink from the back of the backboard into each rail to take three 38mm ($1\frac{1}{2}$ in) No 8 screws (fig 3, below). Apply adhesive to the grooves in the backboard, centre the dowel rails one at a time, and screw the rails in place.

Paint or finish as required.

PEGS

Cut the seven pegs from the hardwood dowel to length (fig 1). They start at 304mm (about 12in) and decrease by 38mm ($1\frac{1}{2}$ in) each time down to the smallest peg at 76mm (about 3in), so that their ends form a straight, sloping line after fixing.

Mark off the peg spacings down the backboard (fig 1), and, with a marking gauge, mark a vertical line centrally down the backboard to give the drilling positions.

In order to prevent items from sliding down the pegs, rout a shallow half-round groove across what will be the upper side of each peg, 25mm (1in) from the ends (fig 4). It is best to use a router for this, but

you can also use a drill; if a drill is used, cramp two pegs together and drill between them, 25mm (1in) from the end, to form a groove in each.

Drill 25mm (1in) diameter holes into the backboards from the front, at an angle of about 63 degrees, until the point of the drill bit just emerges through the back of the board. There are two ways of angling the pegs accurately: either the drill can be held upright in a drill stand and the backboard held at a 63 degree angle on a specially cut wedge; or the drill can be held in place at a 63 degree angle using a portable drill accessory available from DIY stores.

Apply adhesive to the holes and push in the dowels in the correct order (fig 1) until they are stopped by the back of the holes. When the glue has set, plane the parts of the pegs protruding at the back of the board so they are flush.

Paint or finish as required.

FIXING THE UNITS

Drill and countersink at the top and bottom of the backboards, 50mm (2in) in from the ends and screw and plug securely to the wall (see Techniques, page 120), ensuring that the backboard is vertical.

Sawing	118	
Planing	119	
Drilling	120	

Fixings 120	
Screwing 120)
Housing joint	123

ASSEMBLY

BEDROOMS

Shelf, Rail and Peg Storage

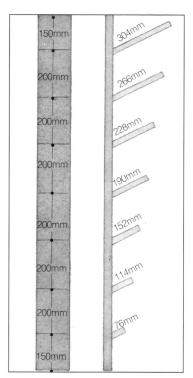

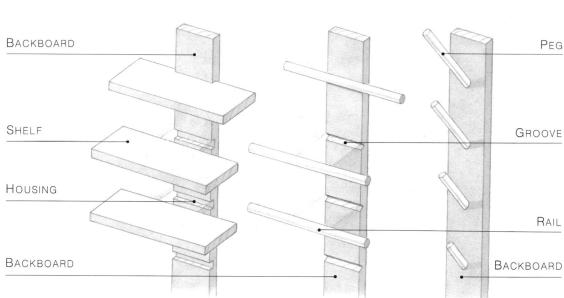

Spacings on the Backboard Left Mark length of backboard as indicated. Right Cut peg dowels to decrease by 38mm (1½in) each time.

Fitting the Shelves
Rout or cut housings for the shelves
at marked positions. Glue and screw
in place from back of board.

Fitting the Rails
Rout or cut V-shaped grooves at
marked positions. Glue and screw
rails in place from back of board.

Above left Rout shallow grooves across tops of pegs, 25mm (1in) from front.

Below left Position the pegs in the backboard, angled upwards at 63 degrees.

Right Glue pegs in place; plane ends flush with back of board.

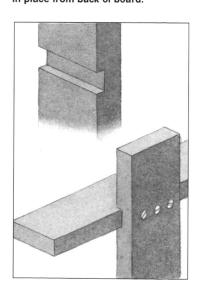

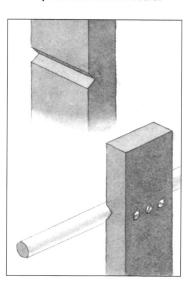

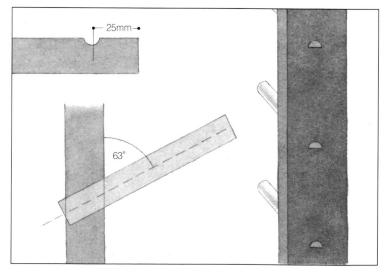

CHILD'S FOUR-POSTER BED

Your child can be a prince or princess every night in this bed. It consists of a simple timber framework with 100×18 mm $(4\times\frac{3}{4}\text{in})$ tongue-and-groove and V-jointed matching pine cladding, and a medium-density fibreboard (MDF) base for the mattress to rest on. Make the bed to fit the mattress.

The four corner posts are 75×75 mm $(3 \times 3in)$ planed all round (PAR) softwood, 1500mm (60in) long. The framing at the base is 50×38 mm $(2in \times 1\frac{1}{2}in)$ PAR timber (fig 1). For a really professional job this should be housed into the corner posts by 25mm (1in) as shown, although it is possible simply to butt join the pieces of wood using screw-on plastic knockdown screw block connectors.

At the sides and foot of the bed, the framing timbers are aligned with the inside faces of the corner posts to allow for the timber cladding to be fixed on the sides and end of the bed (fig 2). At the head end, the framing timbers are aligned with the outside faces of the posts so the cladding faces inwards (fig 3).

The cladding is glued and pinned to the timber framing. On the head and foot ends of the bed, the top edge of the cladding is pinned to a $50 \times 25 \text{mm} (2 \times 1 \text{in})$ batten which is fixed narrow edge upwards between the corner posts.

The mattress support board is 18mm (3in) thick MDF; it sits on the top framing timbers and a support strip screwed to the headboard. Supported along all four edges, the board for a single-bed mattress will not need additional support across the middle. To give access to the storage area under the mattress, cut an opening about 900×600 mm (36×24 in) in the centre of the mattress support board. Frame the underside of the opening with 50×25 mm (2×1 in) timber and replace the cut-out section after drilling a 25mm (1in) diameter hole for lifting it. Drill additional 25mm (1in) holes in the support board to air the mattress.

To complete the effect, fit 50×25 mm $(2 \times 1$ in) battens between the corner posts at the top, to which decorations can be fixed.

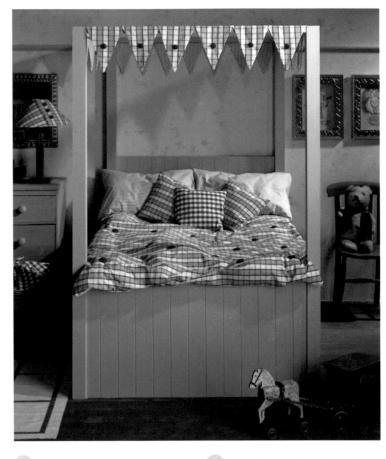

Side Detail

T-&-g boards are nailed to the outside of the framing timbers. Top length acts as mattress support.

Rear View of Headboard
At the head of the bed, cladding is
nailed inside the frame; a third
batten is fitted to support top edge.

Left The frame consists of lengths of 50×38 mm ($2 \times 1\frac{1}{2}$ in) PAR fixed to corner posts and then clad with tongue-and-groove boarding. Right Ideally, the framing timbers should be housed into the corner posts.

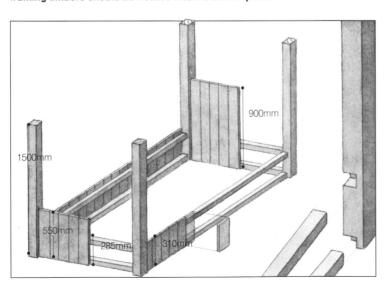

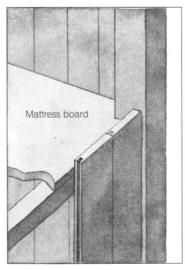

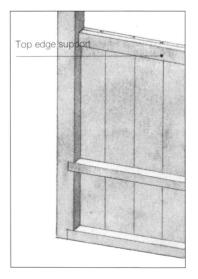

LOW-LEVEL SHELVES

BEDROOMS

Low-level Shelves

42/43

Low-level shelving with invisible fixing supports can look most attractive in a wide alcove in a child's room, especially when it matches the flooring as shown here. In our example solid wood shelving is used, but the same effect can be achieved at considerably less cost by constructing hollow box-section shelving. In either case, the method of fixing to the back wall is the same.

In our photograph, the shelves are 38mm ($1\frac{1}{2}\text{in}$) thick, 230mm (9in) deep and span the width of the alcove. If solid timber can be obtained in suitable lengths, it is simply carefully planed and sanded smooth. If the depth you require is not available, two or more pieces can be glued together using biscuit joints or dowel joints along the length of the pieces of timber to reinforce the join (fig 1). The timbers are cramped together until the glue has set, and then the shelf is planed and sanded smooth.

Box-section shelves are made by fixing top and bottom panels of 6mm (¼in) thick plywood over a framework of 25 × 25mm (1 × 1in)

Making a Deep Solid Shelf For a deeper shelf, join two widths using biscuit joints (above) or dowel joints (below).

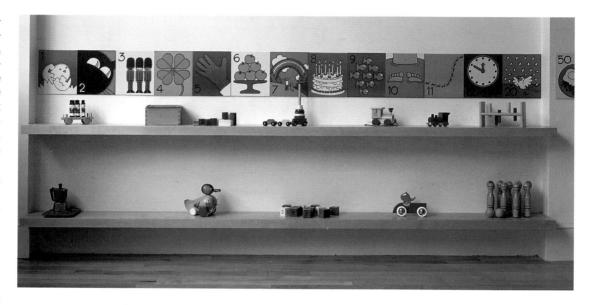

battens; the back batten is recessed 25mm (1in) to take a support batten fixed to the wall (fig 2). The shelves are edged with $38 \times 16 \text{mm} \left(\frac{11}{2} \times \frac{5}{8} \text{in} \right)$ timber battens mitred at the corners to give a neat finish and a solid appearance. By using $38 \text{mm} \left(\frac{11}{16} \text{in} \right)$ wide edging on a $37 \text{mm} \left(\frac{11}{16} \text{in} \right)$ thick shelf, you can sand down the edge to give an excellent finish, and

Making a Box-section Shelf A box-section shelf can be made using veneered plywood over timber battens and edged with solid wood.

if the edging matches the timber used to veneer the plywood, the result will be a box shelf that is almost impossible to tell from solid wood.

The shelves are fixed invisibly to the back wall with 12mm (½in) thick steel rods. These should be set 75mm (3in) into pre-drilled holes in the wall and should pass into matching holes in the shelves. In the

case of a solid shelf these should be drilled at least 150mm (6in) deep. With a hollow shelf the rods pass through a 25mm (1in) square support batten fixed to the wall. They must still be 75mm (3in) in the wall itself, and in the shelf should be set as deep as the front batten. Packing pieces about 6mm (¼in) thick hold the shelves level at the front.

Basic Assembly and Fitting of a Box-section Shelf

Above The basic framework is nailed together with space left at the back for a support batten to be screwed to the wall. Below Cross section shows steel rods set into the shelf with 75mm (3in) protruding into the wall.

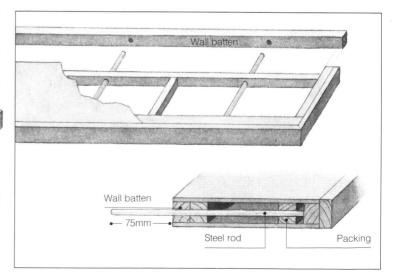

PLAYROOMS

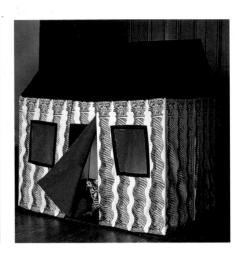

Play, in all its forms, is a vital element in a child's development. Children play to develop and test their skills, to explore their imaginations, to act out different roles, to learn how to share toys and games and to get along together.

Play can be messy, noisy and boisterous; it may well require supervision. Children learn by copying what their parents do and need access to the adult world to develop; very young children need a watchful eye until they can negotiate the world safely. But there are equally times when children need to shut the door behind them and get on with their own private world of make-believe. And adults too need to feel that some corner of the house is not dominated by children and their toys.

The element of magical transformation – making something out of nothing – can form the basis of a child's most memorable hours of play. A sheet thrown over a table and painted to look like a house, old cardboard boxes turned into robots or monsters, a castle constructed of upturned chairs and a pile of blankets will be remembered long after the plastic toy advertised on television has been broken and discarded.

PLAYROOMS

Low-level units are accessible and adaptable without being obtrusive (above). The complete storage wall (above right) incorporates rows of drawers, cupboards with doors for hiding clutter and a configuration of shelving to suit every requirement from storing books, records and games to displaying treasured possessions. A ladder on wheels securely anchored to a rail provides access to the topmost compartments.

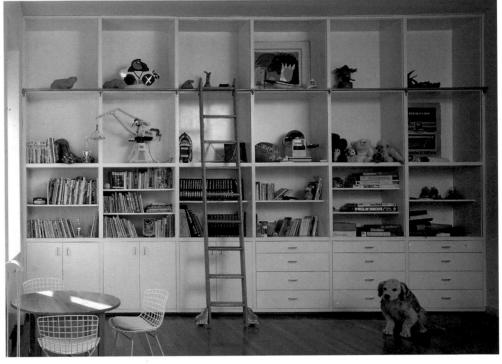

The fluid and varied nature of children's play means that no parent can equip a 'playroom' and reasonably expect their children to spend most of their time there. A series of play areas in the house is a more realistic and practical proposition; equally there should be rooms which remain firmly designated for grown-ups. For most children, their bedroom will also be the place where they play. Really messy activities, such as painting and modelmaking, are often best tackled in the kitchen (when space permits), where surfaces are more easily cleaned. For many households with young children, it may well be worth turning a separate dining room into a family room or play area, at least in the early years when children need more supervision. More permanent solutions include converting an attic or fitting out a basement. Children love unusual, quirky spaces - under the eaves or an alcove beneath the stairs can be magical hiding and playing places.

EQUIPMENT AND FURNISHING

In their earlier years, children spend a great deal of time playing on the floor. Flooring in any play area needs to be especially practical and hard-wearing, as well as comfortable. Restricting certain types of particularly messy activity to areas where spills can be easily mopped up can help to prolong the life of a playroom carpet or rug. And because many games demand a lot of floor area, tables, chairs and other pieces of play equipment which can be packed away, folded up or stacked add flexibility to a room. Stacking stools, folding chairs and painting easels that fold away are all good, versatile and spacesaving playroom items.

Although it is best to avoid too much in the way of miniaturized furniture, child-sized table and chairs are indispensable for painting, drawing and other creative pursuits, as well as dolls' tea parties, games of shop-keeping and going

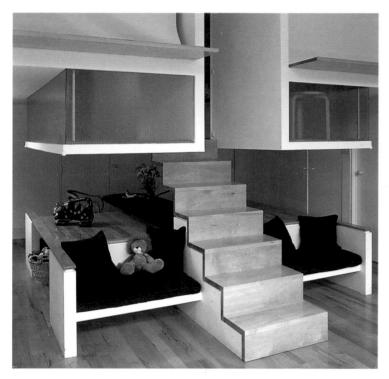

to school. When your child eventually outgrows this set of furniture, it will be time to provide a proper desk or table for homework and quiet study. A good chair that supports the back well is essential. Old school desks can also be revamped with a coat of paint.

As with furniture, any wall decoration which is tied specifically to one age group will need to be changed before too long, so it is best to choose a style that will suit children of different ages. Friezes and borders are extremely popular. There is now a wide range of paper borders available, featuring alphabets, animals, trains and a host of other appropriate designs. The same effect can be achieved by stencilling designs on to the wall in horizontal bands or by using templates to create a simple row of figures, and the advantage of this approach is that you can paint over the design very quickly and easily when your child has outgrown the decoration or wants a change.

Wallpaper designed for children, patterned with everything from nursery-style ducks and rabbits to Boy's Own-style aeroplanes, is also widely available, though it is usually horrible. Less specific patterns, such as more abstract geometric shapes, have a longer life, however. Alternatively, special paint effects can be used to create a uniquely patterned wall. Sponges, rags and stipple brushes can be used to make speckled and mottled paint finishes that are quick and easy to apply and which have a lively surface appeal and depth of interest.

STORAGE AND DISPLAY

Crunching across a floor littered with small plastic bricks and the debris of an afternoon's riotous play is an all-too-familiar experience for most parents. Children and clutter seem indivisible; to the bounty of birthdays and Christmases will be added mounting collections of 'precious' objects which must on no

PLAYING PLACES

The nature of the play area itself can provide a springboard for the imagination, prompting all manner of games and play activities. Play space underneath projecting platform bedrooms has an appealing enclosed feeling like a den or hideout, where children can retreat to escape the watchful eyes of grownups (above left). A wall painted to look like the Three Bears' cottage makes a vivid backdrop for games of make-believe (above).

PLAYROOMS

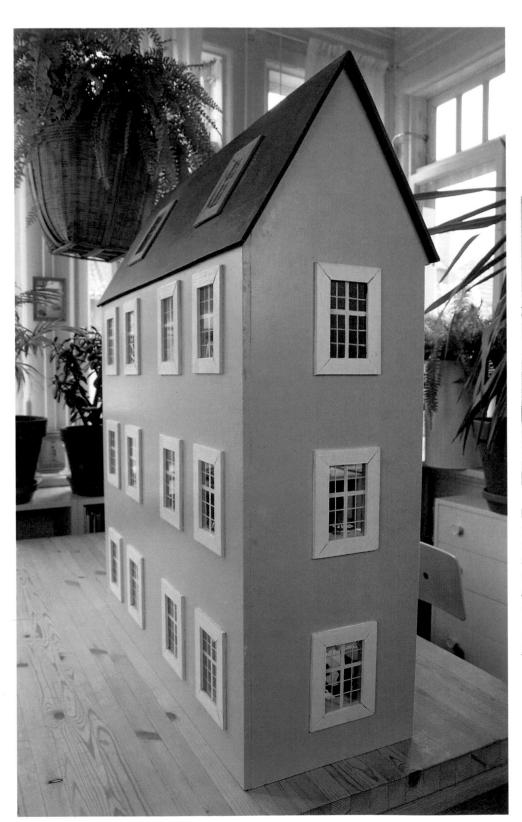

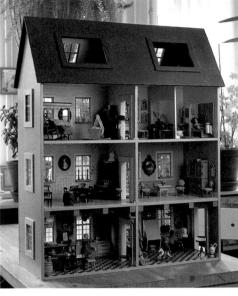

Doll's House

The miniaturized world of the doll's house has fascinated children for generations. Making and furnishing such a house down to the last detail can be as absorbing a pastime for a parent as it is for a child (left and above). And the greater attention to detail you pay in furnishing and decorating the interior of a doll's house, the more time and enjoyment your children will derive from playing with it.

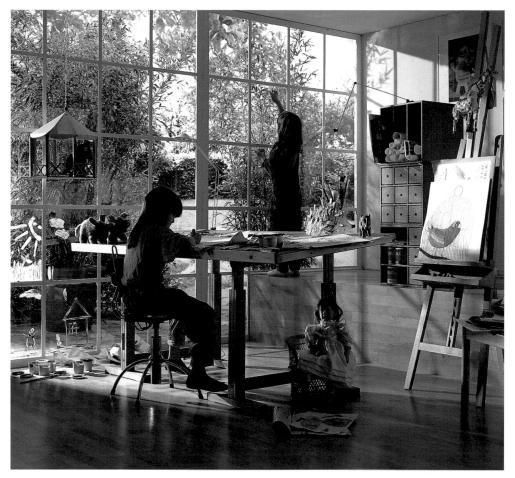

WORK TABLES

To encourage children's creativity you don't necessarily need a full-scale studio, but a good work table, an easel and storage boxes and drawers to keep materials in order are invaluable (left). Young children, too, need somewhere to sit and paint, such as this set of table and chairs with 'crayon' legs (below).

FINISHING TOUCHES

However you tackle the basic features of your child's room, it is the details and finishing touches that will bring it to life. Such features as height charts, name plates, your child's own framed drawings or paintings hung on the wall, or a row of favourite toys will all help make a room a special and meaningful place for a child. And there should always be a reasonable amount of space – a shelf, table top or top of a chest of drawers, for instance - for those much-loved shrine-like collections of bits and pieces that all children seem to take such pleasure in accumulating and which are an important part of their learning process.

account be thrown out. But accumulating is one thing, tidying up quite another. Good storage plays a vital role in bringing order out of your children's chaos and helping to teach them to put things away.

For children, toys, rather than books, do furnish a room. Storage which incorporates some means of display enables children to enjoy the feeling of being surrounded by their favourite things. Systems of adjustable shelves allow books and toys to be arranged on view, well within reach, with games requiring adult supervision or breakable possessions on a higher level. Wall hooks or pegs can be used for hanging up puppets or kites beyond the grasp of small siblings. And it is important to make provision for dis-

playing the latest examples of your children's work. A pinboard or pegboard allows you to rotate pictures easily. For older children you might put up a calendar, world map or museum posters.

To keep the clutter under control, labelled wire baskets or stacking crates can be used to organize and keep separate games or toys with many tiny components. Containers with divisions, such as tool boxes, make good places for crayons, paints or craft supplies. A wicker hamper or old school trunk is ideal for storing dressing-up clothes. And a large basket or blanket box with a hinged lid makes a good all-purpose toy box into which things can be hurled out of sight at the end of the day's play.

PLAYROOMS

PLAYING AWAY

If you have the space, a playroom is the ideal place for children to let their imaginations and creativity run loose. The playroom here is equipped with the Painting Table and Doll's House projects contained in this book, as well as some quick and effective decorating ideas. The brightly patterned screen on the left of the main picture is painted with blackboard paint on the other side to allow children to chalk away to their hearts' content (above). A striking and surprisingly simple effect is created by painting a 'picture frame' on the wall, inside of which a painted bowl is stacked high with glued-on papier mâché fruit.

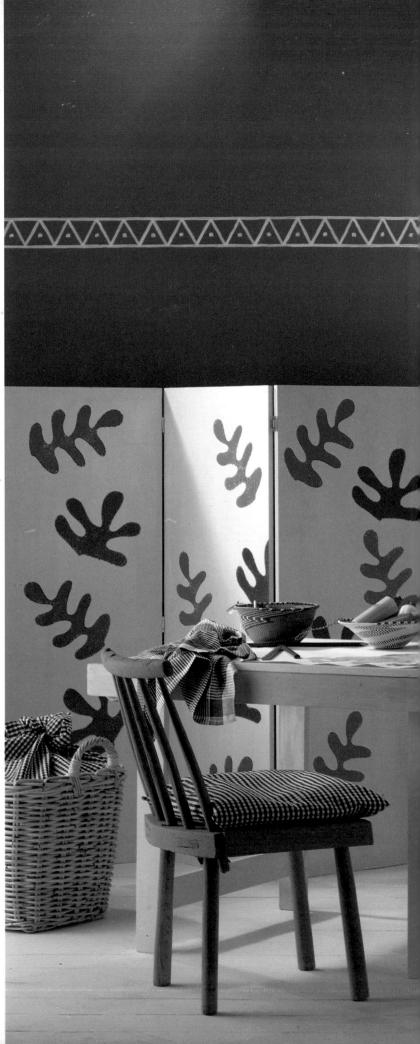

Doll's House

The doll's house has always been a popular toy, and it is easy to understand why. The first dolls' houses were elaborate curios, intricate architectural models with highly detailed interiors. But, ever since the eighteenth century, there have also been dolls' houses for children to play with and exercise their own creativity. A house in miniature gives children the opportunity to invent a whole world, and there is the added fascination of making or collecting pieces to furnish the rooms.

Rather reminiscent of a Scottish house, with its pedimented roof and blockwork framing the door, this design is a very simple box construction, with a hinged front panel. The four rooms inside are visible through cut-out windows. A strip of moulding and pediment shape elegantly trim the top; thin plywood scored to resemble large blocks is stuck around the door. The basic material is MDF, which is easy to cut and provides the best surface for decorating.

If you already have a collection of doll's house furniture, the dimensions of the house could be altered to make rooms of suitable proportions. And decoration, inside and out, can be as elaborate as you like. The paint finish for the outside of the house in this example consists of a sandy base colour with boot polish wiped over the top to give a textured look.

The finished house is handsome enough to sit in the living room. Every child should have one!

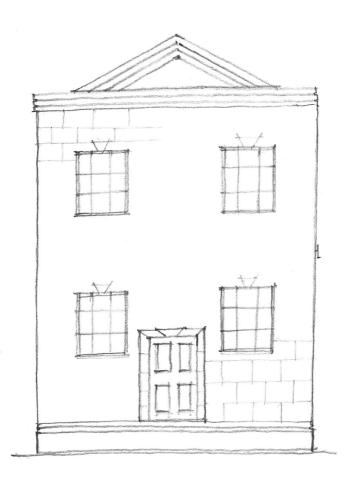

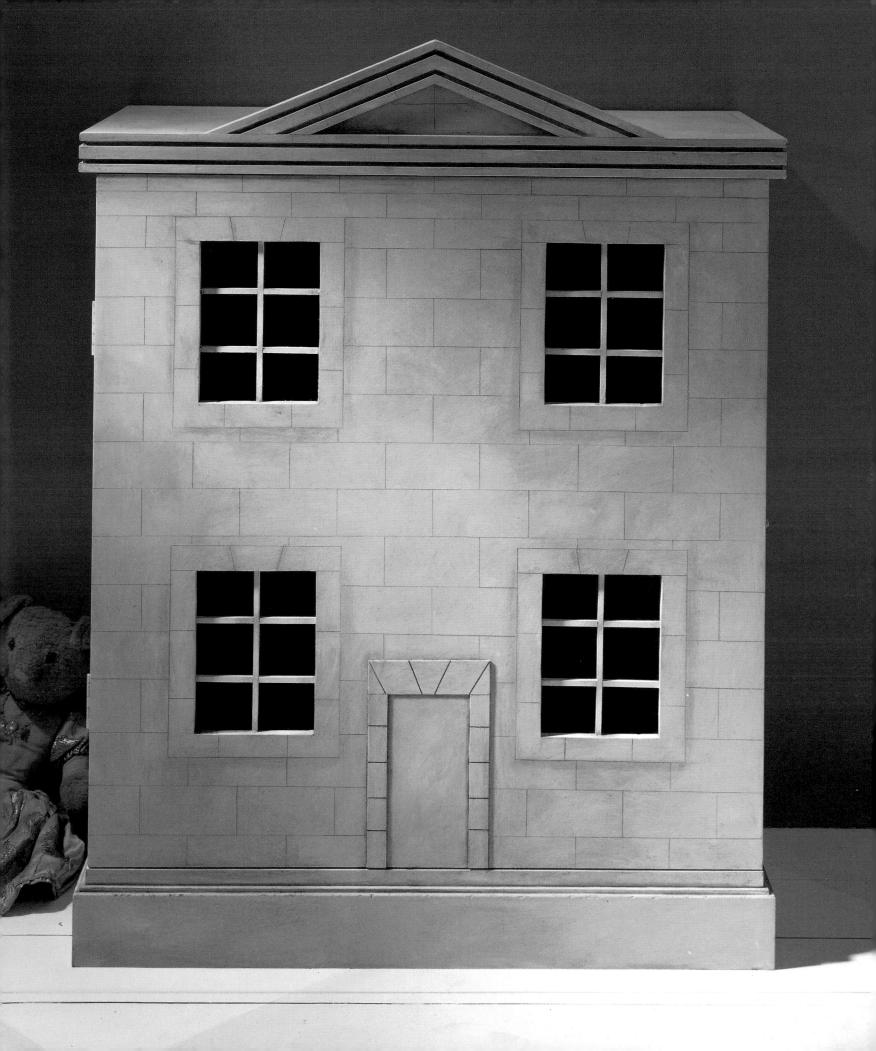

Doll's House

Part	Quantity	Material	Length
CARCASS			
TOP	1	15mm (§in) MDF	650×321 mm $(25\frac{1}{2} \times 12\frac{5}{8}$ in $)$
BASE	1	As above	650×335 mm $(25\frac{1}{2} \times 13\frac{1}{8}$ in)
SIDE	2	As above	705×321 mm $(27\frac{3}{4} \times 12\frac{5}{8}$ in)
CENTRAL PARTITION	1	As above	695×316 mm $(27\frac{3}{8} \times 12\frac{1}{2}$ in)
SHELF	2	As above	312×316 mm $(12\frac{1}{4} \times 12\frac{1}{2}$ in)
BACK	1	4mm (½in) MDF or plywood or hardboard	705×640 mm ($27\frac{3}{4} \times 25\frac{1}{4}$ in)
DOOR PANEL	1	12mm (½in) MDF	660 × 650mm (26 × 25½in)
PLINTH			
PLINTH FRONT	1	18mm (³in) MDF	670×75 mm $(26\frac{3}{8} \times 3$ in $)$
PLINTH BACK	1	As above	634 × 75mm (25 × 3in)
PLINTH SIDE	2	As above	345×75 mm ($13\frac{1}{2} \times 3$ in)
DETAILING			
FRONT MOULDING	1	15mm (§in) MDF	680×40 mm $(26\frac{3}{4} \times 1\frac{1}{2}$ in)
SIDE MOULDING	2	As above	Cut 2 from 680×40 mm $(26\frac{3}{4} \times 1\frac{1}{2}$ in)
TOP MOULDING	2	As above	500×40 mm $(19\frac{5}{8} \times 1\frac{1}{2}$ in $)$
TOP TRIANGLE	1	4mm (‡in) MDF	445×90 mm $(17\frac{1}{2} \times 3\frac{5}{8}$ in $)$
DOOR STOP	2	15mm (§in) MDF	650×35 mm $(25\frac{1}{2} \times 1\frac{3}{8}$ in $)$
DOOR (imitation)	1	2mm (1/16in) MDF	200 × 75mm (8 × 3in)
GLAZING BAR (vertical)	4	6×6 mm $(\frac{1}{4} \times \frac{1}{4}$ in) balsa-wood	165mm (6 <u>1</u> in
GLAZING BAR (horizontal)	8	As above	125mm (5in)

Tools
ROUTER
SET OF CHISELS
TENON SAW
PIN HAMMER
NAIL PUNCH
FILLING KNIFE
SCREWDRIVER
SLIDING BEVEL
DRILL (hand or power)
JIGSAW or PADSAW
DRILL BIT – approximately 3mm (in) to drill pilot holes

A traditional doll's house is a wonderful toy that any child lucky enough to own will treasure and enjoy for endless hours of makebelieve. This simple yet classic model is easy to construct with the help of a router. The advantage of its design is its adaptability – you can scale its dimensions up or down to tailor them to specific requirements. When constructing a doll's house it is

Rebating the Main Carcass Above Rout $15 \times 10 \text{mm} \left(\frac{5}{8} \times \frac{3}{8} \text{in}\right)$ rebates along top panel. Below Rebates along base stop short.

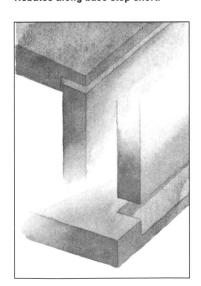

important to base the scale on what is to be placed inside it, so that the rooms are built in correct proportion to furniture, furnishings or figures of a specific size.

The house is built almost completely of medium-density fibreboard (MDF). A small amount of balsawood provides the glazing bars, and plywood or hardboard may be used instead of MDF for the back.

Paper or paint the walls as you wish. You can either improvise or visit specialist shops for ready-made furniture and accessories.

MAIN CARCASS

Cut out all the components of the main carcass – the top, base, sides, central partition, shelves and back.

Rout a rebate 15mm ($\frac{5}{8}$ in) wide and 10 mm ($\frac{5}{8}$ in) deep along the two side edges of the top panel from front to back (fig 1, above).

Cut rebates of the same dimensions in the two side edges of the base, but stop 15mm ($\frac{5}{8}$ in) from the front to allow the base to protrude (fig 1, below). Chisel the corners of the rebates square.

2 Top and Base Housings Cut 15×5 mm ($\frac{5}{8} \times \frac{1}{4}$ in) housings across centre of top and base panels, stopping short in base.

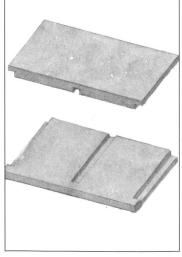

PLAYROOMS

Doll's House

54/55

Doll's House Assembly

Sawing 118

Rebates 123

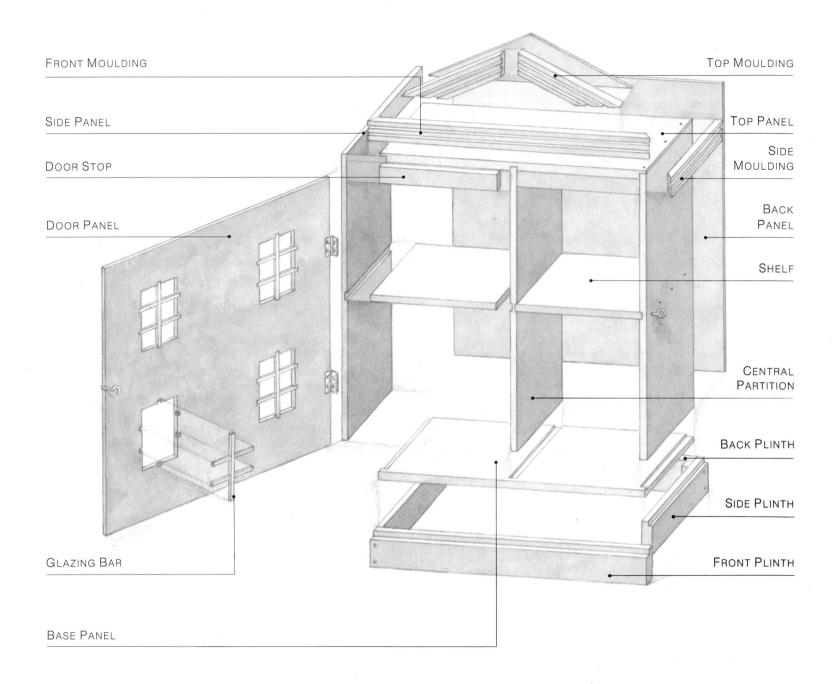

Doll's House

CUTTING THE HOUSINGS

Across the centre of the top and the sides and across the centre of both sides of the central partition, cut 15×5 mm $\left(\frac{5}{8} \times \frac{1}{4} \text{in}\right)$ housings to accept the interior partitions. Cut a housing across the base but stop 15mm $\left(\frac{5}{8} \text{in}\right)$ short of the front, in line with the side edges (fig 2, page 54 and fig 1, page 56).

REBATING BACK PANEL

Cut a rebate into the back edges of the top, sides and base for the back panel. This rebate should be 10mm ($\frac{3}{8}$ in) wide and the thickness of the back panel – 4mm ($\frac{1}{8}$ in).

ASSEMBLING THE CARCASS

Glue and pin the top to the sides and then the base. Ensure all edges are flush and square. Slide the central partition in from the back and glue and pin it in place. Next, slide in the two shelves from the back of the carcass and glue and pin them through the sides of the main carcass. Finally, glue and pin the back panel in place (fig 2). All

Central Partition Housings Cut 15×5 mm ($\frac{5}{8} \times \frac{1}{4}$ in) housings for interior partitions across centre of both sides of central panel.

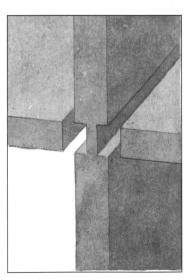

the pin heads should be driven below the surface with a punch, covered with filler and smoothed flush with the surface when dry.

PLINTH

Cut out the four sides of the plinth and glue and screw them together using two 38mm ($1\frac{1}{2}$ in) No 6 screws at each joint. The sides fit behind the front and on either side of the back. Glue an 18mm ($\frac{3}{4}$ in) offcut of MDF into each corner to strengthen the joints. The offcuts should be flush with, or slightly below, the top of the plinth (fig 3). Cut a decorative rebate 6×6 mm ($\frac{1}{4} \times \frac{1}{4}$ in) into the top outside edge of the plinth front.

Screw the plinth to the base using 50mm (2in) angle brackets – two at the front and two at the back.

FITTING THE DOOR STOPS

Cut two lengths of 15mm (§in) MDF for the door stops. Fix these in position to the underside of the top panel on either side of the central partition using glue and 25mm (1in) No 6 screws (see Doll's House Assembly, page 55).

Adding the Back Panel The back panel fits into 10×4 mm ($\frac{3}{8} \times \frac{1}{8}$ in) rebates cut in the back edges of the top, sides and base.

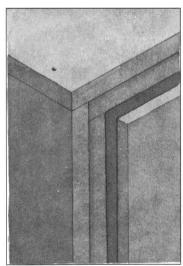

Mouldings

Cut all the mouldings (front, side and top) roughly to length, then use the router to cut two decorative $6\times6\text{mm}$ ($\frac{1}{4}\times\frac{1}{4}\text{in}$) grooves along their length (fig 4). Cut mitres for the corners of the front and side mouldings, then glue and pin them in place, flush with the top (fig 5).

Cut out the triangle for the top decoration from a piece of 4mm ($\frac{1}{8}$ in) MDF. The two top mouldings must be angled at their base (where they meet the top of the house) and mitred to meet each other at the apex. Use a sliding bevel to mark the angles, then glue and pin them on to the triangular piece of MDF, flush with the edges and so that the grooves meet exactly.

Using a small drill bit, drill pilot holes into the front triangular moulding and pin in position through the moulding and into the roof. Glue an offcut of MDF to the back of the triangle and the top of the house to hold the triangle in place. Punch all the pin heads below the surface and fill.

WINDOWS

Cut out the door panel and mark the outlines of the windows on it: ours measure 150×110 mm $(6 \times 4\frac{1}{2}in)$. Cut out the window openings using a jigsaw, a padsaw (drill a starter hole in the corner of each window first) or a router.

GLAZING BARS

Balsa-wood, obtainable from model shops, is ideal for the glazing bars. For each window, cut one vertical and two horizontal bars. Each should be 15mm (1/2 in) longer than the length and width of the window opening - in this case, 165mm (61/in) and 125mm (5in). Use a fine saw and a tiny chisel to cut halving joints half way across the horizontal bars and one third and two thirds of the way down the vertical bars (fig 6). Glue the pieces together. Mark off the positions of the glazing bars around the inside faces and inside edges of the window openings. Use a tiny chisel to cut out the 6 × 6mm $(\frac{1}{4} \times \frac{1}{4}in)$ notches and glue all the assembled bars in position.

3 Assembling the Base Plinth

Above Glue and screw plinth together, strengthening corners with MDF offcuts. Below left Cut a 6×6 mm ($\frac{1}{4} \times \frac{1}{4}$ in) rebate in top edge of plinth front. Below right Use angle brackets to screw plinth up into base.

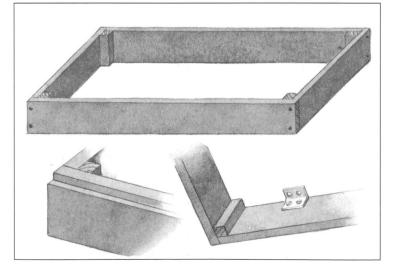

Drilling 120

Screwing 120

Hinges and catches 122

Butt joint 123

Halving joint 123 Housing joint 123 Mitre joint 123

Rebates 123

PLAYROOMS

Doll's House

56/57

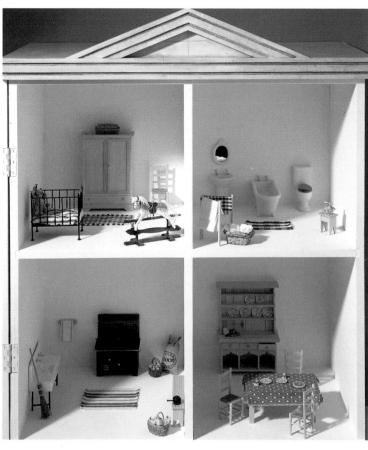

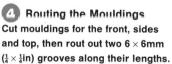

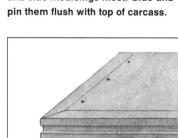

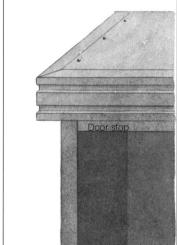

G Adding the Mouldings Cut mitres in the ends where front and side mouldings meet. Glue and

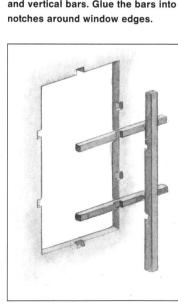

6 Fitting the Glazing Bare Cut halving joints to join horizontal and vertical bars. Glue the bars into

FINISHING OFF

Make a false front door from an offcut of MDF and glue it in place on the front of the door panel. Hang the door panel using two butt hinges and fit a hook-and-eye catch on the other side of the house.

You can paint the house in various ways: for example, emulsion for the walls, and undercoat and gloss to pick out the door, windows and mouldings. The exterior finish shown here is achieved by painting the carcass with a base colour of sandy emulsion. When this has dried, roughly pencil in the brickwork. Finally, rub a small amount of boot polish gently over the surface. Use an artist's paintbrush around delicate areas such as the window frames. Protect the paint effect with a top coat of clear varnish.

PAINTING TABLE

Although the kitchen table may be a practical place for children to draw and paint, it is much better if they have a table scaled to their own size, where they can also keep crayons, brushes and a supply of paper permanently to hand. From a surprisingly early age children enjoy making pictures, even if at the beginning these are no more than the briefest of scribbles. A painting table will encourage them to explore their creative instincts.

No more than about half a day's work, this simple pine table consists of a framework that is glued and screwed or dowelled together. It is topped with a hinged lid made of melamine-faced board to enable splashes and spills to be wiped away easily. The lid covers a storage space deep enough to take boxes of crayons and other drawing and painting materials. Alternatively, the top can be screwed down and the base omitted.

Children can get through a great deal of paper. At one side of the table, a dowel drops in place and can be used to hold a roll of lining paper, a versatile and cheap way of meeting children's paper needs; you can tear off individual sheets or unroll a long length for murals or banners. At the other side of the table, there is a place to keep plastic beakers filled with poster paints or water, which helps to reduce mess and accidental spills.

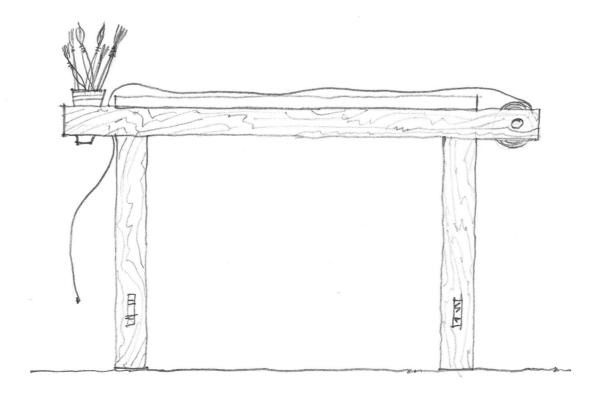

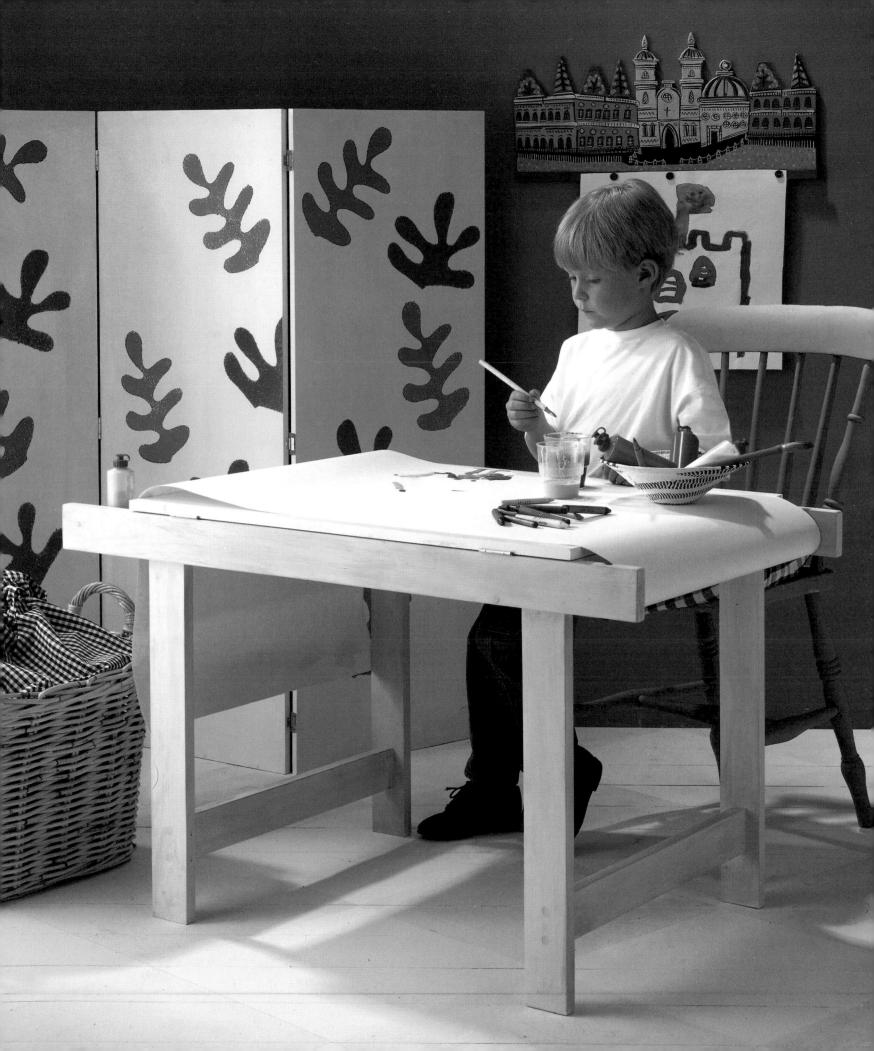

PAINTING TABLE

MATERIALS

Part -	Quantity	Material	Length
LONG RAIL	2	75 × 25mm (3 × 1in) PAR softwood	1000mm (39in)
LEG	4	As above	610mm (24in)
TOP CROSS RAIL	2	As above	570mm (22½in)
BEAKER-HOLDER SHELF	2	As above	As above
BOTTOM CROSS RAIL	2	As above	528mm (20 ³ / ₄ in)*
PAPER RAIL	1	12mm (½in) dowel	610mm (24in)*
DOWEL	8	As above	80mm (3½in)
TOP	1	15mm ($\frac{5}{8}$ in) melamine-faced chipboard	765 × 610mm (30 × 24in)*
BASE (optional)	1	4mm ($\frac{1}{8}$ in) plywood or hardboard	725×570 mm $(28\frac{1}{2} \times 22\frac{1}{2}$ in)*
BASE-SUPPORT BATTEN	4	9×9 mm ($\frac{3}{8} \times \frac{3}{8}$ in) hardwood	2.5m (8ft) cut to fit

Also required: iron-on edging strip; stay for hinged top; two 75mm (3in) flush hinges for hinged top or four 50mm (2in) angle brackets for permanently fixed-down top

PRIDE OF PLACE

When they've finished painting, children need a means to display their work. We painted a board with a church and some houses, cut it out and stuck a magnetic strip across the bottom to hold the paintings.

perfect outlet for fun, imagination, education and creativity. When a child has a paintbrush, lovely colours and water with which to experiment, it is clearly time to leave self-expression free to develop. But this cannot be achieved in a restrictive atmosphere, and finding that ideal somewhere for such a messy activity is not always easy.

The understandable and necessary concern for the protection of furniture and furnishings can be obviated, however, with this simple, functional painting table. It provides an activity centre combined with storage for materials so that setting up and clearing away takes only a minute or two.

Every child loves to paint. It's the

The design of this table is based on a standard roll of wall lining-paper which can be obtained at any

decorating shop. It is a cheap, white paper normally pasted on to walls but which provides a large amount of paper ideal for painting on. The roll is stored on a dowel at one end of the table and can be pulled across the top to provide a continuous clean painting surface as required. The used paper is fed through a small gap at the other end of the table. Circular holes are cut in a shelf at one end of the table to provide safe storage for paint and water containers.

The table top is made from melamine-faced chipboard, so it has a wipe-clean surface. Although the top could be permanently fixed down, with a little more effort a base can be added and the top fixed with hinges so that it can be raised to give access to a convenient storage area for materials beneath it.

TOOLS

STEEL MEASURING TAPE
TRY SQUARE
TENON SAW
DRILL (hand or power)
FLAT BIT - 12mm (½in)
SCREWDRIVER
COUNTERSINK BIT
ONE PAIR OF G-CRAMPS
HAMMER
EXPANSIVE BIT or HOLE SAW or JIGSAW or PADSAW
CHISEL
MALLET or HAMMER

^{*} Approximate dimension - measure exactly and cut to fit

PAINTING TABLE ASSEMBLY

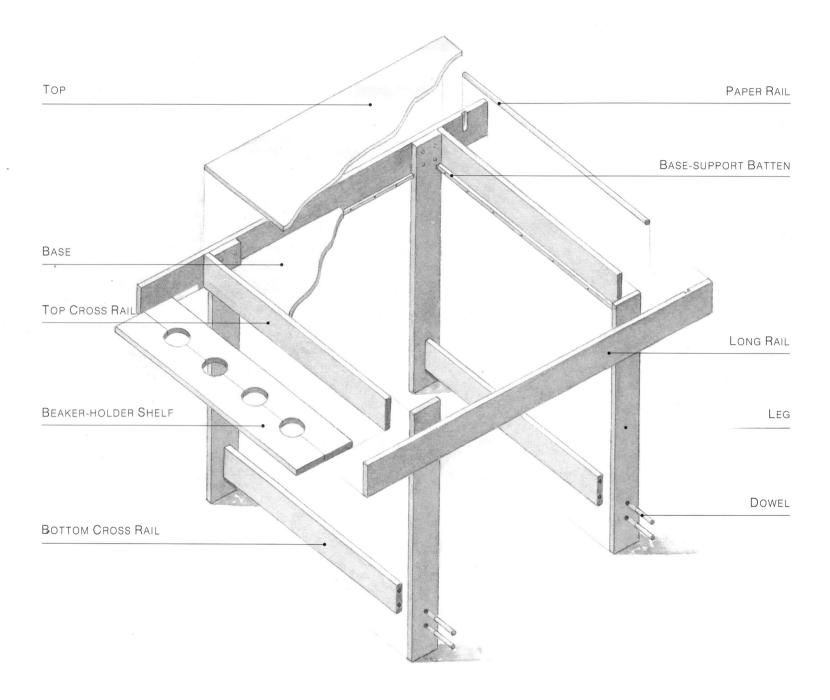

PAINTING TABLE

CONSTRUCTION

Cut the top rails and legs to length. Round over the ends of the long rails to reduce impact injuries. Cut the beaker-holder rails and join them with PVA (polyvinyl acetate) adhesive; cramp and leave to dry.

TOP FRAME

On the two long rails, mark the positions of the centre lines of the top cross rails. These will be 150mm (6in) in from the beaker-holder end and 110mm ($4\frac{1}{2}$ in) in from the other end. Square the marks around on to the opposite faces of the long rails.

Into each of the four marked centre lines, drill three equally spaced holes to accept 50mm (2in) No 8 screws. Countersink each hole so that the screw heads will be flush with the surface (see Techniques, page 120). Glue and screw the long rails to the ends of the top cross rails ensuring that the rails are exactly square at the points where they join (fig 1). Cramp the joints together while the glue dries.

Constructing the Top Frame

Mark on the long rails the positions of the top cross rails so they are 150mm (6in) in from one end and 110mm ($4\frac{1}{2}$ in) from the other. Glue and screw through the long rails into the ends of the top cross rails.

LEGS

The legs should be fitted tight into the inside corners of the frame to ensure rigidity. Each leg is glued and screwed from inside the frame using four 38mm (1½in) No 8 screws (fig 2). Drill and countersink the holes through the legs and into the long rails, ensuring that their top edges are flush with the top of the frame.

BOTTOM CROSS RAILS

Measure for and cut the bottom cross rails to length. The top edge of each rail should be 150mm (6in) up from the bottom of each leg. Mark a line and square around on to the opposite face and mark off two equally spaced dowel positions. Cramp one rail accurately centred in position between two legs, then drill 12mm $\left(\frac{1}{2}in\right)$ diameter, 75mm (3in) deep holes through the legs and into the rail. Repeat for the other bottom cross rail.

Cut and prepare eight 12mm ($\frac{1}{2}$ in) diameter dowels, 80mm ($3\frac{1}{4}$ in) long. Score thin grooves along the length of each dowel. Apply PVA

The simple addition of hinges to the table top and a base beneath creates a space in which paints, pencils and crayons can be stored. The beaker-holder shelf prevents pots of paints from tipping over.

2 Fitting the Legs
The legs are glued and screwed tightly and squarely into the inside corners of the top frame.

Bottom Cross Rails
Position the cross rails between the legs, 150mm (6in) up from the bottom. Drill and dowel in place.

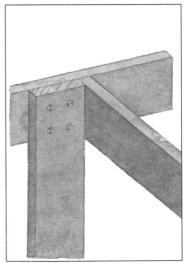

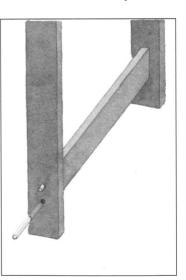

Cutting a	circle	118	
Marking	square	118	
Sawing	118		
Drilling	120		***************************************

Screwing	120	
Hinges and	d catches	122
Butt joint	123	
Dowel join	t 124	***************************************

PLAYROOMS
Painting Table
62/63

adhesive to each hole, then hammer home the dowels leaving the ends protruding (fig 3). Leave the cramps in place until the adhesive has set, then saw off the protruding dowel to leave a flush finish.

BEAKER-HOLDER SHELF

The number and diameter of holes is optional and will be determined by the size of the beakers or other containers used. Here we used four equally spaced 50mm (2in) diameter holes (fig 4). They can be cut using an expansive bit, a hole saw, a jigsaw or a padsaw (see Techniques, page 118).

Position the shelf between the long rails, flush with their undersides and ends. You should leave a small gap between the innermost edge of the beaker-holder shelf and the outside face of the top cross rail for the paper to feed through — if the gap is not wide enough, plane a little off the edge of the shelf.

Drill four countersunk holes in the edge of each long rail and fix the shelf in place using 50mm (2in) No 8 screws (fig 5).

Deaker-holder Shelf
Join two lengths of 75 × 25mm
(3 × 1in) PAR edge-on. Cut holes to fit the beaker size.

PAPER RAIL

At the opposite end of the table, fix the dowel that holds the roll of paper. This simply rests in slots cut centrally into the protruding ends of the long rails (fig 6). The slots are 12mm ($\frac{1}{2}$ in) wide and 25mm (1in) deep. Ensure the two slots are aligned with careful marking before drilling. Drill a hole at the base of the slot, then saw down the sides with a tenon saw. Pare out the waste of each slot with a chisel. Cut the dowel long enough to fit snugly in position, without it being too tight.

TABLE TOP

The top should be cut to fit flush with the outside edges of the long rails and cross rails. Measure the exact dimensions before cutting. It is a good idea to ask the supplier to cut this to size for you, since melaminefaced board sometimes splinters along the cut. The exposed, sawn edges of the top should be covered with iron-on edging strip which is readily available where you buy your melamine-faced chipboard.

Fitting Deaker-holder Shelf Position the shelf between the long rails, flush with the undersides and ends. Screw in place.

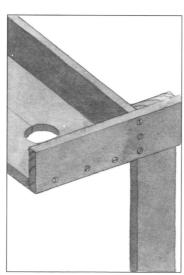

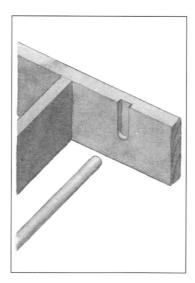

If you want a fixed top, secure it to the cross rail using 50mm (2in) angle brackets screwed to the inside of the top frame and the underside of the table top – two on each side will give a secure fixing.

For a hinged top, use two 75mm (3in) hinges – flush hinges are easiest to fix (see **Techniques**, **page 122**). For safety, fit a support stay to hold the top firmly in position when it is raised up.

BASE

Fit this only if you hinge the top. Cut four lengths of $9 \times 9 \text{mm}$ ($\frac{3}{8} \times \frac{3}{8} \text{in}$) ramin for the base supports, and glue and pin them flush with the bottom edges of the rails (fig 7).

The base should be cut to fit the inside dimensions of the long rails and cross rails, so measure before cutting. Use an offcut from one of the $75 \times 25 \text{mm} (3 \times 1 \text{in})$ legs as a template for the corner notches. Dab adhesive on to the supports to hold the base in position.

Make sure the wood is free from splinters, then paint, stain or varnish according to the finish you want.

6 Fitting the Paper Rail
Cut slots on the inside faces of the
long rails and rest a length of 12mm
(\frac{1}{2}\text{in}) dowel in place.

The optional base is notched at the corners and rests on battens nailed to the long and top cross rails.

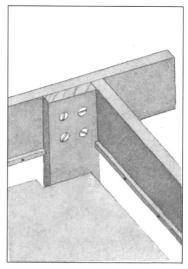

SWING-DOOR WARDROBE

As with the Storage House on page 32, this design uses play as a means of encouraging children to look after their own belongings. Either as a free-standing unit or fitted into an alcove, the simple box framework is designed to accommodate hanging space for clothes on one side and a washbasin (optional) on the other. Compartments above can take folded clothes, shoes, toys and sports gear. The size of the system overall can be adapted to suit the space available.

Made of chipboard or MDF, the frame construction is quick and easy. A length of wooden dowel serves as an adjustable hanging rail for clothes.

The play value comes in the decoration of the door, which swings on hinges to reveal a 'kitchen' on one side and a clothes 'shop' on the other. Playing at cooking and running a shop are perennial favourites; the vivid backgrounds provided by each side of the door lend an extra dimension to the make-believe.

Decorating the door need not be difficult. You can cut out a series of basic shapes or stencil outlines to give a degree of uniformity and then apply real food labels from food tins or packets on the 'kitchen' side, or stick on cut-out wrapping paper to trim the clothes on the 'shop' side. In the same way, the lid of the toy box, which can be lifted out and reversed, is simply painted with circles to make the rings of a play cooker on one side and as a shop counter on the other.

PLAYROOMS Swing-door Wardrobe 64/65

SWING-DOOR WARDROBE ASSEMBLY

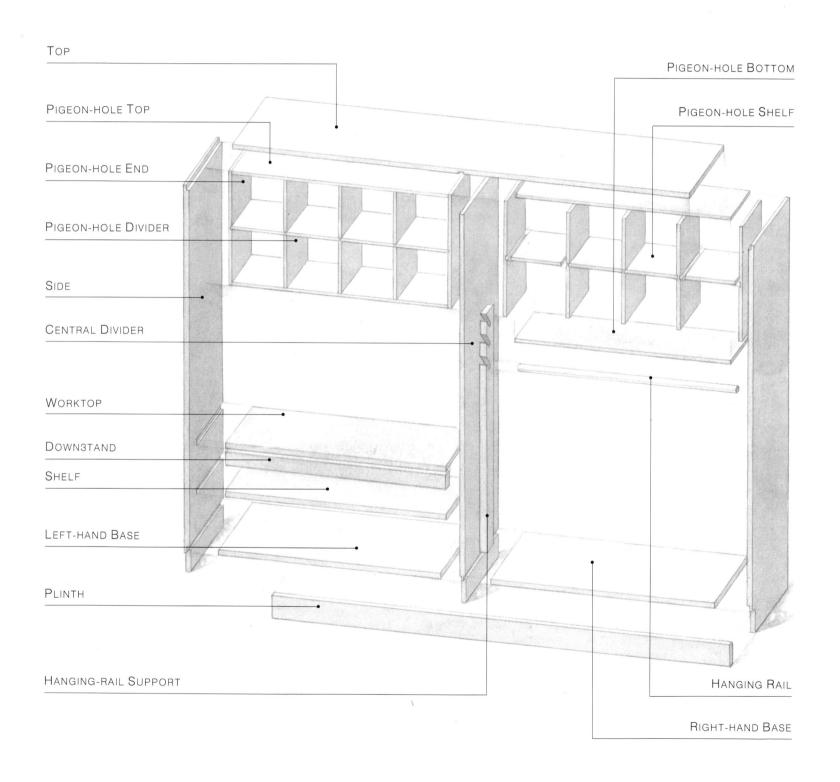

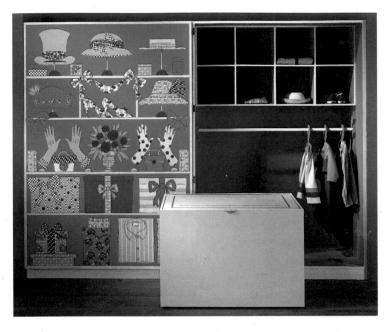

DOUBLE THE FUN

We painted the door with backdrops for playing against: when the right-hand side of the wardrobe is open, the door is painted to look like a shop (above); swing the door the other way, and a kitchen stacked with exotic ingredients is revealed (right).

SWING-DOOR WARDROBE

Tools
WORKBENCH (fixed or portable)
STEEL MEASURING TAPE
TRY SQUARE
SLIDING BEVEL
JIGSAW
POWER DRILL
DRILL BITS – various for pilot holes
COUNTERSINK BIT
FLAT BIT - 25mm (1in)
CIRCULAR SAW or PANEL SAW
SMOOTHING PLANE
BELT SANDER OF POWER FINISHING SANDER OF HAND SANDING BLOCK
SCREWDRIVER
ROUTER
STRAIGHT-CUTTER BIT –12mm $(\frac{1}{2}in)$ and 19mm $(\frac{3}{4}in)$

Children will be able to keep their room tidy and have good fun with this combined wardrobe and shelving system, which doubles as a play area. It can be made to whatever width required, up to a maximum of 2.4m (8ft) (since the width of the swing-door panel must not exceed 1220mm [48in]). The unit has panels at each end, so it can be built as a free-standing unit against a wall, or it can be built wall-to-wall, or to fit into an alcove. Even if it is builtin, it should be built square as a freestanding unit and then pushed back into the alcove or between the side walls. If these walls are not true (exactly square), scribing fillets can be scribed to the wall to fill the gaps.

Whether the wardrobe is built-in or free-standing, for safety it must be fixed securely against the rear wall, as the door exerts a considerable pull away from the wall when it is swung from one side to the other. If you build the wardrobe to its maximum length, you will need 1220mm

Part	Quantity	Material	Length
CARCASS			
SIDE	2	18mm (3in) blockboard or MDF	1830 × 550mm (72 × 215in)
CENTRAL DIVIDER	1	As above	1818 × 550mm (71½ × 21½ in
TOP	1	As above	As required
BASE	2	As above	As required
WORKTOP	1	As above	As required
SHELF	1	As above	As required
PLINTH	1	As above	As required
PIGEON-HOLE UNIT			
TOP	2	12mm (½in) blockboard or MDF	As required
ВОТТОМ	2	As above	As required
END	4	As above	As required
DIVIDER	6	As above	As required
SHELF	8	As above	As required
WARDROBE SECTION			
HANGING-RAIL SUPPORT	2	100 × 25mm (4 × 1in) PAR softwood	Cut to fit
HANGING RAIL	1	25mm (1in) diameter dowelling	As above
DOWNSTAND	1	50×25 mm (2×1 in) PAR softwood	As above
DOOR	1	18mm (3in) blockboard	As above
FIXING BATTEN	2	25×25 mm (1 × 1in) PAR softwood	1830mm (72in)
Toy Box			
FRONT	1	18mm (3in) blockboard or MDF	900 × 600mm (36 × 24in)
BACK	1	As above	As above
SIDE	2	As above	570 × 600mm (22 ³ / ₄ × 24in)
BASE	1	6mm (¹ / ₄ in) plywood	Cut to fit
BASE SUPPORT BATTEN	4	25 × 25mm (1 × 1in)	Cut to fit
LID SUPPORT BATTEN	3	As above	Cut to fit
LID	1	6mm (±in) plywood	900 × 590mm (36 × 23½in)

Also required: corner fixing blocks and scribing fillets; 1 screen hinges; 2 magnetic catches; angle brackets or fixing plates; 4 castors; silicone rubber mastic (for fixing washbasin).

(48in) of free space in front of the wardrobe for the door to swing open. If you do not have sufficient space, you can either scale down the length of the wardrobe, or you could cut the door panel down the middle and hinge the two pieces

together with butt or folding door hinges so that they flap back on one another, needing only 610mm (24in) of free space in front.

The storage unit can be made from 18mm ($\frac{3}{4}$ in) MDF (mediumdensity fibreboard) or blockboard.

Blockboard is lighter and stronger than MDF; however, its exposed edges must be filled or covered with iron-on lipping. MDF is easy to cut and paint, but it is too heavy for the door panel. Size and weight dictate that assembly is done on site.

Sawing 118 Screwing 119 Scribing 119

Drilling 120 Housing joint Rebates 123

PLAYROOMS Swing-door Wardrobe 68/69

CONSTRUCTION

Measure for the width of the unit and allow a space of about 40mm (1½in) on either side if building wallto-wall or into an alcove. This gap will be taken up by scribing fillets.

SIDES

Cut out the side panels and cut an 18×6 mm ($\frac{3}{4} \times \frac{1}{4}$ ln) rebate along the top inside edge of each (fig 1). Cut an 18×6 mm $(\frac{3}{4} \times \frac{1}{4}$ in) housing on the inside for the base panel in each side panel (fig 2). The bottom of the housing is positioned 75mm (3in) up from the bottom of the panel. Finally, cut a 75×18 mm $(3 \times \frac{3}{4}$ in) notch in both side panels to take the plinth (fig 2, below).

CENTRAL DIVIDER

Cut out the central divider. Cut an 18×6 mm ($\frac{3}{4} \times \frac{1}{4}$ in) housing, 75mm (3in) up from the base on each side to take the base panels (fig 3, above). Cut a 75×18 mm $(3 \times \frac{3}{4}$ in) notch at the bottom to take the plinth (fig 3, below).

TOP PANEL

Cut the top panel - this should be the overall width of the unit, less 24mm (about 15 in). On the underside, mark the centre line across its width and cut out an 18 x 6mm $(\frac{3}{4} \times \frac{1}{4} in)$ central housing.

BASE PANELS

Cut out the two base panels. The length of each is the overall width of the unit divided in half, less 15mm (sin) for each half. The width of each panel is 550mm (215in).

WORKTOP AND SHELF

These are both the same length as the base panels, but only 500mm $(19\frac{3}{4}in)$ wide. Cut $18 \times 6mm(\frac{3}{4} \times \frac{1}{4}in)$ housings for both these panels in the left-hand side panel and the lefthand side of the central divider (see Swing-door Wardrobe Assembly, page 65). The worktop housing is 700mm (27½in) up (from the bottom edge of the side panel to the bottom edge of the housing) and the shelf housing is 350mm (133in) up. The housings are stopped 50mm (2in) short of the front edge.

LEFT-HAND SIDE ASSEMBLY

Working from the outside of the lefthand side panel, drill and countersink through the three housings and the top rebate for five screws in each joint. In the central divider, drill and countersink in the right-hand side through the housings in five places each time for the worktop, shelf and bottom panel.

Lay the left-hand side panel on its back edge and glue and screw the worktop, shelf and left-hand base panel into their respective housings (fig 1, page 70).

Lay the central divider on its back edge, then offer it up in place. Glue and screw through the housings into the ends of the worktop, shelf and base. Ensure that all screwheads are fully countersunk.

Rebating Top of Side Panel Cut an 18×6 mm ($\frac{3}{4} \times \frac{1}{4}$ in) rebate along the top inside edge of the two side panels.

Routing the Side Panel Above On side panel inside face, cut a housing 75mm (3in) up from the bottom. Below Cut a notch for plinth.

Routing the Central Divider Above Cut a housing 75mm (3in) up from bottom on both faces of divider. Below Cut a notch at base for plinth.

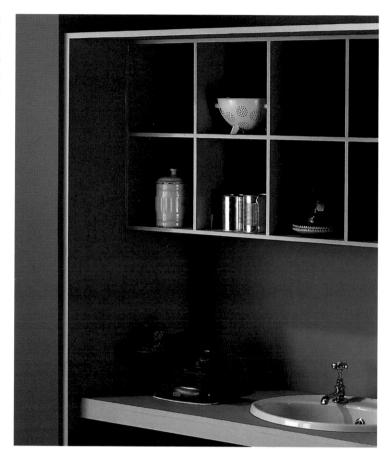

SWING-DOOR WARDROBE

TOP FIXING

Stand the top panel on its back edge and offer up to the housing in the left-hand side panel and locate on to the central divider. Glue and screw through the left-hand side panel into the edge of the top panel (fig 1, below). Drill and countersink the top panel from the outside into the centre of the housing in five places and glue and screw through the top into the central divider.

RIGHT-HAND SIDE **ASSEMBLY**

Drill and countersink through the right-hand side panel from the outside through the top and bottom housings for five fixings in each joint. Put the right-hand base panel in position. Offer up the side panel, trapping the base, and glue and screw into the top and base.

Glue and screw a corner fixing block (cut from an offcut of wood) under the base, screwing into the central divider and up into the base panel, to secure the base panel at the left-hand end (fig 2, below).

Assembling the Main Carcass

Left Drill and countersink through left-hand side panel to assemble worktop, shelf and base panel. Right Offer the central divider up to the left-hand side assembly. Below Glue and screw top panel to side panel and central divider.

PLINTH

Cut the plinth to the full width of the unit and 75mm (3in) high. Drill, countersink and then glue and screw into the notches in the uprights in two places (fig 3, above). Also drill, countersink and screw down through the front of the base panels into the edge of the plinth. This completes the basic carcass.

FITTING IN POSITION

If fitting the unit to a wall at the end, fix 25×25 mm(1×1 in) battens to the full height of the side panels, on the outside, set 50mm (2in) back from the front edge (fig 3, below). Later, the scribing fillets will be fixed to these battens so that the unit appears to be fitted tightly to the wall, with no unsightly gaps.

Measure the diagonals of the unit, which should be equal, to ensure the unit is square, and hold it square by nailing a temporary bracing batten across the front.

The unit can now be stood upright and fixed in position against the wall using angled fixing plates in

several unobtrusive places to make the unit absolutely secure. Make sure the unit remains perfectly square as you do this.

PIGEON-HOLE UNITS

These units are made up separately and then fitted into the main carcass as complete units.

The units are 300mm (12in) deep and are fitted flush with the back. Measure the internal width of both right- and left-hand sections. The top and bottom pigeon-hole panels will be this length, less 24mm ($\frac{15}{16}$ in).

Cut out the top and bottom panels. To make the pigeon-holes square, take the internal width of one section, subtract the combined thickness of the dividers and ends (in our case, 60mm [2흶n]) and divide by the number of required spaces (in our case, four). Our pigeon-holes have internal openings 283mm (11½in) wide. Make the internal height of the pigeon-holes the same as the internal width.

To work out the height of the pigeon-hole ends, add together two times the internal spacing plus the

Right-hand Assembly Above Screw through right-hand side panel into base. Below Fit fixing

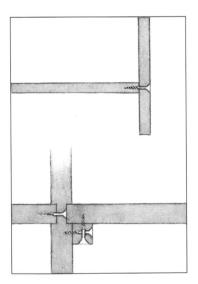

combined thickness of the top, bottom and middle shelves (36mm [1½in]) to give the final length to cut (in our case, 602mm [233in]). Cut out the ends to length. Cut the internal dividers to the height of the ends, less 24mm (15in).

Cut 3×12 mm ($\frac{1}{8} \times \frac{1}{2}$ in) housings on the insides of the end panels (see Swing-door Wardrobe Assembly, page 65) and on both sides of the dividers on the centre lines.

Cut out the shelves to the width of the internal spacing, but allow an extra 6mm (1/4in) to fit into the housings (3mm [ain] either end).

Glue up all the housings. Tap the shelves into the housings of the dividers (fig 4, above). Use a piece of scrap wood to protect the shelves from the hammer blows.

Mark the three centre lines on the top and bottom panels for where the dividers will be positioned, then drill and countersink through the lop and bottom panels from the outside faces for three fixings along each line. Glue and screw through the panels into the ends of the dividers (fig 4, below).

Finishing Off Main Carcass Above Screw plinth into notches cut in the uprights. Below Add battens to outside of side panels.

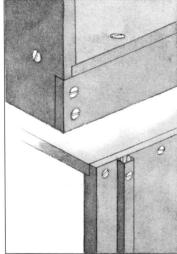

70/71

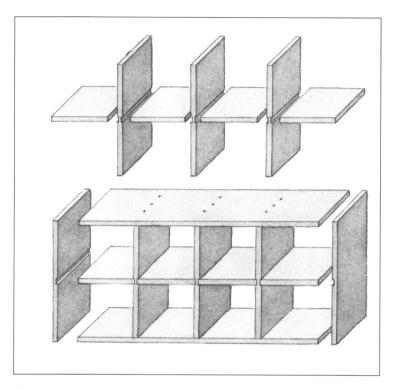

Assembling the Pigeon-hole Units

Above Cut housings across the middles of both sides of the dividers to accept the shelves. Below Cut housings in the top and bottom panels to correspond to positions of dividers; screw in place. Finally add end panels.

5 Fitting the Pigeon-hole Units Position units flush with back of carcass. Screw through from inside into sides and top of carcass.

Hanging Rail Supports downward slots as shown at the intervals indicated.

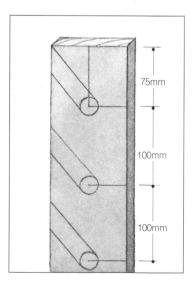

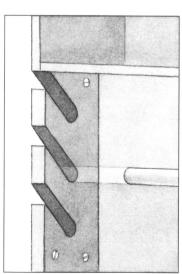

Offer each unit in place and screw through the sides and top from the inside of each pigeon-hole, into the main carcass (fig 5). Use four screws in the top of each pigeon-hole and two in the ends of each. Countersink the screws.

HANGING RAIL

Measure from the underside of the pigeon-holes to the base for the length of the hanging rail supports and cut two lengths of 100 × 25mm (4×1in) PAR softwood.

Drill a 25mm (1in) diameter hole centrally, with its centre 75mm (3in) down from the top (fig 6), another hole 100mm (4in) below that, and another hole 100mm (4in) below that again. Using a sliding bevel, mark off and cut a 25mm (1in) wide slot from the top corner down into the top hole. Repeat for parallel slots down to the other holes.

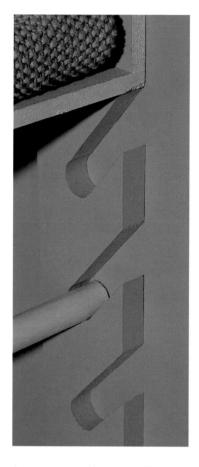

ADJUSTABLE HANGING RAIL These slots allow you to alter the height of the rail according to the length of clothes hung from it.

SWING-DOOR WARDROBE

Fix these supports to the side panel and central divider in the right-hand section, with the front edges flush with the fronts of the pigeon-holes (fig 7, page 71). Fix with pairs of screws down the length. Cut a length of dowel to fit the internal width. This gives an adjustable-height hanging rail.

BASIN

If you are fitting a vanity basin in the worktop in the left-hand unit, fit it at this stage. The basin will be supplied with a template, so place this centrally on the worktop. Either mark around the template on to the worktop, or glue the template in place on the worktop. Use a jigsaw to make the cut-out for the basin. Drop it in place and make sure the rim fits snugly against the worktop and that it is level. Remove the basin and apply a bead of silicone rubber mastic to its lower edge. Replace the basin in the cut-out and secure it to the worktop on the underside using clips supplied by the manufacturer.

Employ a plumber to fit the taps and waste outlet and to make all the necessary connections.

DOWNSTAND

This strengthens the front edge of the worktop. Cut a 50 x 25mm (2×1) batten to the internal width of the left-hand section. Drill and countersink through the worktop into the batten in five places and glue and screw to the underside of the worktop, flush with the front.

Door

Calculate the width of the door by measuring from the outside edge of the unit to the nearest edge of the central divider (in our case, a width of 1210mm [475in]).

For the height, measure from the top of the unit to the underside of the base (ie, the top of the plinth) - in our case 1755mm (approximately 69in). Remember to allow for the thickness of any lipping.

Cut out the door and hinge it to the edge of the central divider using four screen hinges (fig 1).

Fit magnetic catches to the inside of both side panels, and catch plates to both sides of the door.

If you haven't enough space for the swing of the door, cut the door down the middle and hinge the parts together using butt or folding door hinges. The latter are easier to fit because they do not need recessing. You will need to fit a handle near the hinged edge to pull the door open on one side because the hinges will only open one way. Alternatively, fit screen hinges so the door opens in either direction.

TOY BOX

Glue and screw the front, back, and sides together at the corners (see Toy Box Assembly). The sides are fitted between front and back panels with five countersunk screws down each edge. Screw 25 x 25mm $(1 \times 1 \text{in})$ battens to the inside faces of the sides, front, and back, 10mm (3in) up from the bottom edge.

Hingeing the Swing-door Use four screen hinges to screw inside edge of swing-door to front of central divider.

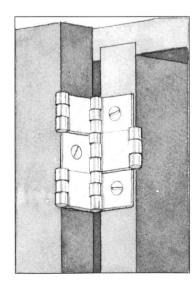

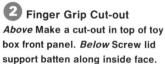

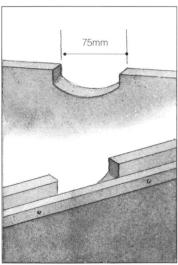

Cut-outs for Lid Pivots Above Box lid pivots on two cut-outs as marked. Below Angle back end of side lid support battens.

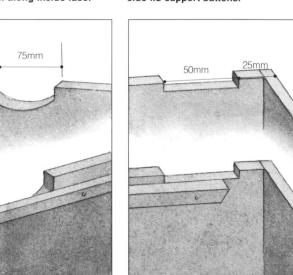

Sawing 118
Cutting curves 119
Scribing 119

Cut the base to fit the internal dimensions of the box. Drop the base into the box, gluing and pinning it down into the battens.

In the centre of the top edge of the front panel cut out a finger grip hole using a jigsaw or a coping saw (fig 2, above). This should be 75mm (3in) wide and cut down vertically 9mm $(\frac{11}{32}$ in) curving to a semi-circle below this depth.

Make the cut-outs for the lid pivots 50mm (2in) long and 9mm ($\frac{11}{32}$ in) deep in the top edge of the sides, spaced 25mm (1in) from the back edge (fig 3).

Fit a 25×25 mm (1 × 1in) batten to the inside of the front panel (fig 2, below), 9mm ($\frac{11}{32}$ in) down from the top edge. Cut battens to fit the sides, running from the front batten to 8mm ($\frac{5}{16}$ in) short of the back of the pivot cut-outs (fig 3, below). At the rear end of the batten undercut at an angle of 10 degrees as shown. Fix to the sides by gluing and screwing in three places.

LID

Cut out the lid as specified in the materials list. Place it on top of the box with the back edge just 2mm $(\frac{1}{16}in)$ inside the inside face of the back panel and mark off the positions of the pivot and finger cutouts. Cut out the lid to the inside dimensions of the box, leaving the extensions projecting about 17mm $(\frac{11}{16}in)$ at the pivots (fig 4), and projecting about 25mm (1in) at the front finger cut-out to act as a handle (see Toy Box Assembly).

Fit four castors to the underside of the base for ease of movement.

SCRIBING

Finally, if you are fitting the wardrobe wall-to-wall or in an alcove, finish off using sections of 4mm ($\frac{5}{32}\text{in}$) plywood scribed to the wall and pinned through into the side panel battens (see Techniques, page 119). Paint the scribing fillets to match the colour of the wall.

Drilling 120

Screwing 120

Hinges and catches 122

PLAYROOMS

Swing-door Wardrobe

72/73

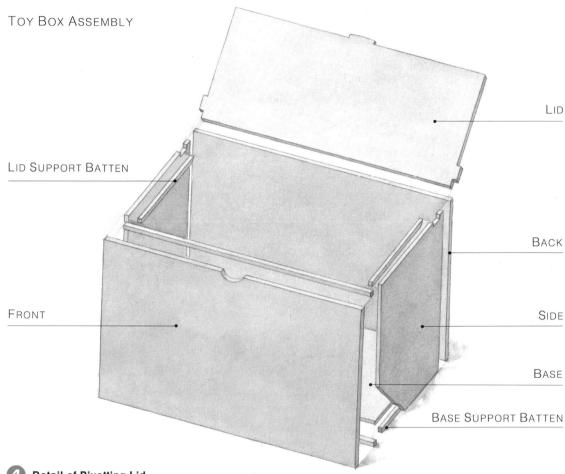

Detail of Pivotting Lid
Lid tongues rest in cut-outs. Angled
lid support battens prevent lid
slipping when open.

DECORATION

We painted the main carcass a bold blue, outlining the edges and the frame in yellow. The swing-door offers an opportunity for your imagination to let rip. We stencilled on all of the basic motifs (a quick and easy process) and then decorated these with food labels on the 'kitchen' side and wrapping paper on the 'shop' side. Simply glue them in place, and apply a coat of varnish when you've finished. Most children would enjoy the chance to help out, cutting up cereal packets and brightly coloured paper, but make sure they are supervised.

ROCKING HORSE

Another nursery classic, the rocking horse satisfies a child's basic desire to make something move. This design, stylized to make it simpler to construct, is nevertheless realistic enough to give the right impression of horsiness.

Traditional rocking horses, which tend to be elaborately carved and finished, are expensive; and the skills required to make such a toy are well beyond most people's abilities. This simple version, with its cheerful finish and lively details – the rope tail and the swivelling ears – would find a welcome home in any child's room.

Although simply painted here, the rocking horse could be decorated in a more ambitious, sophisticated style if your painting skills are sufficiently good. Additionally, the mane could be made from frayed rope so that it matches the tail and a colourful bridle could be tied around the horse's neck.

The body of the horse is composed basically of two sheets of plywood. The two keel-like half-curved shapes between the plywood body at either end are a safety feature; they prevent the horse being rocked too energetically and toppling over as a result. Like the horse's body, the head, saddle and ears are cut from a sheet of plywood, which is very economical. Pieces of dowelling are used to provide the footrests and handgrips.

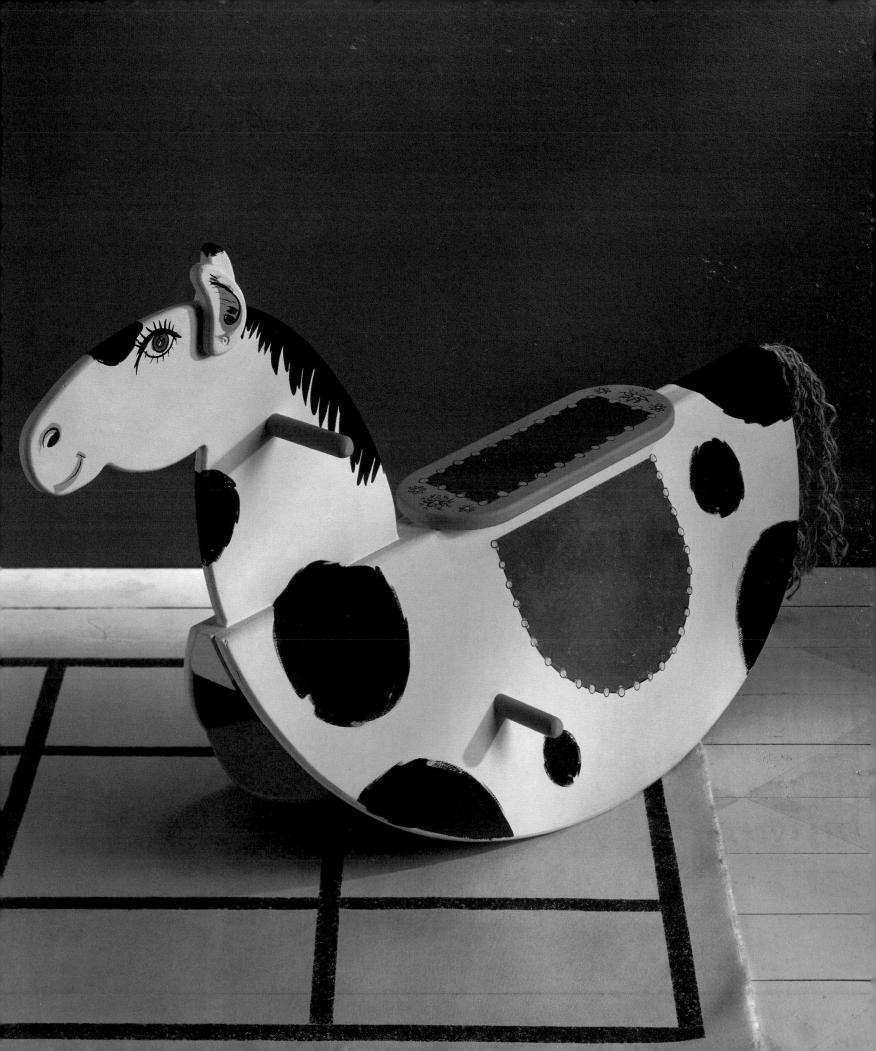

ROCKING HORSE

TOOLS

WORKBENCH (fixed or portable)
STEEL MEASURING TAPE
TRY SQUARE
JIGSAW
POWER DRILL
DRILL BIT - 4mm (½in)
COUNTERSINK BIT
FLAT BIT - 25mm (1in)
PANEL SAW
SMOOTHING PLANE (hand or power)
POWER FINISHING SANDER
SCREWDRIVER
ROUTER
ROUNDING-OVER CUTTER
STEEL RULE

You can have almost as much fun yourself making this stylized rocking horse as young children will have playing on it. You can follow our grid designs to make up paper patterns or cardboard templates for the head and ears. Alternatively, you can make the head more or less any shape you like, allowing you to stamp your own personality on this comparatively easy-to-make activity toy: there's nothing to restrict you to a rocking horse, and you may prefer to make the head to look like a sheep, a pig, a cat or a dog.

Most of the parts are made from 18mm (¾in) plywood. The semicircular side pieces that form the 'body' are joined at the top by a softwood 'backbone' and are braced by gussets at the front and back. The braces ensure that the side pieces form a sturdy 'base' on which to rock, and also form stops to prevent the horse from rocking too vigorously and tipping over.

MATERIALS

Part	Quantity	Material	Length
BACKBONE	1	75×75 mm (3×3 in) PAR softwood	1040mm (41in)
HEAD	1	18mm (3/4 in) plywood	Approx. 530×500 mm $(20\frac{7}{8} \times 19\frac{5}{8}$ in)*
SIDE	2	As above	Approx. 1040 × 430mm (41 × 17in)*
BRACING PIECE	2	As above	Approx. 250 × 250mm (10 × 10in)*
SEAT	1	As above	450 × 150mm (17 ³ / ₄ × 6in)
EAR	2	As above	Approx. 125×75 mm $(5 \times 3$ in)*
FOOTREST	1	25mm (1in) hardwood dowelling	440mm (17 <u>4</u> in)
HANDGRIP	1	As above	230mm (9in)

^{*} Cut from scale pattern provided on page 77

Also required: PVA adhesive; length of rope for tail

MAKING A START

You will need to make paper patterns or templates for the sides and bracing pieces, and on these you should mark the positions for the footrests and handgrips. Make the patterns from thick brown paper (though newspaper will do if you treat it carefully); cardboard templates are best if more than one rocking horse is to be made. In pencil, draw a 100 x 100 mm $(4 \times 4in)$ grid on the paper and follow the shapes on our grid to produce full-size patterns of a side panel, head, ear and front brace. Cut out these patterns and temporarily paste or stick them to the plywood for accurate cutting out. On the head, mark the centrepoint of the handle, and on the side pattern mark the centrepoint of the footrest position. Where two pieces of the same shape are required, such as the sides, use the patterns to cut out the first piece, and use this piece as a template to draw around and mark the second piece, which can then be cut out.

BACKBONE

Cut the backbone to length from PAR (planed all round) softwood. Cut a mortise slot 25mm (1in) from one end right through the timber (fig 1). The mortise is for the head to fit into and should be 18mm ($\frac{3}{4}$ in) wide and 280mm (11in) long.

Chamfer the sides of the backbone by about 20 degrees on each side to leave a flat surface centred across the top so that it is about 20mm (13in) wide.

HEAD

Cut the head to shape from the pattern, with the tenon (tongue) at the bottom to fit into the mortise (slot) in the backbone (fig 1, above). Round over the edges of the head, except for the tenon, either using a router fitted with a rounding-over cutter, or by hand using a spokeshave. Use your full-size pattern to mark the handle position on the head, and with the head held flat on a piece of scrap board, drill through at this point using a 25mm (1in) diameter flat bit.

Shaping the Backbone

Above Finished, chamfered backbone has a mortise slot cut 25mm (1in) from one end to accommodate the horse's head. Below Chamfer the sides of the backbone by about 20 degrees so that the top face is 20mm $\binom{13}{16}$ in) wide.

Sawing 118 Cutting curves 119 PLAYROOMS

Rocking Horse
76/77

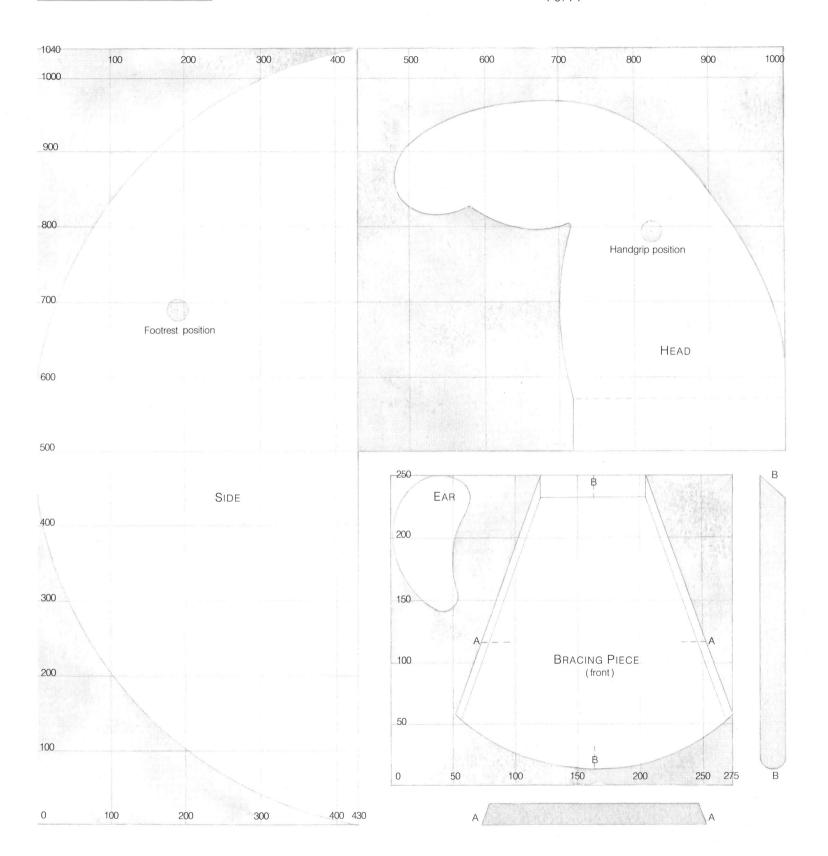

ROCKING HORSE

HEAD

HANDGRIP

SEAT

FOOTREST

BACKBONE

BRACING PIECE

SIDE

1 Temporary Assembly of the Main Parts Above Temporarily screw head in backbone mortise: turn over and plane off protruding part of tenon. Below Temporarily screw sides to backbone: plane tops of sides level with backbone and curve the ends of the backbone.

Final Front Assembly
The front of the backbone is curved in line with the side pieces, the edges of which are rounded over.

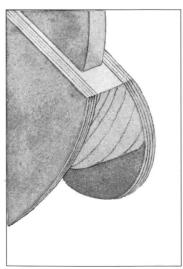

Cutting curves 119 Planing 119 Drillina 120 Screwing 120

PLAYROOMS Rocking Horse 78/79

Fit the head into the mortise in the backbone and temporarily screw it in place; then either plane off the protruding part of the tenon flush, or sand it flush using a belt sander. Remove the head.

SIDES

Use the pattern to cut out the two sides. Cut one side to shape, sanding it to a smooth curve if necessary, then use this first side as a template to mark out and cut an identical second side. Using the roundingover cutter or a spokeshave, round over the curved edges of the sides.

Sand the edges smooth, and, using the pattern, transfer the centrepoints of the footrest positions to the sides. Don't drill these holes yet.

SHAPING THE ENDS OF THE BACKBONE

Temporarily screw the sides to the backbone with four screws along each side and plane the top edges of the sides level with the top of the backbone. Mark off the curve of the sides on to the backbone at both ends (fig 1, below). Dismantle the

Fitting the Bracing Pieces Bracing pieces front and back are glued and screwed in place through the side panels.

sides and cut the backbone to the marked curves. Use a jigsaw to trim the ends as close as possible to the lines, then smooth off using a belt sander or power sander.

ASSEMBLY

Glue the head into the mortise in the backbone with PVA (polyvinyl acetate) adhesive and then screw it in place with four No 8 screws. Insert the screws from both sides so that the head is firmly fixed. Glue and screw the sides in place using four countersunk screws on each side.

BRACING PIECES

The bracing pieces serve two purposes: they brace the sides rigid. and they act as stops to restrict overenthusiastic rocking action.

Use the pattern to mark out the bracing pieces and cut them out. The edges must be bevelled as shown on the pattern. This is done either by tilting the saw blade while cutting out, or by planing the edges after the pieces have been cut out. Round over the bottom edges of the braces to form bull-noses.

View of the Underside

Note how the two bracing pieces are angled outwards and protrude beyond curved sides to act as stops. Footrest dowel feeds through holes drilled in

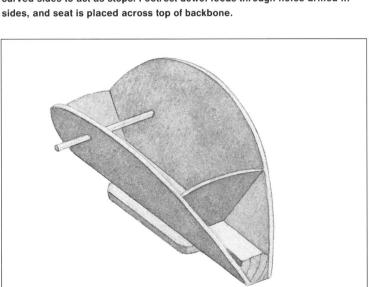

Slide the braces into place between the sides, and adjust their positions until the curved bottom edges coincide with the curved bottom edges of the horse's sides. Drill pilot holes through the sides of the rocking horse into the edges of the bracing pieces, then glue and

screw in place using four No 8

countersunk screws each side.

SEAT

Cut out the seat panel. Use a paint tin to mark half-rounds at each end, then cut these out using a jigsaw. Round over the edges as before. Glue and screw the seat down on to the backbone, about 40mm (13in) back from the head.

FOOTREST AND HANDGRIP

Drill through the sides horizontally to take the footrest. At the marked positions, drill 25mm (1in) diameter holes horizontally and square to the backbone. It is best to get a helper with a good eye to line up the drill for you. Cut the footrest dowel to length, round over the ends, and slide the dowel into position (fig 4). Fix it in

place with a dab of glue. Cut the handarip dowel to length, round over the ends, and fix it with alue in the hole drilled through the head.

EARS

Use the pattern to mark out the ears. Cut them out using a jigsaw, then round over the edges. Screw the ears in place on either side of the head (fig 5), offsetting them slightly so that the screw positions do not coincide. Countersink the screws. Do not glue the ears - this allows them to swivel, an amusing touch that also reduces impact danger.

TAIL

Drill a hole the thickness of the tail rope centrally in the end of the backbone to a depth of about 50mm (2in). Use a piece of rope about 450mm (18in) long and glue one end into the hole, then tease out the other end to give a tassle.

Paint the horse as required. The finish here is very basic, but you could paint it more intricately to look like a fairground attraction, time and skill permitting.

Handgrip and Ears Round over ends of handgrip and glue in place. Screw the ears to sides of head so that they swivel.

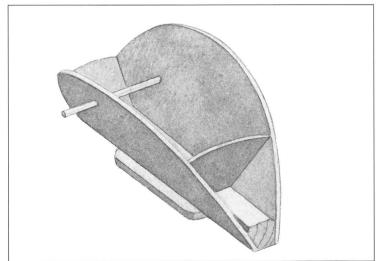

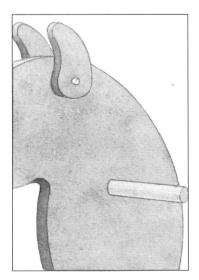

Giving hours of amusement as the focus of children's theatrical interest and skills, this grand and exciting puppet theatre would make a superb Christmas present. It has been designed for use with marionettes, and is tall and deep enough for productions to be easily staged. The theatre can be easily dismantled and packed entirely flat when not in use, or it could provide a focal point in a child's bedroom or playroom, or even in the corner of the sitting room. Although it looks imposing, it takes time rather than money to make, and it is not demanding in terms of woodworking skills.

Based on a traditional design, the theatre consists of a front 'proscenium' arch whose sides curve round to support a backdrop flat, a middle section with a staircase at one side going up to a balcony, and a rear section comprising two L-shaped portions which frame another flat. Below the balcony, doors open to reveal another view. The entire effect is very theatrical, with a sense of different spaces opening up, false perspectives and light filtering in from the sides. The three flats can be painted on both sides to provide twice as many scenes, and extra ones can be made later on for new shows.

The theatre is constructed from thin plywood and battens. Although construction is very simple and no joinery is required, the stairs are rather fiddly to make and the middle section would be simpler if you omitted them. The main skill required is the ability to cut out each section accurately so that the individual parts slot correctly on to the locating pieces screwed to the base.

Undecorated, the theatre has a strong architectural character. For decoration, copy details from cut-out paper theatres or adopt a simpler style if you are not confident about your painting skills.

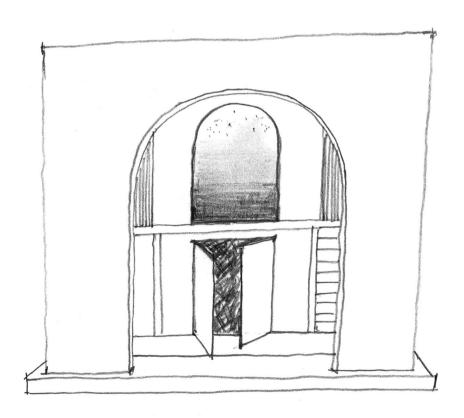

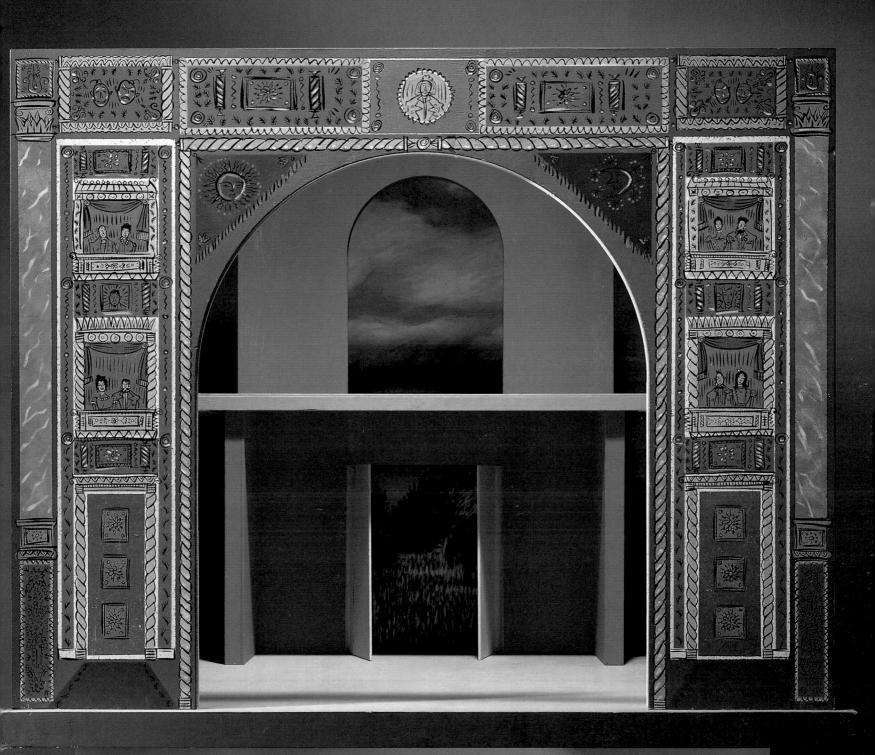

Youngsters will keep themselves amused for hours with this traditional puppet theatre, making up and performing their own plays.

The theatre is made entirely from 4mm ($\frac{3}{16}$ in) plywood – the cheap interior-quality redwood type is fine – and 25×25 mm (1×1 in) PAR (planed all round) softwood battens to strengthen the frame. The base section which forms the stage is supported by a framework of 50×25 mm (2×1 in) PAR softwood.

The theatre is made up in four parts – the front section, the central section, the back section and the base – and has three different flats for changes of scenery which can be painted on both sides for twice as many backdrops. The sides are kept open to allow the puppets to be brought on and off the stage.

TOOLS

WORKBENCH (fixed or portable)
STEEL MEASURING TAPE
TRY SQUARE
POWER JIGSAW
POWER DRILL
DRILL BIT – 4mm (3/16in)
PAIR OF G-CRAMPS
SMOOTHING PLANE (hand or power)
POWER FINISHING SANDER or HAND SANDING BLOCK
LIGHTWEIGHT HAMMER
COPING SAW – for cutting stairway tread slots

Part	Quantity	Material	Length
FRONT SECTION			
FRONT ARCH SECTION	2	4mm (3/16 in) redwood plywood	1000 × 800mm (39 × 31½in)
SIDE WING	2	As above	800 × 270mm (31½ × 10¾in)
FRONT FLAT SUPPORT	4	As above	800 × 150mm (31½ × 6in)
FRONT FLAT	1	As above	800 × 740mm (31½ × 29½in)
SPACING BATTEN	2	25 x 25mm (1 x 1in) PAR softwood	780mm (30 <u>3</u> in)
SPACING BATTEN	4 .	As above	800mm (31½in)
CURTAIN POLE	1	12mm (½in) dowel	1000mm (39in)
CENTRAL SECTION			
CENTRAL ARCH SECTION	2	4mm (3/16in) redwood plywood	800 × 600mm (31½ × 24in)
BALCONY SUPPORT	4	As above	400 × 173mm (15 ³ / ₄ × 6 ³ / ₄ in)
BALCONY	1	As above	990 × 350mm (38½ × 13¾in)
CENTRAL FLAT	1	As above	800 × 290mm (31½ × 11½in)
STAIRCASE SIDE	2	As above	400 × 250mm (15 ³ / ₄ × 10in)
STAIRCASE BACK PANEL	1	As above	400 × 145mm (15 ³ / ₄ × 5 ³ / ₄ in)
STAIR TREAD	12	As above	155×30 mm ($6\frac{1}{8} \times 1\frac{3}{16}$ in)
SPACING BATTEN	4	25×25 mm (1 × 1in) PAR softwood	800mm (31½in)
SPACING BATTEN	4	As above	400mm (15 <u>3</u> in)
LOCATING PIECE	2	As above	Approx. 130mm (5½in)
BALCONY STIFFENING PIECE	As required	As above	Cut to fit from approx. 3.5n $(11\frac{1}{2}\text{ft})$
BACK SECTION			
BACK FLAT SUPPORT	4	4mm (3/16in) redwood plywood	800 × 300mm (31½ × 12in)
BACK WING	2	As above	800 × 475mm (31½ × 18¾in)
BACK FLAT	1	As above	800 × 440mm (31½ × 17½in)
SPACING BATTEN	4	25×25 mm (1 × 1in) PAR softwood	800mm (31½in)
BASE SECTION			
STAGE	1	4mm (3/16in) redwood plywood	1040 × 1040mm (41 × 41in
STAGE PLINTH	2	50 x 25mm (2 x 1in) PAR softwood	1040mm (41in)
STAGE PLINTH	7	As above	Cut to fit
LOCATING PIECE	9	25×25 mm (1 × 1in) PAR softwood	Cut to fit

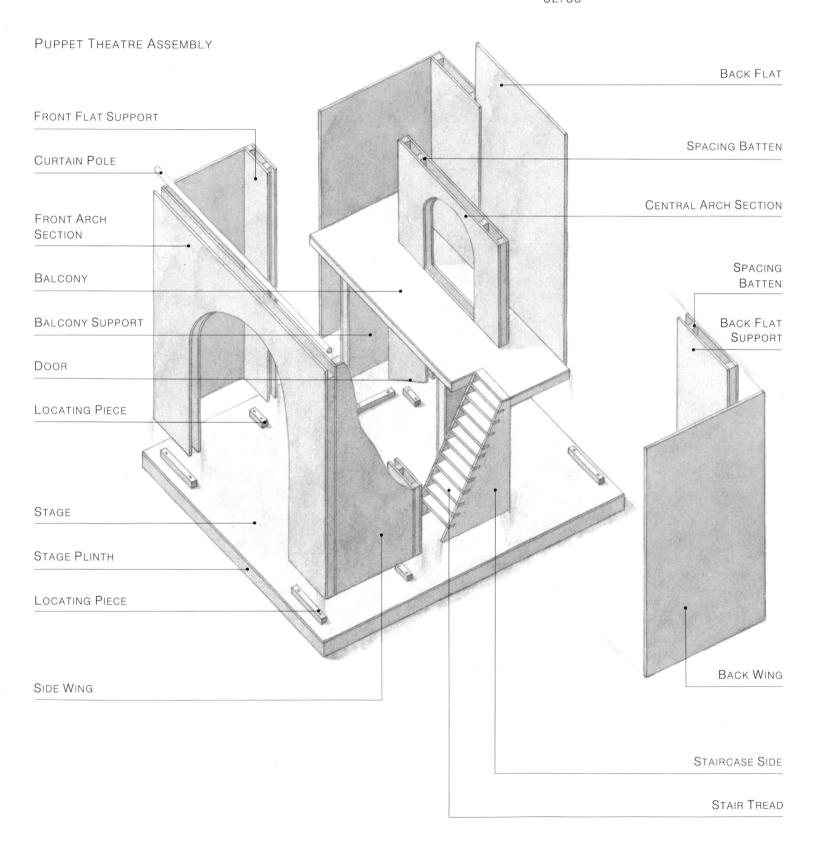

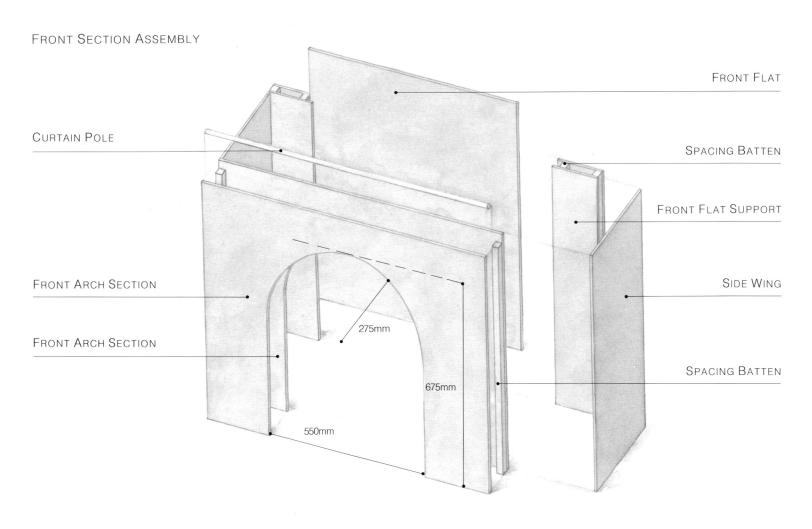

FRONT SECTION

Cut out all of the plywood pieces required for the front section.

On one of the plywood panels for the front arch section, mark out the arch centrally so that it is 550mm ($21\frac{3}{4}$ in) wide and 675mm ($26\frac{1}{2}$ in) high, leaving 125mm (5in) of plywood above the top of the curve. Mark out the curve so that it has a radius of 275mm ($10\frac{7}{8}$ in).

Cut out the arch using a jigsaw. Transfer the outline to the other front panel and cut it out; alternatively, cramp the two panels together and cut both pieces simultaneously.

Cut two spacing battens 780mm $(30\frac{3}{4}\text{in})$ long, then glue and pin them between the two arch panels, flush with the side and bottom edges (see Front Section Assembly). This leaves space for the curtain pole to sit on top of the battens and the curtains to be drawn back.

Cut four spacing battens 800mm (31½in) long, and glue and pin two between each pair of front flat support panels. One batten is flush with the edges of the plywood, the other is 20mm (about ¾in) in from the opposite edges to allow the front flat to slot in place (fig 1). The flat can be painted both sides to allow different scene changes.

SIDE WINGS

The two side wings are attached to the front arch section and the two front flat supports with long canvas hinges (fig 2). This allows the side wings and front flat supports to be folded flat against the front arch section for packing away. Cut four strips of canvas 800mm (31½in) long. Using fabric adhesive, glue two of these to the insides of the front arch section and the side wings so that the sides are flush with the edges of the front section. Glue the other two strips to the outside of the side wings at the back to join them to the front flat supports.

CURTAIN POLE

The curtain pole is a 1000mm (39in) long piece of dowelling that rests on top of the spacing battens in the front section (see Front Section Assembly). Once the curtains have been made and threaded on to it, the dowel can be pinned in place down into the batten at both ends.

CENTRAL SECTION

Cut out all the plywood pieces for the central arch section, including the central flat, the balcony and the balcony supports. Cutting curves 119

PLAYROOMS

Puppet Theatre
84/85

On the central arch section, two cut-outs are required for doorways (fig 3). On one of the arch section plywood panels mark out the lower doorway and top arch centrally, 250mm (10in) wide. Mark the lower doorway 300mm (12in) high. For the top arch mark the base line 405mm (16in) up from the bottom and 355mm (14in) high. The radius of the top curve is 125mm (5in), leaving 40mm (about 1½in) of plywood above the arch (fig 3).

Cut out the doorway and arch using a jigsaw, then use the cut-out panel as a template to transfer the marks to the other panel; alternatively, cramp the panels together and cut out both pieces simultaneously. Keep one of the lower door cut-outs to make into a pair of doors for the lower doorway later on.

From 25×25 mm (1 × 1in) PAR softwood, cut four lengths of spacing batten, each 800mm (31½n) long. Glue and pin these between the two plywood arch panels, one down each long edge, and one 20mm (about ¾n) in from each edge of the doorway cut-outs (fig 3).

Front Flat Supports
Position spacing battens; one flush with panel edges, the other inset 20mm (3in) from opposite edges.

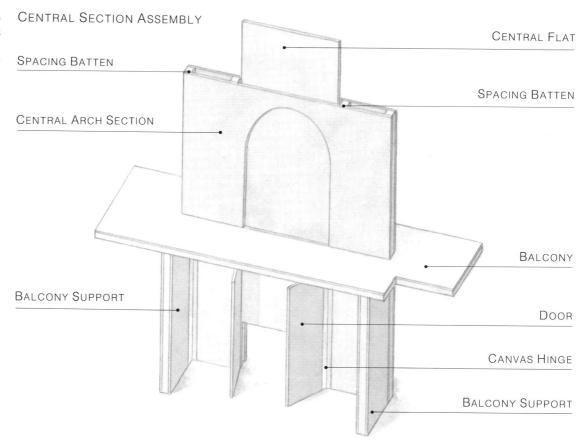

2 Hingeing the Front Section

Above left Fabric hinge inside face of side wings to back of front arch section.

Above right Fabric hinge outside face of side wings to outside edges of front flat supports. Below Plan view shows how front section folds flat for storage.

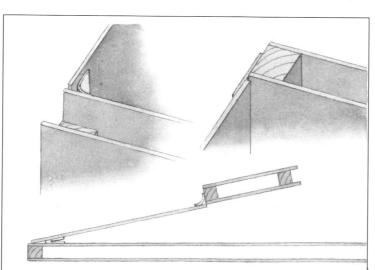

Central Arch Section

Make cut-outs for two doorways; cut
both central arch panels and join
using four spacing battens.

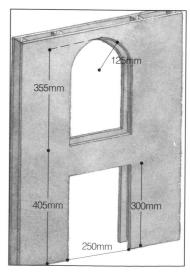

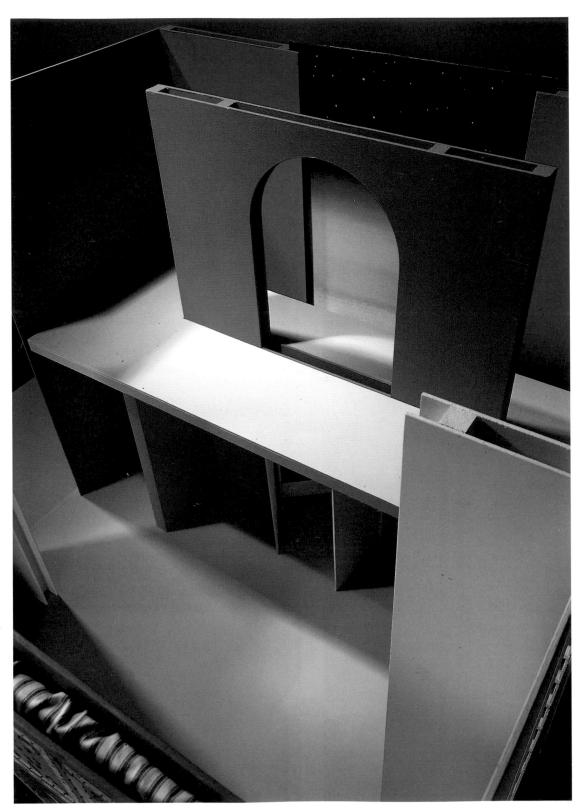

BALCONY SUPPORTS

Cut four spacing battens, 400mm (15\frac{3}{4}in) long. Glue and pin these between the balcony support pieces, flush with both edges (fig 1).

Make hinges for the supports by cutting two lengths of canvas, 400mm ($15\frac{3}{4}\text{in}$) long. Fabric-hinge the supports to the front of the bottom half of the central section so that each support is flush with an outside edge (fig 1).

DOUBLE DOORS

Saw one of the lower door cut-outs in two lengthways to make a pair of doors. Make hinges for the doors by cutting two lengths of canvas 300mm (12in) long. Fabric-hinge the doors to the front of the central section on either side of the lower opening (fig 2).

BALCONY

The balcony needs a cut-out on the front right-hand corner to take the staircase. This cut-out should be $155 \text{mm} \ (6\frac{1}{8}\text{in})$ wide and $100 \text{mm} \ (4\text{in})$ deep (fig 3, above).

Balcony Supports
The balcony support pieces are fabric hinged to central arch section flush with outside edges.

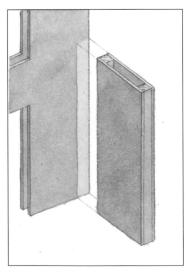

Sawing	118	
Drilling	120	
Nailing	120	
Butt join	t 123	

PLAYROOMS

Puppet Theatre

86/87

The central arch section fits into a slot cut into the balcony. This slot measures 602mm (24½n) long and 30mm (1¾n) wide, and is situated centrally on the length of the balcony panel and 193mm (7½n) back from the front edge (fig 3, above). It is important that the slot is precisely positioned, so double check your markings before cutting out. Cut out the slot using a jigsaw after first drilling a couple of holes for the blade to go through.

Turn the balcony upside down. Cut lengths of $25 \times 25 \text{mm} (1 \times 1 \text{in})$ PAR softwood to go all the way around the edges of the balcony on the underside and across it, then glue and pin these in place (fig 3, below). These balcony stiffening pieces strengthen the floor.

Cut two locating pieces from the 25×25 mm (1 × 1in) PAR softwood, about 130mm ($5\frac{1}{8}$ in) long; these will fit into the cavities at the top of the two balcony supports (fig 1). To position these pieces, slot the balcony over the central arch section, turn the assembly upside down, and draw around the

Adding the Doors

Make a pair of doors from one of the lower cut-outs; fabric hinge them to the central arch section.

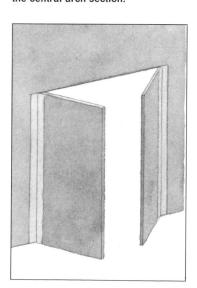

balcony supports to mark their positions on the underside of the balcony. Remove the balcony and position the locating pieces centrally in the marked positions. Glue and pin them in place.

CENTRAL FLAT

Cut an 800×290 mm $(31\frac{1}{2} \times 11\frac{1}{2} in)$ plywood flat to fit into the central arch section. This can be painted to depict views through the doorway and arch – again, paint both sides of the flat to give a different change of scenery on each side.

STAIRCASE

Cut out the back panel, the two sides and 12 stair treads following the dimensions given in the Materials chart (page 82). The height of the staircase should be to the balcony level, allowing for a 4mm $(\frac{3}{16}\text{in})$ thick tread which sits on the top of the staircase sides.

Cramp the staircase side pieces together and cut them diagonally through their length so that they are 25mm (1in) wide at the top and 250mm (10in) wide at the bottom.

Mark out 11 equally spaced slots for the treads along the diagonal edge. These should be parallel with the base of the side section and should measure $30\text{mm} \left(\frac{3}{16}\text{in}\right)$ long and $4\text{mm} \left(\frac{3}{16}\text{in}\right)$ wide to take the stair treads. The top tread simply sits on top of the staircase (fig 4).

To make it easier to cut out the slots, drill a 4mm $(\frac{3}{16}\text{in})$ diameter hole at the end of each slot, then cut down each side of the slot using a tenon saw if working by hand, or using a power jigsaw. To cut exactly matching slots, which is important if the stair treads are to be level, cramp both side panels together, one on top of the other and cut out the slots at the same time.

Glue and pin the back panel in place between the two sides, flush at the back. Glue and pin the top tread in place, then glue and slide in the bottom one, using PVA (polyvinyl acetate) adhesive. Allow the glue to set, then glue and slot in all the other treads, keeping a tight fit for maximum strength. When dry, sand down the ends of the stair treads flush with the side panels.

Making the Balcony

Above Measure accurately for cut-outs in middle to take central arch section and in right-hand corner for staircase. Below Add battens to underside of balcony for strength, plus two locating pieces to fit in balcony supports.

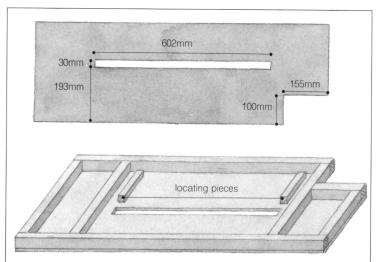

BACK SECTION

Cut out from the plywood the back flat, the four back flat support panels and the two back wings following the Materials chart (page 82).

Cut four lengths of spacing batten 800mm (31½in) long and make up the two back flat supports in the same way as the front flat supports, with the battens sandwiched between the panels. Two battens should be glued and pinned flush with the outer edges of the panels, and the other two should be set 20mm (about ¾in) in from the inner edges to form a slot into which the back flat will slide.

Fabric-hinge the two back wings on to the back flat supports (fig 1, page 88) so that they can be folded either way to allow use of both sides for scene changes, and to allow the section to fold flat for storage.

Cut the back flat 800mm (31½n) high and 440mm (17¼n) wide to fit between the flat supports. Again, this flat can be painted on both sides with different scenes.

4 Making the Stalrcase
Glue and pin the back between the
sides. The top stair tread sits on top,
the others slot in place.

BASE SECTION

Cut out this section to form a stage 1040 mm (41 in) square. This will be large enough to allow about 20 mm ($\frac{3}{4} \text{in}$) all around the theatre when all the pieces are in place.

For the stage plinth, we used 50×25 mm (2×1 in) PAR softwood. This is fixed to the underside of the stage, flush with the edges all the way around and across the middle to act as strengthening (fig 2). Cut two battens to the full length of the stage to fit flush along the front and back edges. Cut three more battens to fit exactly between these first two lengths - two to fit flush along the sides, and the third to sit mid-way between them. Finally, cut four lengths of batten to fit flush between the battens at the sides and the batten half way across.

Glue and nail up the strengthening framework of battens, then glue and pin the stage panel on top, securing through the plywood into the timber framework.

Sand all of the edges flush.

Hingeing the Back Section Above Fabric hinge back wings to back flat supports on the outside.

Below Plan shows back folded flat.

LOCATING PIECES

These lengths of $25 \times 25 \text{mm}$ (1 × 1in) battens are positioned on the base section to hold the front, central and back sections in place (see Puppet Theatre Assembly, page 83). Cut the battens to lengths that will allow them to fit loosely inside all of the box sections that will be standing on the base.

To position the locating pieces, stand the three sections in place on the base with roughly 20mm (3in) lip all around. Make sure that the stage plinths that run to the full length are positioned at the front and the back, since the front plinth will be visible to the audience. Either mark around the box section on to the base using a pencil, or measure in for their positions. Remove the sections, and mark the positions for the locating pieces, allowing for the width of the plywood of the box sections and for the spacing battens. Then glue and screw the locating pieces in place, and check that they are correctly positioned by repositioning the front, back and central sections.

FINISHING OFF

For a really splendid, theatrical look, it is worth spending that extra bit of time making sure that you get the details just right.

CURTAINS

For curtains that pull across, allow one and a half to twice the width of the arch, divided into two to make two curtains. The width for the curtains depends on how thick the fabric is as you will probably want the curtains to pull back completely into the sides of the arch section. Allow extra fabric on the sides for turning and neatening the edges, and about 75mm (3in) on the length to allow for a hem at the bottom and turning over at the top to take the curtain pole (fig 3).

Cut out the fabric and hand- or machine-stitch the sides and hem. Turn over the top edge to make a casing, and thread the curtain pole through. Place the pole across the front arch section and pin it down on to the battens at both ends.

For decorative effect, you could tie the curtains back, leaving them in full view as shown in the photographs (opposite). We have also glued a remnant of fabric at the top of the arch for a pelmet.

PAINT EFFECTS

We painted the flat supports and wings of the theatre in bold, contrasting colours. The front of the theatre, however, shows just how spectacular the finished effect can be. The paint is applied in quite an impressionistic fashion, and the details then inked in with a black marker pen. This is undeniably ambitious, and you may not think your own skills can match those shown here. You can still attempt a fair imitation, however: the design consists of a series of boxes and panels, and it would be relatively straightforward to paint these in over a background colour, and then to add a few details.

On the flats, a field of grass, a beach or a sky at night can all be depicted with as much or as little detail as you choose.

3 Adding the Curtains
Turn over the top edge of the
curtains to make a casing through
which to thread the curtain pole.

Giue and nail $50 \times 25 mm$ (2 × 1in) strengthening battens around the perimeter of the underside of the stage, another across the middle, and four more to fit between the side and middle battens.

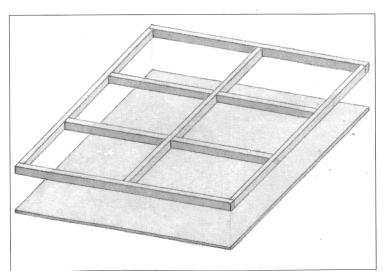

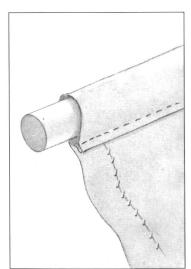

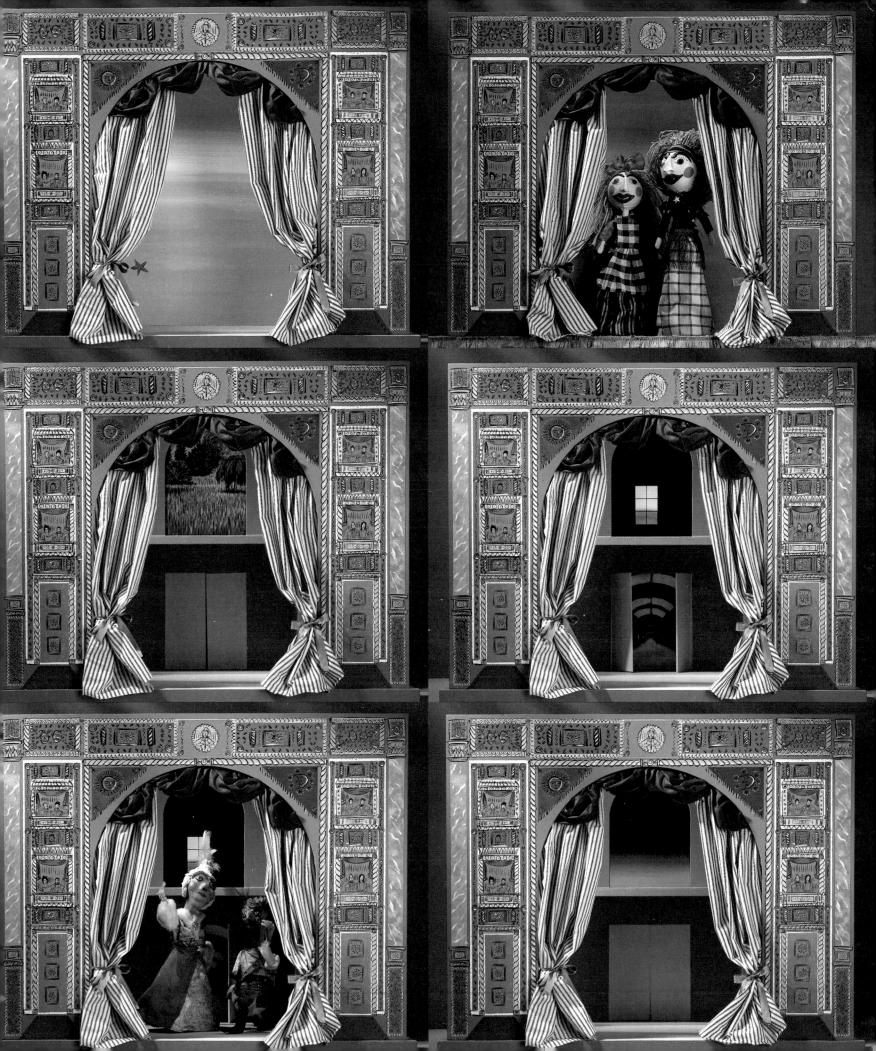

BLACKBOARD SCREEN

This blackboard screen is just the job for encouraging self-expression. Presented with the screen and a handful of coloured chalks, no child will be able to resist drawing or writing on it. It is an entertainment and educational aid rolled into one.

The beauty about making your own board instead of simply buying one is that it can be far, far bigger and so much more appealing to young eyes. By linking three boards together, you can create a screen with half a dozen surfaces which can be used to hide clutter quickly at the end of playtime.

A maximum safe height for the screen is about 1220mm (48in). Anything much taller encourages smaller children to climb on to furniture in order to reach the top.

Also, a height of 1220mm (48in) is convenient and economical as it can be cut from a 1220mm (48in) square sheet of medium-density fibreboard (MDF). Three screens can be cut from the width, each being 400mm (16in) wide. Of course, you can make any size screen you prefer.

The hinges you choose will dictate the thickness of board to buy, so buy the hinges first, checking with the manufacturer's advice, then buy the boards. Use three hinges between each pair of screens. Cabinet hinges are usually used with a minimum board thickness of 15mm (\$\frac{5}{8}in\$). These are face-fixed so you don't have to cut hinge slots. Screen hinges enable the screens to be folded in any direction for flexibility (fig 1). They are usually used with boards 25mm (1in) thick.

Paint the boards with two coats of blackboard paint before you fix the hinges. It is quick-drying so the coats can be applied soon after each other – check the manufacturer's instructions for precise times, but allow 24 hours after the second coat before use. Blackboard paint is available in fairly small quantities so there will be little waste.

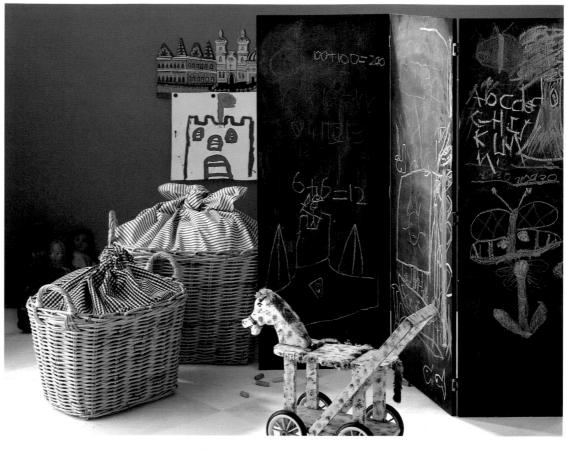

SCREEN TEST

Painted in bold colours on the other side, the screen will instantly hide a messy corner.

The screen is free-standing but a base can be added. This is important if children are going to use the blackboard element, since the pressure they exert when chalking may tip the screen over.

A simple base can be made by screwing a pair of 50mm (2in) square battens to a 25mm (1in) thick base of chipboard or MDF for each board of the screen. The gap between the battens should be very slightly greater than the thickness of the boards so that they slot comfortably into place but are held firmly (fig 2). The detachable bases allow the boards of the screen to be folded flat when not in use.

Fitting the Hinges
Screen hinges screwed to the edges
of adjacent boards enable screen to
be folded in either direction.

2 Detachable Base Screw a pair of 50 × 50mm (2 × 2in) battens to a piece of board so that screen will slot firmly in place.

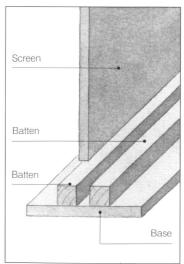

TRUCK DESK

PLAYROOMS
Truck Desk
90/91

The neat thing about this attractive truck desk is the small amount of wall space it takes up, and the compact 'box' it forms when closed in which to tuck away homework and reference books when not in use. The wing mirrors also let you see who's coming up behind!

The basic desk unit is made from 12mm ($\frac{1}{2}$ in) medium-density fibreboard (MDF) or plywood, with 18mm ($\frac{3}{4}$ in) thick MDF or plywood used for the drop-down writing flap, and 150 × 38mm ($6 \times 1\frac{1}{2}$ in) planed all round (PAR) timber for the tyres and back of the cab. The whole unit is 1250mm ($49\frac{1}{4}$ in) high and 900mm ($35\frac{1}{2}$ in) wide. When closed it protrudes 268mm ($10\frac{1}{2}$ in) from the wall; with the writing flap down it protrudes 618mm ($24\frac{1}{4}$ in).

The writing flap measures 900×400 mm ($35\frac{1}{2} \times 15\frac{3}{4}$ in); it is the same width and height as the desk unit which is 180mm (7in) deep. It is open topped, with a shelf 100mm (4in) beneath the top edge.

The tyres and cab sections are fixed to the wall first. They are cut to a length of 1250mm (49¼in) and

Forming the Back Cut-outs Cut the tyre and cab sections from 150×38 mm $(6 \times 1\frac{1}{2}$ in) to dimensions shown and screw to wall.

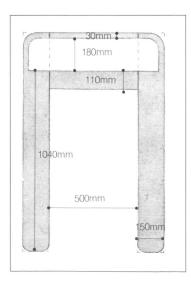

shaped at the top to form the driver's cab (fig 1). The top of the cab is a $38\text{mm}\,(\,1\frac{1}{2}\text{ln}\,)$ wide strip of timber cut from a $500\text{mm}\,(\,19\frac{3}{4}\text{ln}\,)$ length of $150\times38\text{mm}\,(\,6\times1\frac{1}{2}\text{ln}\,)$ timber. The rest of this piece, approximately $110\text{mm}\,(\,4\frac{3}{4}\text{ln}\,)$ wide, forms the lower edge of the cab rear window.

The desk section is made up as shown (fig 2). The desk unit is screwed to the cab uprights so it just covers the bottom of the cab rear window. The writing flap is grooved on its front face to look like planks, and has two $400 \times 75 \times 12$ mm ($15\frac{3}{4} \times 3 \times \frac{1}{2}$ in) battens fixed to it to represent a tail gate. It is hinged to the lower edge of the desk unit and is secured with two short chains so that it opens level.

The final embellishments to add (all from 12mm [$\frac{1}{2}\text{in}$] MDF) are a chassis piece fixed to the wall under the desk unit; an axle fixed 300mm (12in) up from the floor; a 130mm (5in) diameter disc planted on the axle to represent the differential case; two mudguards; rear lights; and wing mirrors. Lastly, glue a cutout of the driver in the cab.

Forming the Box Section
Use 12mm (½in) board to make a box;
fit the top 100mm (4in) down from
the top edge of the back section.

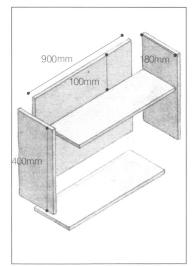

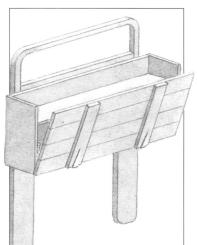

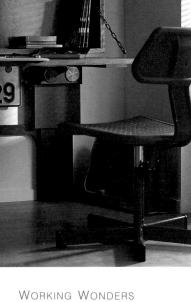

WORKING WONDERS

Homework might get done less reluctantly if a space is set aside and decorated with a witty touch.

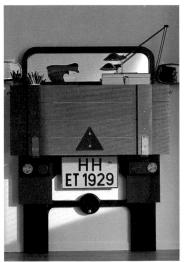

OUTDOORS

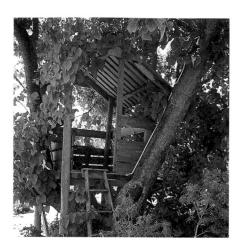

However much space you have, no house is big enough to contain all of a child's prodigious energies. Children need to play outdoors as well as in; they need that sense of physical freedom, distance and space. In outdoor play children find ways of testing their strengths and skills to the limit; in sports and team games they learn co-ordination and co-operation.

But a garden is more than just a place where children can kick a ball around. This relatively protected environment provides the child's first contact with nature and growing plants. Here children can learn other skills, such as how to plan a flowerbed, how to grow vegetables or take care of animals, and take their first steps in understanding the world around them.

Each changing season can bring fresh excitement and entertainment for a child playing in a garden. From building snowmen in winter and watching sapplings grow in spring, through playing in a paddling pool in summer to catching falling leaves in autumn—the distractions that play outdoors can offer are endless. And apart from being healthy, lots of fresh air tends to tire children out, which is an added bonus for parents!

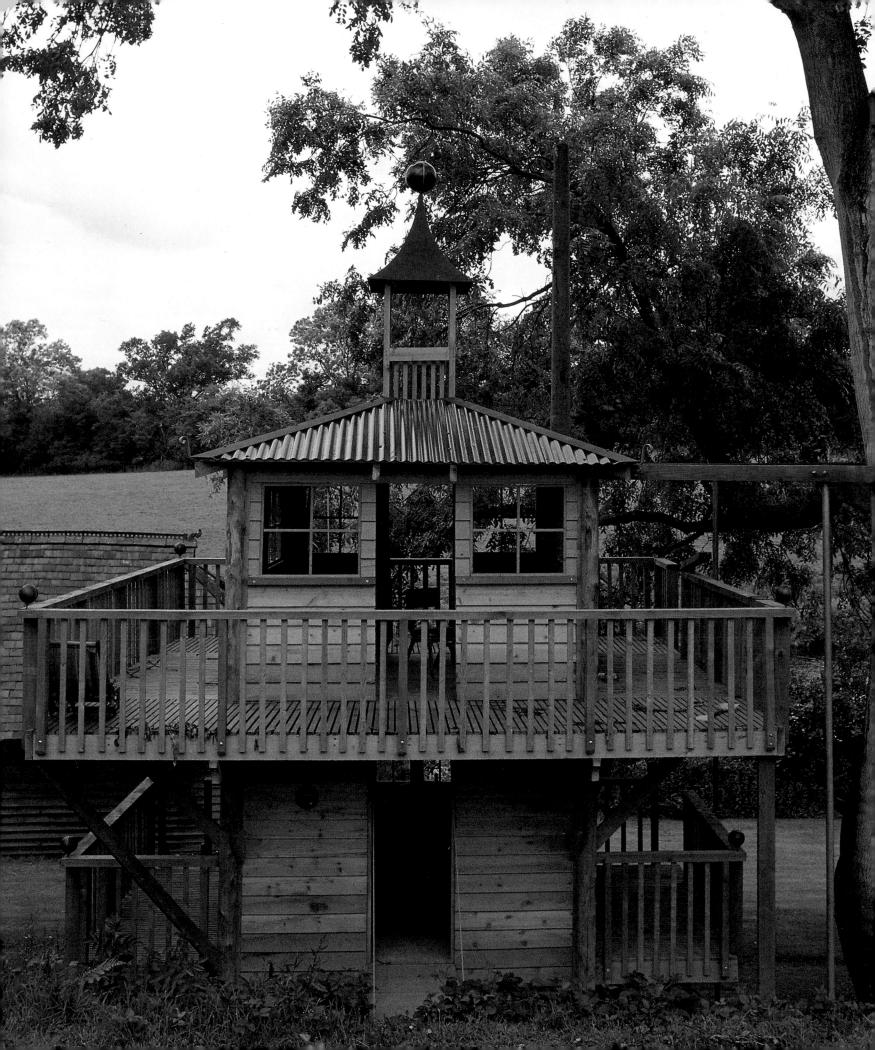

OUTDOORS

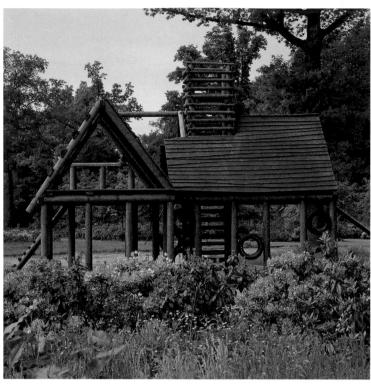

PLAY STRUCTURES

Ingenuity and imagination are just as important in the design of outdoor play facilities. A simple arrangement of stout rope ladders and swings offers the opportunity for children to try out their skills and test their strength, yet does not look glaringly out of place in the garden (above). This superb logcabin play house - half open and half enclosed - has great potential for exploring and make-believe (above right). The witty amusement-park theme of this animal play house, with wild cat slide and giraffe and deer buttresses, makes it irresistible to children (opposite above left). Thick slices of tree trunk are stacked up to make a castle, linked with tree-trunk steps to a drawbridge over a garden stream (opposite above right).

Safety is a key consideration in planning outdoor play areas. Each year, many thousands of children are hurt in accidents that take place on play equipment in their own gardens. It must be every parent's responsibility to ensure that such equipment is sturdy and securely anchored, that surfaces are as safe and impact-absorbent as possible, and that children are well supervised, particularly when playing near water or on structures where they can climb high off the ground.

At the same time, an obsession with safety can be counter-productive. Children who grow up over-protected, without the chance to explore the boundaries of their abilities, are especially vulnerable and through ignorance may take risks in situations where a more experienced child would be wary. Through outdoor play children are able to develop levels of confidence and skill which enable them to meet new experiences safely.

OUTDOOR PLAY

With a little planning and some basic training, adults and children can enjoy the garden together. As is the case indoors, making positive, well-defined play areas will help to prevent children from taking over completely and overrunning those parts of the garden where adults want to sit and relax. Most gardens have potential play areas: an overgrown corner or a neglected patch can provide the perfect spot for children to build a fort or hide out in a secret den. To one side of a terrace, under a pergola or awning, is a good position for a sandbox or sandpit; in poor weather children can still play outside if there is a partially covered area adjacent to the house. Pitches for games should be set out away from flowerbeds full of cherished horticultural specimens and far enough from the house to minimize the risk of a stray ball smashing a window.

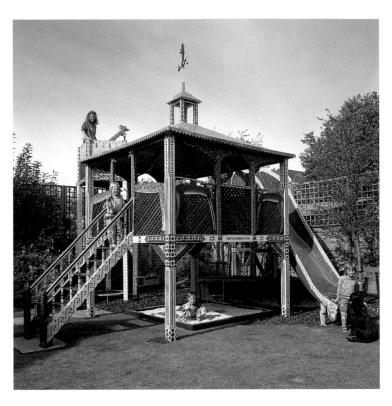

In the same way, children will learn to appreciate your gardening efforts if they have a plot of their own. A vegetable patch, a flowerbed, or even a large container full of spring bulbs will provide the means of introducing them to the pleasures of growing plants. Choose relatively quick-growing species for them to tend, so they don't get too impatient waiting for the results: raising sunflowers, marrows and runner-beans gives children immense pleasure. The garden is also the ideal place for observing local wildlife. A shallow pond, visited by frogs and teeming with goldfish, will give hours of rewarding nature study. Putting up birdtables and nesting boxes will encourage birds to visit your garden.

Children don't need huge, complicated structures to enjoy the garden, but play equipment does help them to explore and to release pent-up energies. Swings, slides and climbing frames

should be set on a level grassy area or on bark chippings for soft landings, and well within view of the house so you can always keep an eye on things. It is also a good idea, space permitting, to have a paved area where children can ride bikes and skate or pull carts.

Sand and water provide young children with hours of amusement. Sandpits should be covered with a lid when not in use to keep animals from fouling them. Paddling pools, old basins or washing-up bowls full of water are great for splashy, messy games.

Children love to play in small, enclosed spaces. On ground level, you can pitch a tent, improvise a play house from a packing crate (making sure, first, that there are no rough edges) or build a play house from wood for a more permanent attraction. And a tree-house is one of the most magical of all childhood retreats; its appeal will last undimmed for years.

CLIMBING FRAME

Slide, swing, climbing frame, sandpit and make-believe house — this play structure will be the focus of hours of fun outside. A particular advantage of this structure is its adaptability. You can tailor the size of the frame to suit the amount of space at your disposal; you can vary the width or spacing of the bars; or go on to create a Meccano-like warren of interconnecting structures following the same basic theme. There is one proviso: the poles should not be required to span a greater distance than about 1.5m (5ft), otherwise they might crack.

Construction depends on a simple system of upright posts and poles. The poles are slotted through holes drilled in the posts and secured by screws at the side; probably the most difficult part of the making is ensuring that the holes are drilled accurately. The sandbox consists of overlapping boards at the sides; the 'roof', made of sheets of exterior-grade plywood, has the double purpose of helping to keep the sand dry in rainy weather and giving a suggestion of a play house. The slide platform and slide are also simple to make.

A key safety consideration is ensuring that the entire structure is anchored securely to the ground. There are various ways of achieving this, but one of the most straightforward is to use a post-hole borer to remove the earth and then to concrete the posts firmly in place. Round over the concrete to encourage rainwater to drain away from the posts. And because the frame will be left outdoors in all weathers, it is important to buy pressure-treated wood (treated pine is ideal) and to coat it thoroughly with preservative to prolong its life.

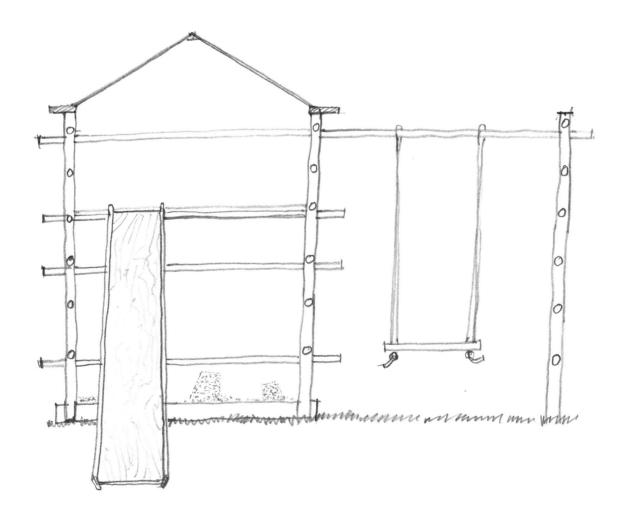

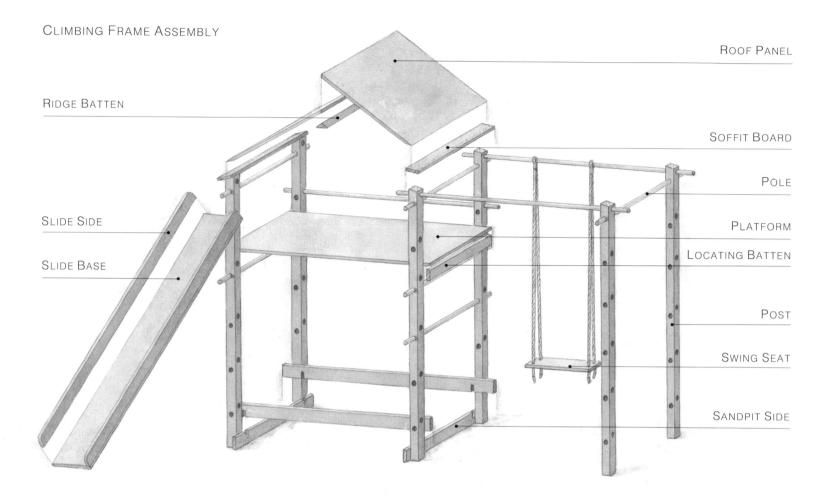

The design of this climbing frame encompasses something for children aged between about two and seven, so that more than one child in a family can play on it at the same time. For the very young there is a sandpit; the slide will keep older children occupied; and the 'house' created by the roof and platform above the sandpit will provide the perfect backdrop for hours of imaginative outdoor play.

The climbing frame *must* be made from pressure-treated timber and is finished with three or four coats of good-quality, exteriorgrade clear varnish. The unpainted finish allows the structure to blend

sympathetically with the garden. Before starting work, steep the ends of the posts that will be below ground in good-quality wood preservative for 24 hours.

This climbing frame is intended for use solely in a garden, since it must be concreted into the ground for stability. It should be sited on a flat area of lawn free of obstacles or hazards; if the lawn is liable to dry out and become very hard in the summer, you should dig a pit around the bottom of the frame and fill it with wood chips or another impact-absorbent material sold specifically for use in playgrounds to reduce the risk of injury.

The framework consists of six posts with holes drilled at intervals down their length through which horizontal poles, 35mm (1½in) in diameter, are slotted to form bars. The number of poles used is optional and their arrangement can be varied quickly and easily since each pole is held in place to the posts with 'locking' screws. These screws can be taken out at any time to release a pole. When poles are repositioned, it is essential always to replace the screws and tighten them. It is not necessary to use poles in every hole - gaps can be left according to the sizes and needs of the children using the frame.

The play platform, constructed from solid 18mm ($\frac{3}{4}$ in) plywood is secured to its platform with locating battens and turnbuckles.

The removable slide is located on to a supporting pole with two turn-buckles. It can then be taken down and stored when not required for long periods of time.

The swing should be suspended from the highest pole, with poles at the front and back of the swing omitted to allow unhindered movement. The height of the seat above the ground is determined by the age of the children for which it is intended and, subsequently, by the lengths of rope used.

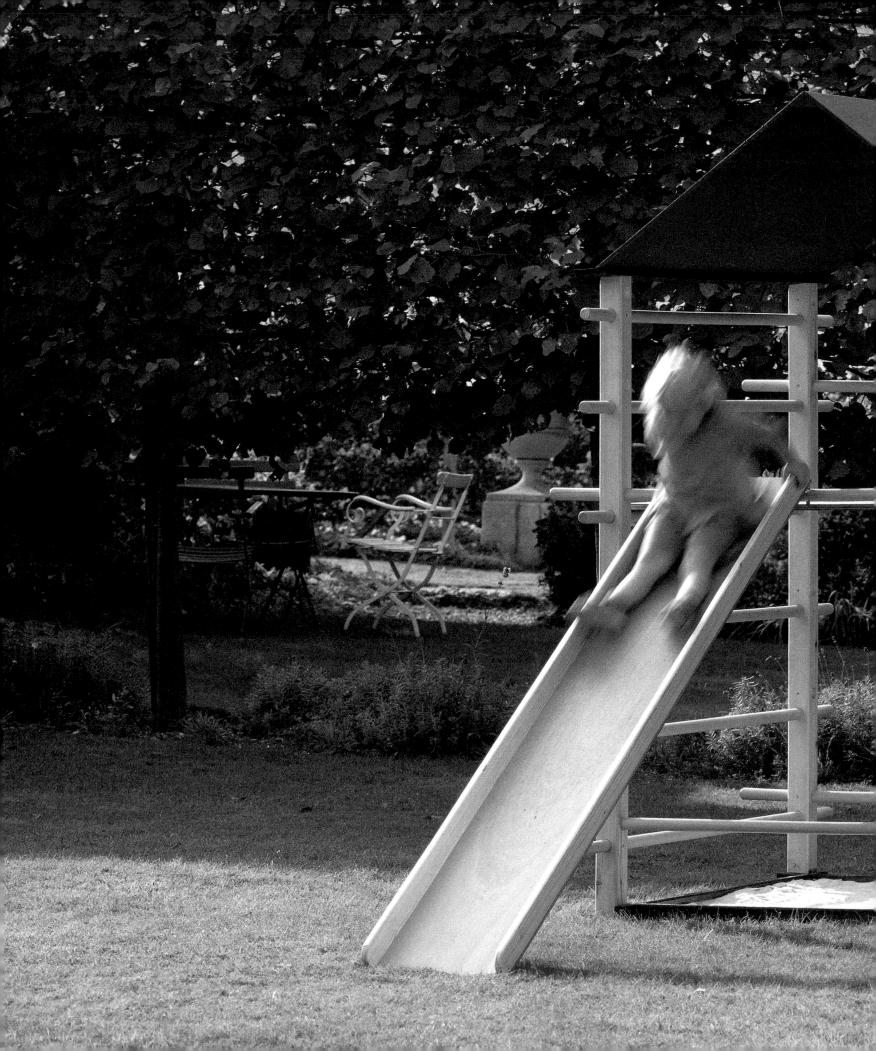

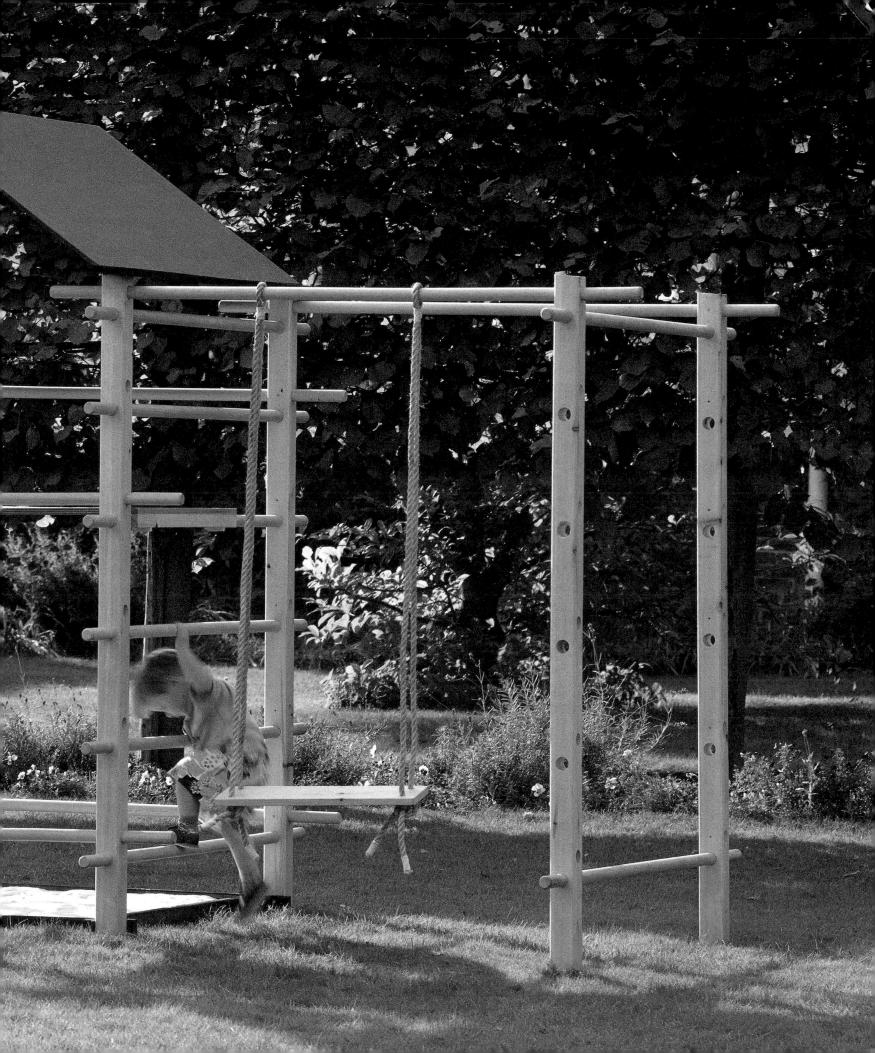

CLIMBING FRAME

Tools

TRY SQUARE

STEEL RULE

SLIDING BEVEL

POWER DRILL and drill bits

FLAT BIT or EXPANSIVE BIT

COUNTERSINK BIT

DRILL STAND

POWER PLANE (for chamfering)

POST-HOLE BORER or NARROW SPADE

SPIRIT LEVEL

SMOOTHING PLANE (hand or power)

POWER ROUTER and ROUNDING-OVER BIT

POWER FINISHING SANDER or HAND SANDING BLOCK

CONSTRUCTION

The construction of the frame is straightforward, the most arduous part being the digging of the holes for the six supporting posts. This can be done using a narrow spade, but a post-hole borer — a large, corkscrew-like tool obtainable from a hire shop — makes the task much easier. It is twisted back and forth to make the hole and lifted out to deposit the waste earth.

CUTTING THE POSTS TO LENGTH

Cut the six posts to length: 2.45–2.6m (7ft 6in–8ft) long, according to how high you intend the frame to be above ground. Remember that at least 750mm (30in) of each post should be sunk into the ground and concreted in place.

MARKING THE POSTS

Using a try square, draw a line on all four faces of each post, 750mm (30in) up from the bottom, to mark the earth-level once the posts are

erected. On one face of the post, mark hole positions at 300mm (12in) intervals above the earth-level mark (fig 1). Make sure that each mark is centrally positioned.

On an adjacent face, mark the first hole 240mm ($9\frac{1}{2}$ in) up from the earth-level mark. Then work up the post, marking off hole positions at 300mm (12in) intervals as before. This will ensure that the climbing bars are staggered on adjacent sides of the climbing frame (fig 2).

Mark the five remaining posts in the same way.

MAKING THE HOLES

Drill the holes through the posts using a 36mm (13mm) drill or an expansive bit. To ensure that each hole is at the centre of the post and is square to the verticals, use a drill stand or use a try square as a visual guide when drilling.

The holes for the locking screws are made in the faces of the posts adjacent to the pole holes. Each screw hole must align with the centre of each pole hole. Drill a countersunk clearance hole for a

37mm (1½in) No 10 woodscrew until the clearance hole meets the larger pole hole. Make sure all the locking screw holes are on what will be the inside faces of the posts.

ASSEMBLING THE FRAME

Cut 21 poles, 35mm (1¼in) in diameter and 1510mm (59§in) long; chamfer or round over the ends.

Assemble the posts and poles on site. At this stage, insert poles through the holes in the posts evenly all round the structure, even if you intend to omit or redistribute some later. Ensure that the locking screw holes are on the inside faces of the posts and position the poles so that they protrude by 75mm (3in) at each end of the posts.

With all the posts in position, insert the locking screws, driving each one half way through the poles to make the assembly rigid.

Mark out the six post positions accurately on the ground. Remove the frame and dig post holes about 100mm (4in) in diameter, using either a narrow spade or a post-hole borer. The holes should be 150mm

MATERIALS Mark ground level on each post and then mark off pole hole positions at intervals indicated.

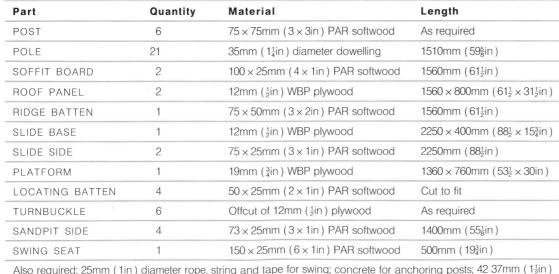

Also required: 25mm (1in) diameter rope, string and tape for swing; concrete for anchoring posts; 42 37mm ($1\frac{1}{2}$ in) No 10 woodscrews for 'locking' poles to posts

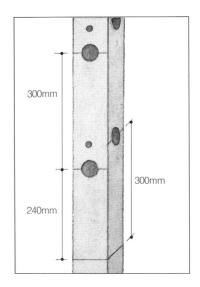

Marking	square	118	
Sawing	118		umboo
Drilling	120		
Screwing	g 120		

prevent the posts rotting.

the hardcore as required.

little water at a time.

Lift the framework into the holes.

Check the assembly is level and

plumb and that the marked lines are

all at ground level. If necessary,

remove the framework and adjust

Make up the concrete, using a

mix of sand, aggregate and cement

in the ratio 1:5:1. Wear gloves to

avoid the risk of burns. Pour the

ingredients on to the mixing area,

and turn it over with a shovel until it

is a uniform grey colour. Make a hole in the top of the pile and add a

Turn over the mix until the water is

absorbed, then add more water and

mix again to produce pliable con-

crete that is not too wet or sloppy.

hole, add a few pieces of broken

brick and tamp them down with a

stick so that there are no air pockets

Tip some of the concrete into a

(6in) deeper than the length of post to be buried, so in this case they will need to be 900mm (36in) deep. Place a 150mm (6in) layer of wellcompacted hardcore in the bottom that rainwater flows away. of each hole for drainage, and to

inserting all the locking screws.

chamfered to drain rainwater.

FIXING THE ROOF

Cut the two soffit boards to size. Along the underside of each, cut a 6×6 mm $(\frac{1}{4} \times \frac{1}{4}$ in) drip groove, 10mm (3in) in from the edge. Screw each one down into the tops of the posts where the roof will be.

Plane the top edge of each roof panel to an angle of 53 degrees and plane the bottom edge to an angle of 37 degrees (fig 3). Use a sliding

around the post. Fill the remaining 300mm (12in) of each hole with concrete, rounding it into a collar around the bases of the posts so

Allow the concrete to set, then arrange the poles as required.

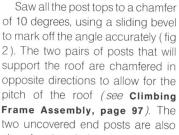

2 Assembling the Poles

Round over the ends of the poles and feed them through the holes in the posts so that they protrude by a maximum of 75mm (3in) at each end. Note top of post is chamfered at 10 degrees.

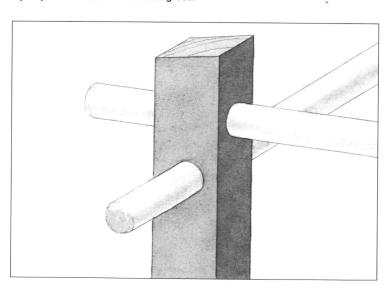

OUTDOORS Climbing Frame 100/101

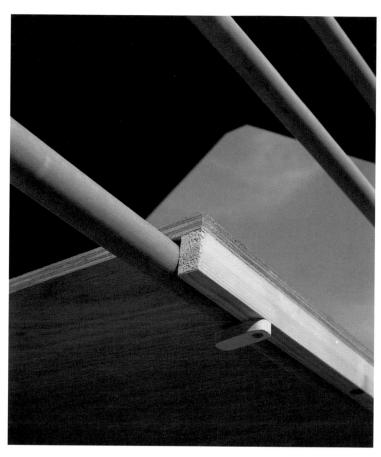

Making the Roof

Above Angle ridge batten as marked so that it will fit in apex of roof. Below Angle apex end of roof panel at 53 degrees and other end at 37 degrees. Glue and screw roof panels to ridge batten at apex.

CLIMBING FRAME

bevel to mark the angles. Mark out and cut the ridge batten to corresponding angles (fig 3, page 101).

Fix the two roof panels at the apex by gluing and screwing down into the ridge batten. Use 25mm (1in) No 8 woodscrews at approximately 300mm (12in) centres.

Place the assembled roof on to the soffits, check for alignment, then secure it by screwing upwards through the soffits into the roof panel edges. Use $37mm (1\frac{1}{2}in) No 8$ screws at approximately 300mm (12in) centres (fig 1).

SLIDE

Fix the sides to the base with waterproof, exterior adhesive and screw up through the base into the sides. Ensure that the edges are flush and use 37mm (1½n) No 8 countersunk screws at 400mm (16in) centres.

Round over all the edges and the corners of the sides at both ends.

The slide is anchored to the pole using battens and notched turn-buckles (fig 2). Cut two 50×25 mm (2 × 1in) battens to the width of the

1 Fitting the Soffit Board Screw soffit board down into top of post; then screw through board up into bottom edge of roof panel. slide. Screw the battens to the slide base, one at the top and the second about 38mm ($1\frac{1}{2}\text{in}$) down from the bottom of the first, so that the battens snugly enclose the pole of the climbing frame to which the slide will be attached.

Insert two screws into the lower batten, with about 38mm (1½in) of the threaded shank protruding. Saw off the screwheads and smooth the jagged points of the sawn ends.

Make two turnbuckles from $12\text{mm}\left(\frac{1}{2}\text{in}\right)$ plywood, cutting a small notch towards the bottom of one side so that they can be locked in place around the screws using a butterfly nut on each. Screw the turnbuckles to the top batten as shown (fig 2), as tightly as possible, but remembering that they must pivot. This method of anchoring gives a safe, secure fastening, but allows the slide to be removed and packed away if required.

Fill the screw holes in the base. Sand it and the sides thoroughly to ensure there are no splinters, then apply several coats of exterior-grade varnish to all surfaces.

When anchoring the slide for use, it must not be any higher than the fourth pole up, otherwise the gradient will be too great. Place an impact-absorbent gym mat at the base, with the back edge held in place underneath the slide.

PLATFORM

The platform can be positioned across any opposite pairs of bars. If the slide is in use, then the platform must be positioned across bars corresponding to the slide level to provide a means of entrance.

Cut the 18mm ($\frac{3}{4}$ in) plywood to size. Glue and screw a 50×25 mm (2×1 in) locating batten to each of the shorter sides of the platform panel, flush with the edges. Use three 37mm ($1\frac{1}{2}$ in) No 8 countersunk screws on each side. Sand the platform to remove splinters.

Cut out four turnbuckles, about 70×20 mm ($2\frac{3}{4} \times \frac{3}{4}$ in) from 12mm ($\frac{1}{2}$ in) plywood. Round over the ends and screw up into the underside of the locating battens, so that the turnbuckles pivot on the screws (fig 3). Varnish all surfaces.

SANDPIT

Remove the turf from the area of the sandpit and simply lay down concrete paving slabs. Butt the edges closely together. If the lawn is uneven, level it with sand. Lay a sheet of thick polythene on top of the slabs so that no vegetation or insects creep into the sand.

Cut the sides of the sandpit to protrude 25mm (1in) beyond the posts at each end. Position each side piece against the inside face of two posts and mark off on the side where it meets the inner corner of the posts. Cut cross-halving joints on the longer side of these marks (fig 4). Round over the top edges. Screw the sides to the posts using two 37mm ($1\frac{1}{2}$ in) No 8 countersunk screws at each end (fig 5).

If you want a greater depth of sand in the pit, either use wider boards or excavate the lawn to the required depth and use boards of sufficient width to rise 75mm (3in) above ground level. Fill the pit with special fine-grade sand available from toy centres.

3 Fitting the Platform
Glue and screw battens to edges of short side of platform. Add turn-buckles to hold platform in place.

Screw battens to the underside of the slide base so they enclose the pole. Screw turnbuckles to the top batten so that they pivot across to enclose sawn-off screws in lower batten and are held in place using butterfly nuts.

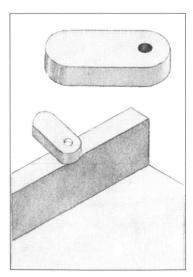

Sawing 118
Drilling 120
Screwing 120
Halving joint 123

OUTDOORS

Climbing Frame

102/103

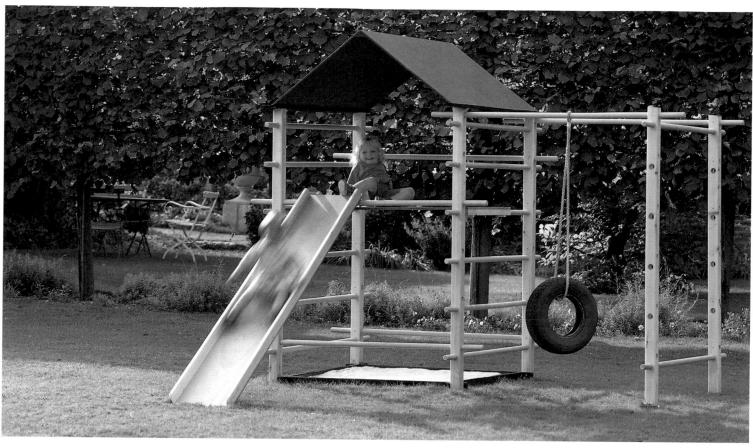

4 Making the Sandpit Sides Mark the inside post corners on the sandpit sides and cut cross-halving joints to join the sides.

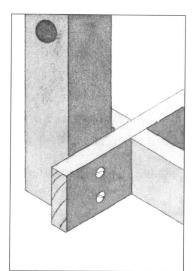

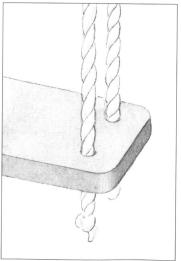

SWING

Drill two holes at either end to take 25mm (1in) diameter rope. Round off the corners and sand the seat smooth. Thread the rope through each pair of holes and tightly knot each end. Wind string at the top to form a loop and knot it firmly.

Feed one end of the pole through the post at the highest position, through the rope loops, and through the opposite post. Centre the swing between the posts, mark the rope positions, and remove the pole. Cut shallow V-shapes in the top of the pole at the rope positions, then feed it back in place. Insert the locking screws, position the ropes in the grooves and screw or nail them in place. Varnish the seat.

If you prefer, you could suspend a tyre from the rope instead.

CART

Children are always fascinated by forms of transportation – things to ride in or push, things to move from place to place. This handsome wooden cart with its elegant tapering shafts is inspired by the shape of an Austrian hay-cart and has a basic simplicity which allows room for the imagination. Chariot or truck, pram or wagon, it can be pulled or pushed, ridden in or filled with toys according to the demands and games of the day.

Certain aspects of the design make this one of the more difficult projects in the book. The body of the cart tapers inwards, which calls for some skill in the setting up and cutting of angles. Contrary to appearances, the curved shafts are not particularly hard to make; the shape can be easily cut out using a jigsaw, although the final shaping of the shafts with a spokeshave introduces an element of craftsmanship. The wheels, of course, are

bicycle wheels, finely engineered and remarkably cheap. Their elegant spokes are echoed in the design of the railed sides. Here, careful measurement and drilling are required to fit the dowels accurately.

The central seat can take two small children sitting side by side. Smartly painted, and with its gleaming wheels, the cart is light and easy to manoeuvre, and will prove as irresistable to play with as it is satisfying to make.

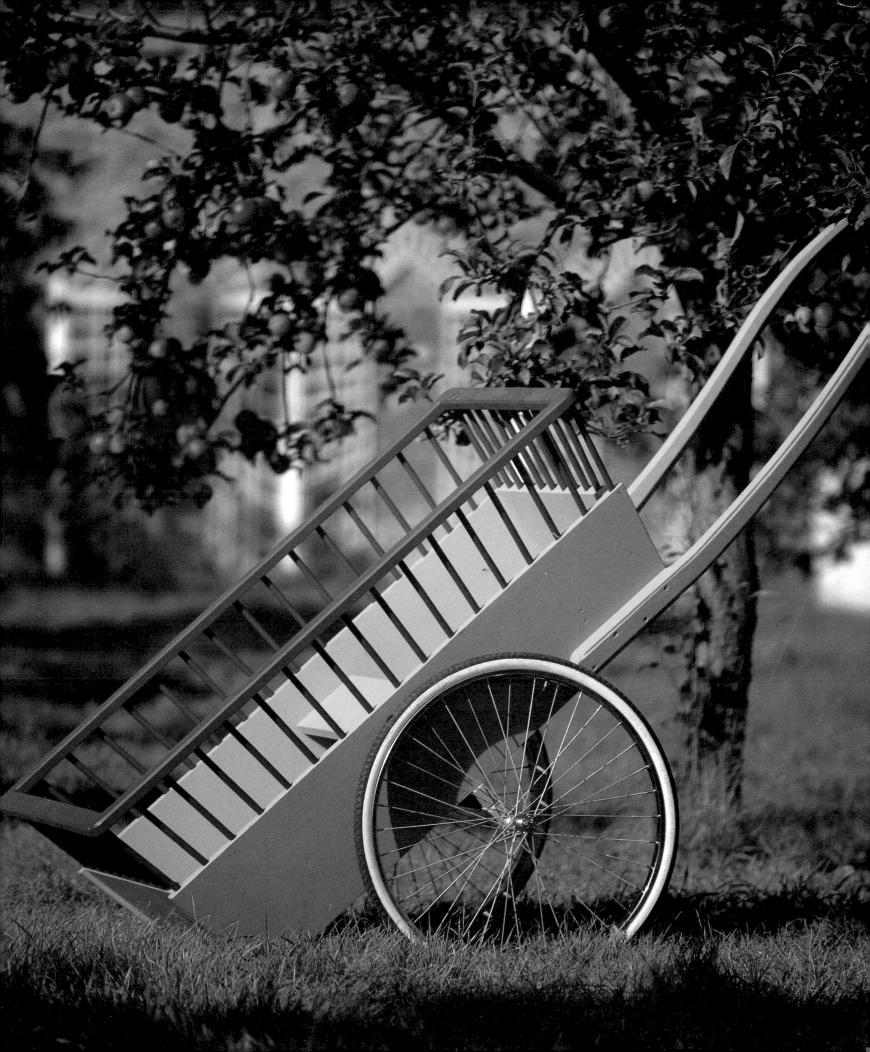

CART

Simpler to make than a peddlecar, and just as much fun, this cart makes a handsome toy for playing with in the garden. It is substantial enough to allow two small children to sit in it, but it would then require an adult to push it around. Softwood is relatively light and, unfilled, even quite small children will want to have a go at pushing the cart; however, they will have difficulty manoeuvring it, so you must supervise children when they play with this item. Stops could be fitted at both ends of the cart to limit the tipping action, especially when children are climbing in or out.

This cart is made to a traditional design using mostly PAR (planed all round) softwood, and two standard 610mm (24in) bicycle wheels. The side and end panels require 255mm (10in) wide, 32mm ($1\frac{1}{4}$ in) thick planed timber which may not be readily available. If this is the case, either buy wider timber - 300×32 mm $(12 \times 1\frac{1}{4}$ in) should be available - or buy two lengths of 32mm (11/4 in) thick planed timber to a suitable width (say two of 150×32 mm $[6 \times 1\frac{1}{4}in])$ and join them together by rub-gluing and cramping them to make up the required width. Both of these alternatives can then be cut down to size.

You will also need the assistance of two helpers to watch and guide you as you drill the angled holes for the dowels that form the cart's sides. These have to be accurately drilled to continue the splay of the cart.

TOOLS

WORKBENCH (fixed or port	able)
STEEL MEASURING TAP	È
MARKING GAUGE	
TRY SQUARE	
SLIDING BEVEL	
PAIR OF DIVIDERS (or cor	mpasses)
JIGSAW	
POWER DRILL	
DRILL BITS – 12mm (½in), provinces sizes for pilot holes	olus
COUNTERSINK BIT	
CIRCULAR SAW (or panel	saw)
SMOOTHING PLANE (har power)	nd or
BELT SANDER OF POWE FINISHING SANDER OF H SANDING BLOCK	
SCREWDRIVER	
ROUTER	
ROUNDING-OVER CUTT SPOKESHAVE	ER or
STRAIGHT CUTTER - 12n (or tenon saw and 12mm [½r	
SASH CRAMPS	
G-CRAMPS	
MALLET	
HACKSAW	
METAL FILE	

MATERIALS

Part	Quantity	Material	Length
SIDE	2	255×32 mm ($10 \times 1\frac{1}{4}$ in) PAR (planed all round) softwood	1120mm (44in)
END PANEL	2	As above	680mm (26 <u>3</u> in)
CENTRAL SUPPORT	1	25mm (1in) plywood	670×195 mm $(26\frac{3}{8} \times 7\frac{3}{4}$ in)
BASE SUPPORT BATTEN	4	25 x 25mm (1 x 1in) PAR (planed all round) softwood	Approx. 550mm (21¾in)*
BASE SLAT	18	50 x 25mm (2 x 1in) PAR (planed all round) softwood	Approx. 650mm (25½in)*
SEAT SUPPORT BATTEN	2	32×32 mm ($1\frac{1}{4} \times 1\frac{1}{4}$ in) PAR (planed all round) softwood	As above*
SEAT	1	150 × 25mm (6 × 1in) PAR (planed all round) softwood	As above*
SHAFT	2	From 225×38 mm $(9 \times 1\frac{1}{2}$ in) joinery-grade PAR (planed all round) softwood	1220mm (48in)
TOP SIDE RAIL	2	50×25 mm (2×1 in) PAR (planed all round) softwood	1190mm (47in)
TOP END RAIL	2	As above	805mm (313in)
DOWEL	52	12mm (½in) diameter dowelling	190mm (7½in)

OUTDOORS Cart

106/107

CART ASSEMBLY

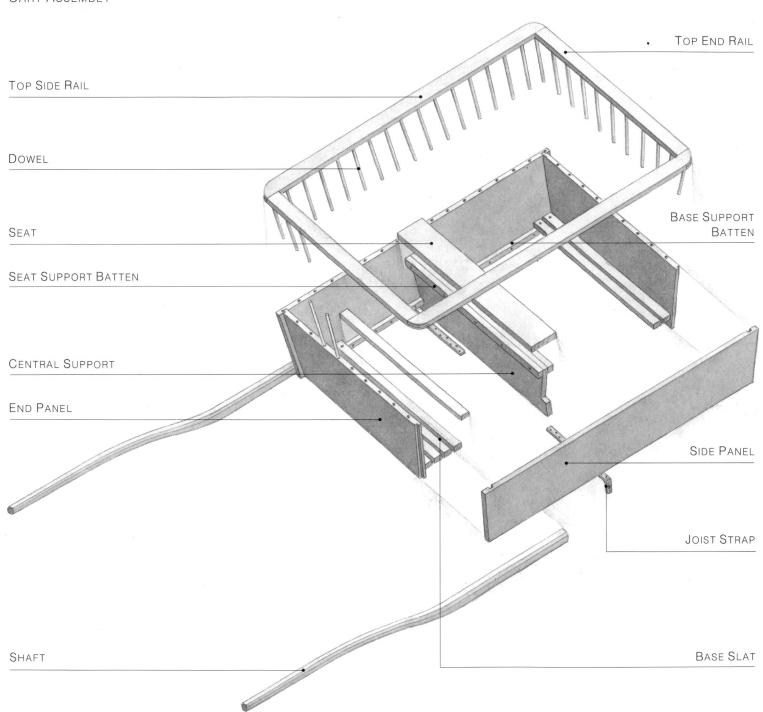

CART

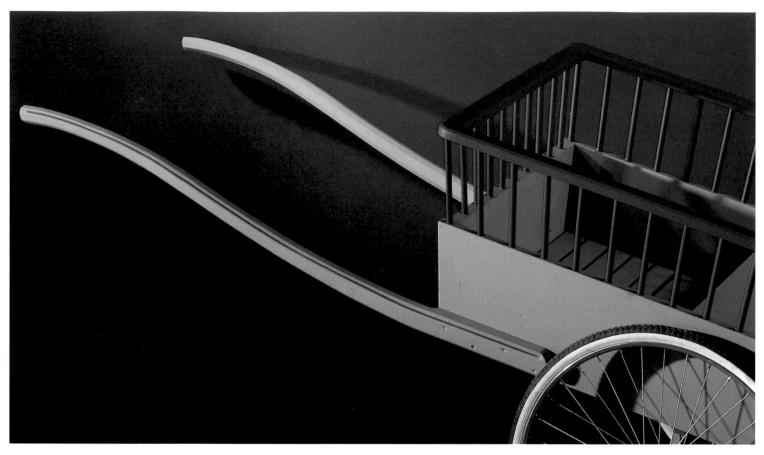

1 Shaping the Sides and Ends Above Angle ends by 10 degrees. Below Rout housings 35mm ($1\frac{3}{8}$ in) in from ends of side panels.

Rebating the End Panels Above Cut 12×6 mm ($\frac{1}{2} \times \frac{1}{4}$ in) rebates in end panels. Below Plan view of end rebated into side housing.

central support and draw around ends on to central support. Below Cut around marked lines on support to leave protruding tongues at base.

3 Shaping the Central Support

Above Centrally position an end panel 40mm (1½in) up from bottom edge of

35mm

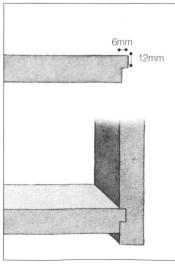

Drilling 120
Screwing 120
Housing joint 123
Rebates 123

OUTDOORS
Cart
108/109

THE BASIC FRAME

The side and end panels of the cart all slope inwards at the bottom. The end panels and central support slot into housings cut into the inside faces of the side panels.

Start by shaping the ends of the side and end panels. Using a sliding bevel, mark a 10 degree angle on the ends of each of these panels from the top (fig 1, above). Saw down these marked lines carefully.

On what will be the inside faces of the side panels, mark a line 35mm $(1\frac{3}{8}\text{in})$ in from, and parallel with, each angled end. Cut a housing 6mm $(\frac{1}{4}\text{in})$ deep and 12mm $(\frac{1}{2}\text{in})$ wide against each of these lines (fig 1, below). Use a router fitted with a guide fence and a 12mm $(\frac{1}{2}\text{in})$ straight cutter; alternatively, draw a second line, cut down it with a tenon saw and chisel out the waste.

On each end of the end panels rout or cut out a rebate to give a tongue 6mm ($\frac{1}{4}$ in) long and 12mm ($\frac{1}{2}$ in) wide so that the rebates fit tightly into the housing in each side panel (fig 2).

4 Housing for Central Support Mark height and width of central support midway along side panels. Rout housing to depth of 6mm (¼in).

CENTRAL SUPPORT

On the central support, mark a line 40mm ($1\frac{1}{2}\text{in}$) up from the bottom edge along the full length of the panel and parallel with the bottom. Centrally position one of the end panels along this line, with the tongues face down. Mark the angles of the end panel's ends on the central support, remove the end panel, and saw down the marked lines to remove the waste, leaving the 40mm ($1\frac{1}{2}\text{in}$) deep sections protruding at the bottom (fig 3).

The central support slots into housings cut midway along the side panels (fig 4). Offer up the central support to the mid-point of a side panel. Mark the length and width of the housing required on the side panel. Remove the central support and accurately mark the housing, checking that its width is exactly the thickness of the central support. Mark a housing for the central support on the inside of the other side panel at its mid-point. Rout or cut the housings to a depth of 6mm $(\frac{1}{4}\text{in})$ in both side panels.

ASSEMBLING MAIN FRAME

Assemble the sides, ends and central support using a waterproof woodworking adhesive. Ensure that the top and bottom edges are flush at the corners, and that the protruding sections on the central support are pushed up tight against the bottom edges of the sides (fig 5).

Hold the assembly together with sash cramps placed across each end and, ideally, across the middle, or use webbing cramps right around the frame. Check that the assembly is square, then leave it until the adhesive is dry.

BASE

Once the basic assembly is dry the base can be fitted. Measure the space between the central support and the end panels, 40mm (1½n) up from the bottom and cut the four base support battens to this length. One edge and one end of each batten will need to be chamfered at 10 degrees so that each batten fits neatly against the side panels (fig 6, above). Then glue, screw and

countersink each batten to the sides, with the top edge positioned 40mm ($1\frac{1}{2}$ in) up from the bottom edge of the sides.

For the base slats, cut one length to fit tightly across the frame, resting on top of the support battens (fig 6, below). This will require you to chamfer the ends by 10 degrees (as before) to fit. When the first base slat has been cut to fit snugly, cut the remaining 17 slats to this length, with the saw blade set to the correct angle for the ends.

Space the slats equally so that there are nine on each side of the central support. Glue, screw and countersink the slats down on to the support battens.

SEAT

Cut the two seat support battens to the length of the top edge of the central support, allowing for 10 degree chamfered ends as before. Drill and countersink holes on the side and underside of each batten and glue and screw to the central support so that the top edges are flush (fig 1, page 110).

Finished Assembly of the Basic Frame
Glue end panels and central support into housings cut into side panels.
Ensure that corners and edges are flush, and that protruding tongues of central support are pushed up against bottom edges of side panels.

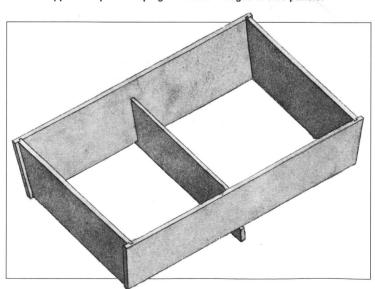

6 Fitting the Base

Above Chamfer edge of batten by 10 degrees to abut side panels. Below Screw base slats to support battens.

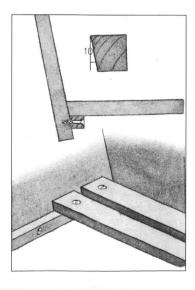

CART

Measure the width of the cart 25mm (1in) above the top of the central support and cut the seat to fit: do not forget that you will need to chamfer both of the ends at 10 degrees. Place the seat in position and screw up through the battens into the seat to secure it (fig 1).

Plane the top and bottom edges of the whole frame so they are perfectly horizontal.

SHAFTS

Both of the shafts can be cut from a single piece of 225 x 38mm $(9 \times 1\frac{1}{2}in)$ PAR (planed all round) joinery-grade softwood. Good-quality, knot-free timber is absolutely essential here for strength; knots would severely weaken the shafts.

Draw sweeping curves on the softwood to its full length and width so the two shafts can be sequentially cut (fig 2, above). Start the shaft at about 55mm (21in) wide, keeping straight for the first 250mm (10in) then curving and tapering to the thickness of the timber, about 34mm (13in), at the other end. Repeat for the second shaft.

Fitting the Seat Fit support battens along length of central support at top. Screw up through the battens into the seat.

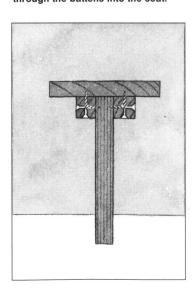

Cut out the shafts using a jigsaw. Mark off the first 250mm (10in), which will be fixed to the cart, and round over the corners at the back end (fig 2. below). Using a spokeshave, chamfer all four corners all along each shaft. Do not chamfer the inner corners along the 250mm (10in) fixing section. The shafts will now be octagonal in cross section at the handle end. Sand the faces of the shafts smooth.

Glue and screw the shafts to the sides of the base frame, with the bottom edges of the shafts positioned 10mm (3in) up from the bottom edges of the cart sides. Use four large screws in each shaft and countersink the screw holes.

TOP RAIL

The top side and top end rails are joined together with half-lap joints. which should be cut so that the side rails are lapping over the end rails (fig 3, above). Cut the joints and glue them up using waterproof woodworking adhesive, holding each joint together with a G-cramp until the adhesive has set.

Shaping the Shafts

Above Mark out both of the shafts on a piece of 225×38 mm ($9 \times 1\frac{1}{2}$ in) PAR and cut out using a jigsaw. Below Round over the corners and edges of the back end and screw to sides.

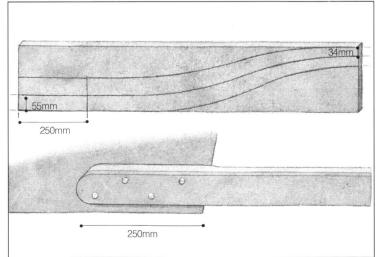

MARKING OUT DOWEL POSITIONS

Mark a centre line along the top edges of the base frame sides and ends, and on the underside of the top rail. Where the centre lines intersect are the centres of the four corner dowel positions.

Measure the distance between the centres of the corner holes along the top edges of the base frame and along the underside of the top rail. Divide these distances by 10 at the ends and by 16 at the sides. Set a pair of dividers or compasses to the calculated spacings to check there are no errors in the calculations, and mark the centre points of the dowel hole positions. The spaces will be wider on the top frame than on the bottom one. Make sure they are all marked out accurately before drilling.

DRILLING DOWEL HOLES

The dowel holes must be drilled accurately at the same angles as the cart sides and ends. This requires the assistance of two people. With the cart on a level surface, one person stands facing the side, and one facing the end. They can then eye up the drill as you work to ensure that the holes are splayed at the correct angle to follow the line of the cart. It will be easier if, as you drill each hole, you put a dowel in place (fig 4). Put a length of insulation tape around the drill bit at a depth of 8mm (3in) to ensure that all the holes are drilled to the same depth.

With the guidance of your helpers, repeat the procedure for the drilling of the top frame, which should be placed bottom side up on a flat surface. Again, insert the actual dowels as guidance for the correct alignment.

ASSEMBLING TOP FRAME

Check that all the dowels are exactly the same length. Put waterproof woodworking adhesive in each dowel hole in the base frame and in the top rail. Repeat this on top of the dowels and wriggle each one up in turn to locate them all halfway into the top rail frame. Gently tap the top frame down with a mallet so that all

Shaping the Top Rail Above Cut half lap joints so that side rails lap over end rails. Below Round over the corners.

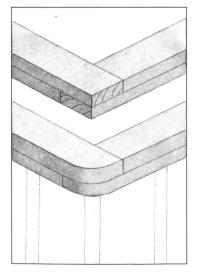

Planing 119
Drilling 120
Screwing 120
Halving joint 123

OUTDOORS

Cart

110/111

the dowels are fully home, top and bottom. Leave the assembly to dry.

Sand all the edges smooth, and, if required, plane them at an angle. Round off the corners of the top frame using a router fitted with a rounding-over cutter or using a spokeshave (fig 3, below). Chamfer the top outer edges.

FITTING THE WHEELS

Turn the cart upside down and cut the two galvanized angled joist straps to length using a hacksaw so that the two straps meet in the middle across the underside of the central support. The angles of the straps should protrude just beyond the outer ears of the central support to give a downstand of 65mm ($2\frac{1}{2}$ in) (fig 5). Use a hacksaw to trim off any excess strap and round off straight edges and corners with a file. Screw the joist straps to the underside of the central support.

Drill a hole in the downstand for the axle of the bicycle wheel to fit through. Tighten the fixing nuts to hold the wheels in place on each side of the cart.

4 Drilling the Dowel Holes Space dowel holes regularly along end and side panels. Drill holes at angle to follow line of cart frame.

With the cart turned upside down, screw two joist straps to the bottom edge of the central support. Drill a hole in the downstand of each of the straps to take the axle of the bicycle wheel.

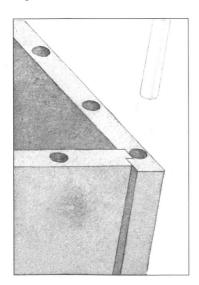

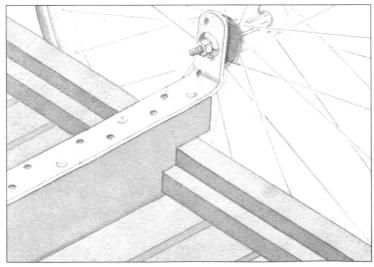

ROUND-THE-HOUSES GOLF

Here's a garden game for all ages which is simple to make, fun to play and can be used on any size of lawn. The 'targets' can be arranged in close proximity or spread wide apart to make things a little more difficult. Older players should be given a handicap to even chances.

The game consists of 18 'holes' of golf. The holes are completed by directing the golf ball through a doorway in a building, by driving the ball against a solid door so that it rebounds, (as in the case of holes No 4, No 10 and No 15), or by hitting a stake (holes No 6, No 9 and No 13). Hole No 11 incorporates an obstacle in the form of a ramp. After playing hole No 10, the ball must be driven up the ramp and through the opening in the house wall; once it has rolled down the other side, hole No 12 can be played.

The game is laid out as shown (fig 1). As can be seen, both the front and back of certain openings in the buildings are used as two holes. For example, hole No 2 backs on to hole No 17 and hole No 5 backs on to hole No 14. The course must be completed in numerical order, with each player taking one shot in turn. The player completing the course with the fewest number of strokes is the winner.

The game can be made more difficult by making each opening only slightly wider than the diameter of the ball being used.

The longer rows of houses are 1.2m (about 4ft) so the game can be stored away tidily indoors or in a shed when it is not in use.

To make the game, first mark out the outline and openings of the buildings on 9mm (§in) exteriorgrade plywood and cut them out using a jigsaw or padsaw. Paint the houses with undercoat then gloss in any preferred colours, then paint on the hole numbers. The white decorative strips in our illustration were made by adding adhesive tape after the paint had dried.

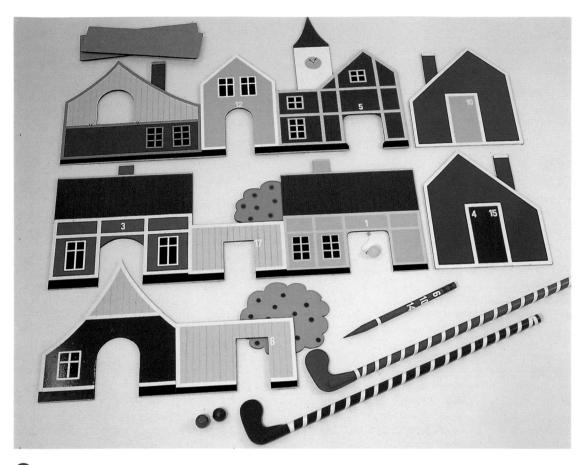

1 Setting Out the Game

The houses are staked into the lawn following the plan below. Players negotiate their route through the 'town' following the painted numbers on the houses (1–18). Note that some openings have numbers painted on both sides.

TOWN DRIVE

This brightly painted miniature town forms a 'golf course' that is quick and easy to make.

The ramps leading up to and down from hole No 11 measure 420×130 mm ($16\frac{1}{2} \times 5\frac{1}{4}$ in). The ends on the ground should be pressed into the soil for stability.

The stake for targets No 6, No 9 and No 13 is $400 \times 22 \text{mm} (6 \times \frac{7}{8} \text{ln})$ exterior-grade plywood. The clubs are $900 \times 28 \text{mm} (35\frac{1}{2} \times 1\frac{1}{4} \text{ln})$ softwood and are screwed to the 'head' using countersunk 25 mm (1 ln) No 8 screws. Paint the clubs in bright colours, then decorate them with white adhesive tape.

The buildings can be wedged upright by driving thin stakes, front and back, into the ground. Make sure an adult supervises this.

Weather Vane

OUTDOORS

Weather Vane
112/113

This unusual figure is not just an ornament but a weather-vane too. It will amuse children and teach them something about wind direction.

The main body of the goose is made from 18mm ($\frac{3}{4}$ in) exterior-grade plywood, about 800 × 300mm ($31\frac{1}{2} \times 12$ in). Cut parts from a full-scale pattern following the grid (fig 1). Each square measures 20×20 mm ($\frac{3}{4} \times \frac{3}{4}$ in).

Apart from the main body (A), you need to cut two of the trapezium-shaped parts (B) and four wings (C). The wings are cut from 4mm ($\frac{1}{8}$ in) exterior-grade plywood and need to be exactly the same shape, so temporarily nail or cramp four pieces of plywood together, draw the outline on the top piece and cut all four pieces together using a jigsaw or a padsaw.

The two wings on each side of the goose are set at an angle to each other to create a propeller shape. This is achieved by mounting each pair on to a 90mm (3\(\frac{5}{8}\)in) long softwood wing block, 35mm (1\(\frac{3}{8}\)in) square. A 4mm (\(\frac{1}{8}\)in) wide diagonal slot is cut in each end of the block. The diagonals must be cut in opposite directions to give the propeller its necessary twist. Fix the wings in the slots using waterproof woodworking adhesive.

Parts B are glued and pinned to the sides of the body as indicated by the dotted line (E). The short ends should face outwards.

Drill a 6mm $(\frac{1}{4}in)$ hole, 80mm $(3\frac{1}{4}in)$ deep in the edge of the goose stomach at an 86 degree angle to take the axle. This is made from a piece of 6mm $(\frac{1}{4}in)$ diameter threaded bolt, 200mm (8in) long, and is tapped into the hole with a little waterproof adhesive added.

Next drill two 5mm ($\frac{1}{4}$ in) diameter holes into short edges of parts B.

Paint all the parts white, allow to dry, then paint the black and grey.

Where the threaded bolt enters the stomach tighten two nuts. Slide the bolt into a 9mm (§in) diameter brass tube fixed into the pole that the goose is to perch on. Place a couple of washers below the nuts before putting the bolt in the tube and add a drop of oil now and then to ensure free movement.

Through each wing block drill a 9mm ($\frac{3}{8}$ in) diameter hole and slip a length of brass tube through it. This acts as a lining to ensure the wing turns freely on the 6×70 mm ($\frac{1}{4}\times2$ in) coach screw that secures it in position. Add a couple of washers to ensure the wings swivel freely.

Fix the pole to a post where it will get the full blast of the wind.

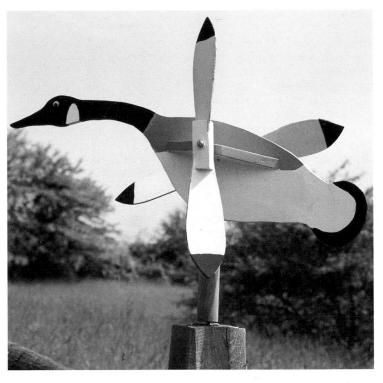

Weathering Well

This handsome goose weather vane pivots around the brass tube according to the direction of the wind. The angled wings on either side also turn in the wind, for added interest.

Marking Out and Cutting the Parts for the Weather Vane On to a $20 \times 20 \text{mm}$ ($\frac{3}{4} \times \frac{3}{4} \text{in}$) grid, transfer the parts for the goose: the body (A), wing supports (B) and wings (C). Note how a threaded bolt encased in a brass tube protrudes up into the body of the goose.

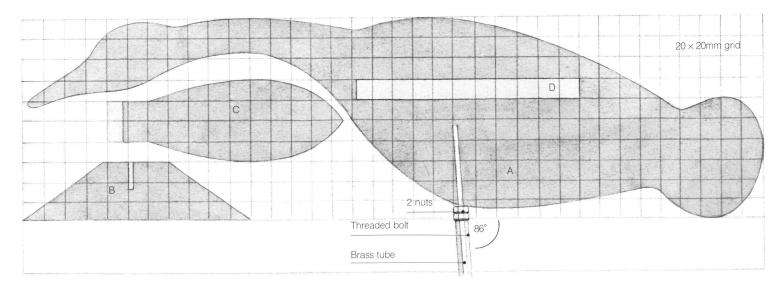

TOOLS, MATERIALS AND TECHNIQUES: TOOLS

TOOLS FOR PREPARATION

Bench stop and vice A vice is fitted to the underside of a bench, the jaws level with the bench top. The jaws are lined and topped with hardwood to protect the work and any tools being used. Some vices incorporate a small steel peg (a 'dog') that can be raised above the main jaw level. This allows awkward pieces of wood to be cramped in position when used with a bench stop fixed at the opposite end of the bench.

Drill stand Enables a power drill to be used with extreme accuracy when, for example, dowel jointing. The hole will be perpendicular to the surface and its depth can be carefully controlled. The drill is lowered on to the work with a springloaded lever which gives good control.

Sliding bevel This is a type of square used to mark out timber at any required angle. The sliding blade can be locked against the stock by means of a locking lever and the blade can form any angle with the stock.

Marking gauge This is used to mark both widths and thicknesses with only a light scratch. The gauge comprises a handle, on which slides a stock bearing a steel marking pin which can be fixed at a precise point.

Mortise gauge Similar to a marking gauge, it has two pins, one fixed, one adjustable, to mark out both sides of a mortise at the same time.

Profile gauge This is also called a shape tracer or a scribing gauge. It comprises a row of steel pins or plastic fingers held in a central bar. When pressed against an object, like a skirting board, the pins follow the shape of the object.

Marking knife Used to score a thin line for a saw or chisel to follow, ensuring a precise cut.

Mitre box A simple open-topped wooden box which is used to guide saws into materials at a fixed 45° or 90° angle, to ensure an accurate cut.

Plumb bob and chalk Used to check or mark accurate vertical lines on walls. A plumb bob is simply a pointed weight attached to a long length of string. The string can be rubbed with a stick of coloured chalk to leave a line on the wall.

Portable workbench A collapsible, portable workbench is vital for woodworking. It is lightweight and can be carried to the job, where it provides sturdy support. A portable bench is like a giant vice — the worksurface comprises two sections which can be opened wide or closed tightly according to the dimensions of the work and the nature of the task. It is used to hold large or awkward-shaped objects.

Scribing block To fit an item neatly against a wall (which is very unlikely to be completely flat), the item has to be 'scribed' flat to the wall using a small block of wood and a pencil (see **Techniques**, **page 119**). A scribing block is simply an offcut of wood measuring about $25 \times 25 \times 25$ mm ($1 \times 1 \times 1$ in). The block is held against the wall, a sharp pencil is held against the opposite end of the block, and the block and the pencil are moved in a unit along the wall to mark a line on the item to be fitted. If you cut to this line, the item will then fit tightly against the wall.

Spirit level Used for checking that surfaces are horizontal or vertical. A 1000mm (39in) long level is the most useful all-round size. An aluminium or steel level will withstand knocks and it can be either I-girder or box-shaped in section. A 250mm (10in) 'torpedo' spirit level is useful for working in confined spaces and can be used with a straight-edge over longer surfaces.

Steel measuring tape A 3m (3yd) or 5m (5yd) long, lockable tape (metal or plastic) is best, and one with a top window in the casing makes it easier to read measurements.

Steel rule Since the rule is made of steel, the graduations are indelible and very precise. A rule graduated on both sides in metric and imperial is the most useful. The rule also serves as a precise straight-edge for marking cutting lines.

Straight-edge Can be made from a length of 50×25 mm (2×1 in) scrap wood. It is used in combination with a spirit level to tell whether a surface is flat and also for checking whether two points are aligned with each other.

Try square An L-shaped precision tool comprising a steel blade and stock (or handle) set at a perfect right angle to each other on both the inside and outside edges. Used for marking right angles and for checking a square.

TOOLS FOR SHARPENING AND CUTTING

Chisels Used to cut slots in wood or to pare off thin slivers. Some chisels may be used with a mallet. When new, a chisel's cutting edge must first be honed with an oilstone to sharpen it.

Mortise chisel Used for cutting deep slots.

Firmer chisel For general DIY use.

Bevel-edge chisel Used for undercutting in confined spaces.

Paring chise! Has a long blade for cutting deep joints or long housings.

Dowelling jig Cramps on to a piece of work, ensuring that the drill is accurately aligned over the centre of the dowel hole to be drilled. It also guides the drill vertically.

DRILLS

Hand drill For drilling holes for screws or for making large holes, particularly in wood. It will make holes in metal and is useful where there is no power source. A handle attached to a toothed wheel is used to turn the drill in its chuck.

Power drill These range from a simple, single-speed model (which will drill holes only in soft materials) to a multi-speed drill with electric control. Most jobs call for something in between, such as a two-speed drill with hammer action.

DRILL BITS

You will need a selection of drill bits in various sizes and of different types for use with a drill.

Countersink bit After a hole is drilled in wood, a countersink bit is used to cut a recess for the screwhead to sit in, so ensuring that it lies below the surface. Different types are available for use with a carpenter's brace or a power drill.

Dowel bit Used to make dowel holes. The top has two cutting spurs on the side and a centre point to prevent the bit from wandering off centre. **Flat bit** Used with a power drill. For maximum efficency the bit must be turned at high speed from about 1000 to 2000 r.p.m. It drills into cross grain, end grain and man-made boards.

Masonry bit Has a specially hardened tungsten-carbide tip for drilling into masonry to the exact size required for a wallplug. Special percussion drill bits are available for use with a hammer drill when boring into concrete.

Twist drill bit Used with a power drill for drilling small holes in wood and metal.

114/115

Tools

Power router This portable electric tool is used to cut grooves, recesses, and many types of joints in timber, and to shape the edge of long timber battens. A range of cutting bits in different shapes and sizes is available and when fitted into the router the bits revolve at very high speed (about 25,000 r.p.m.) to cut wood smoothly and cleanly. Although hand routers (which look like small planes) are available, all references to routers in this book are to power models.

SAWS

Circular saw For cutting large pieces of timber or sheets of board, as well as grooves and angles. The most popular size has a diameter of 187mm (71 in). Circular saws can be extremely dangerous and must be used carefully. The piece of work must be held securely, supported on scrap battens, and the blade depth set so that it will not cut into anything below the work. The tool should be fitted with an upper and a lower blade guard. Coping saw Used to make curved or circular cuts. It has a narrow blade, which can be swivelled. When cutting, the blade can be angled so that the frame clears the edge of the work. Drill a hole close to the edge of the piece to be cut out. and thread the saw blade through the hole before reconnecting it to the handle.

Hacksaw For cutting metal. A traditional hacksaw has a wooden handle and a solid metal frame. The blade is tensioned by a wing-nut. Modern hacksaws have a tubular frame which is adjustable for different lengths of blade.

Jigsaw More versatile than a circular saw, although not as quick or powerful. It cuts curves, intricate shapes, angles and holes in a variety of materials. The best models offer variable speeds.

Padsaw Has a narrow, tapered blade to cut holes and shapes in wood. A hole is drilled and the saw blade is inserted to make the cut.

Panel saw A hand saw used for rough cutting rather than fine carpentry. It has a flexible blade of 510–660mm (20–26in).

Tenon saw For cutting tenons, and for other delicate and accurate work. A tenon saw has a stiffened back and the blade is about 250–300mm (10–12in) long.

Surforms Available in a range of lengths from approximately 150–250mm (6–10in), these rasps are useful for the initial shaping of wood. The steel blade has a pattern of alternating small teeth and holes through which waste wood passes, so that the teeth do not get clogged up.

HAND TOOLS

Cramps For securing glued pieces of work while they are setting. There are many types of cramp, but the G-cramp is most commonly used. **G-cramp** Also called a C-cramp or fast-action cramp, it is important for our projects that the jaws of the cramp open at least 200mm (8in). The timber to be held in the cramp is placed between the jaws which are then tightened by turning a thumb-screw, tommy bar or other type of handle. With a fast-action cramp, one jaw is free to slide on a bar, and after sliding the law up to the workpiece, final tightening is achieved by turning the handle. To protect the work, scraps of wood are placed between it and the jaws of the cramp. Sash cramps These employ a long metal bar, and are indispensable for holding together large frameworks, although you can improvise in some cases by making a rope tourniquet. This consists of a piece of rope which is tied around the object, and a length of stick to twist the rope and so cramp the frame tightly.

Webbing cramp The webbing, like narrow seat belt-type material, is looped around the frame, pulled as tight as possible by hand, and then finally tightened by means of a screw mechanism or ratchet winder.

HAMMERS

Claw hammer The claw side of the head of the hammer is used to extract nails from a piece of work, quickly and cleanly.

Cross-pein hammer The pein is the tapered section opposite the flat hammer head, and it is used for starting off small pins and tacks.

Pin hammer A smaller version of the crosspein, this is useful for light work.

Mallet Most commonly used to strike mortise chisels. The tapered wooden head ensures square contact with the object being struck.

Metal file Gives a metal edge the required shape and finish. Most files are supplied with a removable handle which can be transferred to a file of a different size. Flat or half-round files (one side flat, the other curved) are good general-purpose tools.

Nail and pin punches Used with a hammer to drive nails and pins below the surface so that they are hidden and the holes can be filled.

Orbital sander This gives a fine, smooth surface finish to wood. A gritted sanding sheet is fitted to the sander's base plate. Sheets are graded from coarse to fine, and the grade used depends on the roughness of the surface to be sanded. Always wear a mask when using one.

Paintbrushes A set of paintbrushes for painting and varnishing should ideally comprise three sizes – 25mm (1in),50mm (2in) and 75mm (3in). A better finish is always achieved by matching the size of the brush to the area you are painting.

PLANES

Block plane Held in the palm of the hand, it is easy to use for small work and chamfering edges.

Power plane Finishes timber to precise dimensions. A one-hand model is lightweight and can be used anywhere, whereas the heavier two-hander is intended for workbench use. A power plane will also cut bevels and rebates.

Smoothing plane A general-purpose handheld plane for smoothing and straightening surfaces and edges. The plane is about 250mm (10in) long and its blade 50-60mm ($2-2\frac{1}{2}$ in) wide. The wider the blade the better the finish on wide timber. There is a fine adjustment for depth of cut and a lever for lateral adjustment.

Sanding block and abrasive paper A sanding block is used with abrasive paper to finish and smooth flat surfaces. The block is made of cork, rubber or softwood and the abrasive paper is wrapped around it. Make sure in doing so that the paper is not wrinkled. Coarse paper is used for a rough surface and fine paper for finishing.

Screwdrivers Come in many shapes and sizes, the main differences being the type of tip, the length, and the shape of the handle.

Ideally, you should have a range of screwdrivers for dealing with all sizes of screws. Ratchet models, which return the handle to its starting point, are the easiest to operate.

Spanner A spanner is required for tightening coach bolts. If the correct-size open-ended or ring spanner is not available, any type of adjustable spanner may be used.

Spokeshave This allows curved edges to be shaped. Models with flat faces are intended for convex surfaces, while those with round faces smooth concave curves.

MATERIALS

TIMBER AND BOARDS

Timber is classified in two groups – softwoods and hardwoods. Softwoods come from evergreen trees and hardwoods from deciduous trees. Check your timber for defects before buying it. Avoid wood which is badly cracked or split, although you need not be concerned about fine, surface cracks since these can be planed, sanded or filled. Do not buy warped wood, as it will be impossible to work with. Check for warping by looking along the length of a board to see if there is any bowing or twisting.

When you get your wood home, condition it for about ten days. As the wood will have been stored in the open air at the yard, it will be 'wet'. Once indoors, it dries, shrinks slightly and will warp unless stored flat on the ground. If you build with wood as soon as you get it home, your structure could run into problems later as the wood dries out. To avoid warping and aid drying, stack boards in a pile, with offcuts of wood placed between each board to allow air to circulate. This will lower the moisture content to about 10 per cent and condition the wood for use.

Wood for outdoor projects must be protected from rot and insect attack. It can be bought pretreated with preservative, but this is expensive; alternatively, you can buy untreated wood and treat it, as soon as possible, with a water-based preservative. Pay special attention to end grain and to posts which will be buried below ground — these should stand in pots of preservative for a few days.

Softwood Although usually referred to as 'deal' or 'pine', it comes from many different sources. Softwood is much less expensive than hardwood and is used in general building work. It is sold in a range of standard sizes. After 1.8m(6ft), lengths rise in 300mm (12in) increments up to 6.3m (20ft 8in). Standard thicknesses are from 12mm (½in) up to 75mm (3in) and widths range from 25mm (1in) to 225mm (9in).

It is important to remember that standard softwood sizes refer to sawn sizes – that is, how it is sawn at a mill. Sawn timber is *not* suitable for the projects in this book – all the wood needs to have been planed. Such wood is referred to as PAR (planed all round), and, since planing takes a little off each face, it is about $5 \, \mathrm{mm} \left(\frac{3}{16} \ln \right)$ smaller in width and thickness than stated. Standard sizes should, therefore, be thought of as rough guides rather than exact measurements.

Hardwood Expensive and not as easy to obtain as softwoods. In home woodwork, hardwood (generally ramin) is usually confined to mouldings and beadings, which are used to give exposed sawn edges a neat finish.

Boards Mechanically made from wood and other fibres, they are versatile, relatively inexpensive, made to uniform quality and available in large sheets. All are made in 2440×1220 mm (8×4 ft). You need to know the advantages of each type of board before making your choice.

Hardboard The best known of all fibreboards. Common thicknesses are 3mm, 5mm and 6mm ($\frac{1}{8}$ in, $\frac{3}{16}$ in and $\frac{1}{4}$ in). As hardboard is weak and has to be supported on a framework, it is essentially a material for panelling.

MDF (medium-density fibreboard) A good, general-purpose building board. It is highly compressed, does not flake or splinter when cut, and leaves a clean, hard-sawn edge which does not need to be disguised as do other fibreboards. It also takes a very good paint finish, even on its edges. Thicknesses range from around 6mm to 35mm ($\frac{1}{4}\text{in to } 1\frac{3}{8}\text{in}$).

Chipboard Made by binding wood chips together under pressure, it is rigid, dense and fairly heavy. Chipboard is strong when reasonably well supported, but sawing it can leave an unstable edge and can blunt a saw. Ordinary screws do not hold well in chipboard and it is best to use twin-thread screws. Most grades of chipboard are not moisture-resistant and will swell up when wet. Thicknesses range from 6mm to 40mm ($\frac{1}{4}$ to $1\frac{1}{2}$ in), but 12mm, 18mm and 25mm ($\frac{1}{2}$ in, $\frac{3}{4}$ in and 1in) are common.

Chipboard is widely available with the faces and edges veneered with natural wood, PVC, melamine, or plastic laminates.

Plywood Made by gluing thin wood veneers together in plies (layers) with the grain in each ply running at right angles to that of its neighbours. This gives it strength and helps prevent warping. The most common boards have three, five or seven plies. Plywood is graded for quality: A is perfect; B is average; and BB is for rough work only. Usual thicknesses of plywood are 3mm, 6mm, 12mm and 18mm ($\frac{1}{8}$ in, $\frac{1}{2}$ in, $\frac{1}{2}$ in and $\frac{3}{4}$ in). WBP (weather and boil proof) grade board must be used for exterior work.

Blockboard Made by sandwiching natural timber strips between wood veneers, the latter usually of Far Eastern redwood or plain birch. Although plain birch is a little more expensive than redwood it is of a much better quality. Blockboard is very strong, but can leave an ugly edge when sawn, making edge fixings difficult. Blockboard is graded in the same way as plywood and common thicknesses are 12mm, 18mm and 25mm (½in, ¾in and 1in).

Tongue-and-groove boarding Also called match boarding, or matching, this is widely used for cladding frameworks. The boarding has a tongue on one side and a slot on the other side. The tongue fits into the slot of the adjacent board; this join expands and contracts according to temperature and humidity without cracks opening up between boards. Some boards have a decoration, most commonly a chamfered edge forming a V-joint, hence tongued, grooved and V-jointed (TGV) boarding.

ADHESIVES AND FILLERS

Adhesives Modern types are strong and efficient. If they fail, it is because the wrong adhesive is being used or the manufacturer's instructions are not followed carefully. For all general indoor woodworking, use a PVA (polyvinyl acetate) woodworker's glue — all glue manufacturers produce their own brand. For outdoor woodworking, you must always use either a synthetic resin adhesive that is mixed with water (this has gap-filling properties, so is useful where joints are not cut perfectly) or a two-part epoxy resin adhesive where the parts are applied separately to the surfaces being joined.

Fillers If the wood is to be painted over, use a standard cellulose filler — the type used for repairing cracks in walls. This filler dries white and will be evident if used under any other kind of finish. When a clear finish is needed, fill cracks and holes with a proprietary wood filler or stopping. These are thick pastes and come in a range of wood colours. It is best to choose a colour slightly paler than the surrounding wood, since fillers tend to darken when the finish is applied. Some experimentation may be needed, using a waste piece of matching wood.

In fine work, a grain filler is used to stop the final finish sinking into the wood. This is a paste, thinned with white spirit, and then rubbed into the surface. It is supplied in a range of wood shades.

116/117

FINISHES

The choice of finish is determined by whether the wood or board is to be hidden, painted or enhanced by a protective clear finish.

Paint A liquid gloss (oil-based) paint is suitable for wood, and is applied after undercoat. Generally, two thin coats of gloss are better than one thick coat. Non-drip gloss is an alternative. It has a jelly-like consistency and does not require an undercoat, although a second coat may be needed for a quality finish. If you intend to spray the paint, you must use a liquid gloss. A number of manufacturers produce nursery ranges of leadfree paint especially for use in children's rooms.

Preservative Unless timber for use outdoors has been pressure-treated with preservative and it is not to receive an alternative decorative finish, you must coat it thoroughly with preservative. Modern water-based preservatives are harmless to plant life. They are available in clear, green and a number of natural wood colours according to the finish you want. The preservative helps to prevent rot and to deter insect attack.

Varnish Normally applied by brush, varnish can also be sprayed on. It is available as a gloss, satin or matt finish, all clear. However, varnish also comes in a range of colours, so that you can change the colour of the wood and protect it simultaneously. The colour does not sink into the wood, so if the surface of the wood becomes scratched or marked then its original colour will show through. For this reason, a wood stain or dye is sometimes used to change the colour of wood. It sinks into the wood, but offers no protection, so a varnish also needs to be applied. For outdoor use, always use an exterior-grade varnish or a yacht varnish.

FIXINGS

The choice of fixing depends on the size and weight of the materials being fixed.

Battens A general term used to describe a narrow strip of wood used for a variety of purposes. The usual sizes are 25×25 mm $(1 \times 1$ in) or 50×25 mm $(2 \times 1$ in).

Battens can be screwed to a wall to serve as bearers for shelves or they can be fixed in a framework on a wall, with sheet material or boards mounted over them to form a new 'wall'.

Dowels Used to make framework joints or to join boards edge-to-edge or edge-to-face.

Hardwood dowels are sold in diameters ranging from 6–10mm ($\frac{1}{4}$ - $\frac{3}{8}$ in). Generally speaking, dowel lengths should be about one-and-a-half times the thickness of the boards being joined.

Dowels are used with adhesive and, when the joint is complete, it is important to allow any excess adhesive to escape from the joint. Dowels with fluted (finely grooved) sides and chamfered ends will help this process. If you have plain dowels, make fine sawcuts along the length and chamfer the ends yourself.

Nails For general-purpose frame construction. Round wire nails With large, flat, circular heads, these are used for strong joins where frames will be covered, so that the ugly appearance of the nails does not matter.

Annular ring-shank nails Used where really strong fixings are required.

Round lost head nails or **oval brads** (*oval wire nails*) Used when the finished appearance is important. The heads of these nails are driven in flush with the wood's surface and they are unobtrusive. They should be used when nailing a thin piece of wood to a thicker piece and there is a risk of splitting the wood.

Panel pins For fixing thin panels, these have unobtrusive heads that can be driven in flush with the wood's surface or punched below it.

Masonry nails For fixing timber battens to walls as an alternative to screws and wallplugs.

Screws All types of screws are available with conventional slotted heads or cross-point heads. The latter are the best type to use if you are inserting screws with an electric screwdriver.

For most purposes, screws with countersunk heads are ideal as the head lies flush with the surface after insertion. Round-head screws are for fixing metal fittings such as door bolts, which have punched-out rather than countersunk screw holes. Raised-countersunk head screws are used where a neat appearance is important. **Wood screws** These have a length of smooth shank just below the head. This produces a strong cramping effect, but there is a possibility of the unthreaded shank splitting the wood.

Twin-thread screws Less likely to split wood than wood screws. Except for larger sizes, they are threaded along their entire length, giving an excellent grip in timber and board. The best types are zinc-plated, and so rust-resistant.

Coach screws For heavy-duty fixings when making frameworks requiring a strong construction. The screws have square or hexagonal heads and are turned with a spanner. A washer is used to prevent the head cutting into the timber.

Wallplugs Use a masonry drill bit to drill a hole which matches the size of screw being used (a No 10 bit with a No 10 screw, for example). Insert the plug in the hole, then insert the screw through the object being fixed and into the plug. Tighten the screw for a secure fixing.

Solid wall fixings The method of fixing to a solid brick or block wall is to use a wallplug. Traditional fibre wallplugs have been superseded by plastic versions which will accept a range of screw sizes, typically from No 8 to No 12.

Stud wall fixings To guarantee a secure fixing for stud walls, you should locate the timber uprights which form the framework of the wall and drive screws into them. If you want to attach something heavy and the timber uprights are not in the required position, then you *must* fix horizontal battens to the timber uprights.

Hollow-wall fixings Used on hollow walls, which are constructed from plasterboard partition or lath and plaster and are found in modern and old houses, respectively. There are many types of these fixings including spring toggle, gravity toggle and nylon toggle, and nearly all of them work on the same principle: expanding wings open up to grip the back of the wall, securing the fixing.

Wall anchor bolt Similar to a wallplug, but with its own heavy-duty machine screw, this is used for heavier objects where a more robust wall fixing is required. You need to make a much larger hole in the wall, typically 10mm (and in diameter. The anchor sleeve expands as the bolt is tightened.

Magnetic catches There must be perfect contact between the magnet fixed to the cabinet frame and the striker plate which is fixed to the door. The other important factor is the pulling power of the magnet – on wardrobe doors a 5–6kg (11–13lb) 'pull' is needed to keep the door closed.

Magnetic push latches are also useful. Push on the door inwards and it springs open just enough to be grasped and fully opened by the fingers.

TECHNIQUES: SAWING AND CUTTING

MEASURING AND MARKING SQUARE

Mark the cutting lines lightly with a hard pencil first, and then use a marking knife in conjunction with a straight-edge or try square along a steel rule to create a sharp, splinter-free line on the timber.

To mark timber square, use a try square with the stock (handle) pressed against a flat side of the timber, called the face side or face edge. Mark a line along the square, using a knife in preference to a pencil, then use the square to mark lines down the edges from the face mark. Finally square the other face side, checking that the lines join up right around the timber (fig 1).

BRACING

Bracing is used to hold a frame or structure square, with the corners at perfect right angles (fig 2).

Try square method Nail a batten into one rail, pull into square by using a try square, and then nail the batten into the adjacent rail.

SAWING AND CUTTING

Cross-cutting to length by hand Hold the timber firmly with the cutting line (see Measuring and marking square, above) overhanging the right-hand side of the workbench (if you are right-handed). With the saw blade held vertical and the teeth on the waste side of the cutting line, draw the handle back to start the cut. To prevent the saw jumping out of place, as you begin work hold the thumb joint of the other hand against the side of the saw blade (fig 3).

Rip cutting by hand With the piece of timber or board supported at about knee height, draw back the saw handle to start the cut as described above. Then saw down the waste side of the cutting line, exerting pressure on the down cut only. If the saw blade wanders from the line, cramp the edge of a timber batten exactly above the cutting line on the side of the timber or board to be retained, and saw along it, using the batten as a guide (fig 5).

Using a portable power saw If the cutting line is only a short distance from a straight edge, adjust the saw's fence so that when it is run along the edge of the timber, the blade will cut on the waste side of the cutting line (fig 4, above). If the timber or board is wide, or the edge is not straight, cramp a batten to the surface of the timber or board so that the saw blade will cut on the

waste side of the line when run

along the batten (fig 4, below).

Ensuring a straight cut When cutting panels or boards using a power circular saw or jigsaw, the best way to ensure a straight cut is to cramp a guide batten to the surface of the work, parallel with the cutting line, so that the edge of the saw sole plate can be run along the batten. The batten position is carefully adjusted so that the saw blade cuts on the waste side of the cutting line. Depending on which side of the cutting line the batten is cramped, when using a circular saw, it is possible that the motor housing will foul the batten or G-cramps used to

Bracing a Frame Square
Nail a batten across a corner of the
frame so that a 3-4-5 shape triangle
is formed.

hold the panel in place. In this case, replace the batten with a wide strip of straight-edged plywood cramped to the work far enough back for the motor to clear the cramps.

CUTTING A CIRCLE

With a jigsaw Mark the circle on the face of the panel. If you do not have a compass, a good makeshift alternative can be made with a loop of string pivoted on a drawing pin at the centre of the circle. Hold a pencil vertically in the loop at the perimeter to draw the circle.

In order to have a neat, splinterfree cutting edge, carefully score around the marked cutting line using a trimming knife.

To start the cut, drill a hole about 10mm ($\frac{3}{8}\text{in}$) in diameter just on the inside of the marked circle. Insert the jigsaw blade through this hole and start the cut from this point, sawing carefully just on the waste side of the cutting line. By scoring the cutting line first using a marking knife, it will be easier to follow the line of the circle and get a smooth finished edge (fig 6).

Cross-cutting to Length Hold the timber firmly. Steady the saw blade with the thumb joint as you start to saw.

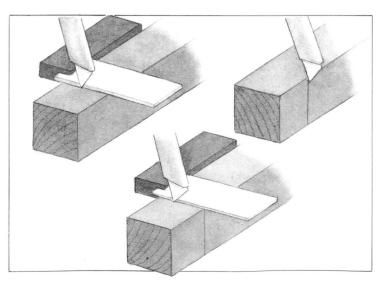

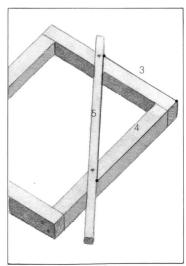

Techniques: Sawing and Cutting

118/119

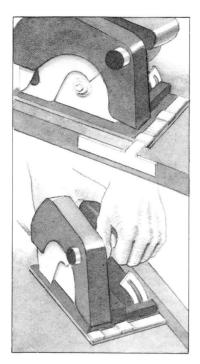

A Straight Power-Saw Cutting Top Use the rip fence of the saw if cutting near the edge of the piece of timber. Above Cutting alongside the guiding batten.

Straight Rip-cutting
Cramp a straight batten alongside
the cutting line and saw beside the
batten. A wedge holds the cut open.

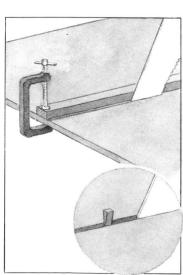

With a coping saw Mark out the circle, score the cutting line, and drill a hole about 10mm(ৰ্ঝাn) in diameter just on the inside of the circle. Disconnect the blade from one end of the frame, pass the blade through the hole, and re-connect it to the frame. It will be best to cramp the piece of work vertically when cutting the circle. The blade can be turned in the frame to help the frame clear the piece of work, but even so, with a coping saw you will be restricted in exactly how far you are able to reach away from the piece of work. If the circle is some way from the edge of the board or timber, use a padsaw or a jigsaw to cut it.

With a padsaw A padsaw, also called a keyhole saw, has a stiff, triangular pointed saw blade attached to a simple handle. A very useful padsaw blade is available that can be quickly and simply fitted into a regular knife handle.

Because this type of saw has no frame, it is ideal for cutting circles and other apertures, like keyholes, anywhere in a panel.

Using a Power Jigsaw
For a straight cut cramp a batten
alongside line. Cut a circle by
following a marked outline.

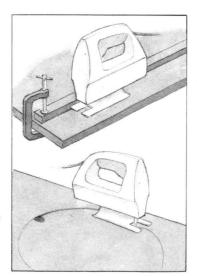

Preparation of the circle for cutting is the same as for a coping saw. When cutting with a padsaw, keep the blade vertical and make a series of rapid, short strokes without exerting too much pressure (fig 7).

CUTTING CURVES

The technique is basically the same as for cutting a circle, except that there will be no need to drill a hole in order to start the cut. You can use a jigsaw, coping saw, or padsaw to make the cut. A coping saw is ideal for making this type of cut because most of the waste can be removed with an ordinary hand saw; you will be cutting close to the edge of the wood, so the saw frame will not get in the way (fig 7, below).

PLANING

By hand Make sure that the plane blade is sharp and properly adjusted. Stand to one side of the work with feet slightly apart so you are facing the work. Plane from one end of the work to the other, starting the cut with firm pressure on the leading hand, transferring it to both

Cutting Circles by Hand
1 Drill a small hole and cut circle
using a padsaw; 2 Making cut with a
coping saw.

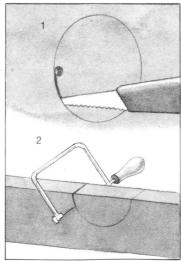

hands, and finally to the rear hand as the cut is almost complete. Holding the plane at a slight angle to the direction of the grain may improve the cutting action.

With a power plane Remove loose clothing, and wear goggles and a dust mask. Cramp the work in place. Start the plane and turn the adjuster knob to set the depth. Start with a shallow cut and increase the depth if necessary.

Stand comfortably to one side of the work and, holding the plane with two hands, set it into the work at one end and pass it over the surface to the other end. When you have finished, switch off and make sure the blades stop spinning before resting the plane down with the cutting depth at zero.

SCRIBING

Scribing fillets are thin slats of wood used to fill the space between a built-in unit and the side walls. In this book they are used with the Swingdoor Wardrobe if it is built-in.

House walls are rarely square, so for a neat finish, make the unit as a free-standing item about 50mm (2in) smaller than the width of the alcove at its narrowest point; then, after fitting the unit into place, scribe (shape) fillets into the gaps between the unit and the walls.

Before fitting the unit into place between the side walls of the alcove. screw 25 x 25mm (1 x 1in) vertical battens to each side of the unit. The battens should extend to the full height of the unit and should be set 50mm (2in) back from the front edge of the unit. A fillet, made from a strip of 6mm $(\frac{1}{4}in)$ plywood, is scribed to the outline of the wall surface and neatly fills the space between the unit and the wall. It is pinned in place to the batten and any small gaps are filled with filler before the fillet is painted to match the wall colour. Setting the unit back in this way ensures a neat finish.

TECHNIQUES: WALL FIXINGS

To scribe the fillet, hold a 75-100mm (3-4in) wide piece of the 6mm (½in) plywood against the front face of the unit and press the edge against the side wall. Where the gap is widest, pull the fillet back so the gap between the edge of the fillet and the wall is 25mm (1in). Hold a pencil against a 25mm (1in) wide block and move the pencil along the wall to draw a cutting line along the fillet that follows the wall profile. Cut the edge of the fillet to this line. Move the fillet back against the wall and mark a straight line on the fillet to coincide with the edge of the unit. Cut the opposite edge of the fillet to this line and press the fillet in place. To secure, pin through the fillet into the fixing battens (fig 1).

CUTTING GROOVES

With a router Use a straightsided router bit set to the required depth. Ideally, the bit should be the exact width of the groove. Otherwise, use a smaller router bit and cut the groove in two or more goes. Make the cut along the waste side with a batten cramped in place as a guide.

Marking and Cutting a Scribing Fillet

DRILLING

To minimize the risk of splitting, drill pilot and clearance holes.

The clearance hole in the timber should be fractionally smaller in diameter than the screw shank.

The pilot hole to receive the screw should be about half the diameter of the clearance hole. The hole depth should be slightly less than the length of the screw.

To ensure that the screwheads lie level with the surface, use a countersink drill bit.

vertical holes To Drilling ensure vertical holes mount the drill in a stand (fig 2). If this is not possible, stand a try square on edge so that its stock is resting on the work alongside the drilling position, and the blade is pointing up in the air. Use this as a sighting guide and line up the drill as close as possible with the square to ensure the drill is vertical (fig 3). It is helpful if an assistant can stand back and sight along the drill and square to ensure the drill is straight.

SCREWING

When screwing one piece of wood to another ensure that half of the screw penetrates through the bottom piece of wood. Its thickness should not exceed one-tenth of the width of the wood into which it has to be inserted. Keep screws at a distance of five times their shank diameter from the side edge of the wood, and ten times the shank diameter from its end.

NAILING

The correct length of nail to use is two-and-a-half to three times the thickness of the timber being fixed. However, check that the nail will not pierce right through two pieces being fixed. Wherever possible nail through the thinner piece of wood into the thicker piece.

Nails grip best if driven in at an angle ('skew nailing', fig 5). A row of nails is driven in at opposing angles to each other. Framework joints are usually held in by skew nailing. Cramp or nail a block of wood temporarily against one side of the

FIXINGS

first nail is started.

Solid wall The normal fixing for a solid wall is a woodscrew and plastic or fibre wallplug. Before drilling the fixing hole, check with a metal detector that there are no pipes or cables hidden below the surface. Drill the holes for the wallplug with a masonry drill bit in an electric drill. The wallplug packing will indicate the drill size to use. The screw should be long enough to go through the fitting and into the wall by about 25mm (1in) if the masonry is exposed, and by about 35mm (13in) if fixing into a rendered wall.

vertical piece to stop it sliding as the

blunt the points of the nails by hitting

them with a hammer before driving

them home. Blunt nails will cut

through timber fibres neatly, while

pointed nails are more likely to push

the fibres apart like a wedge.

To prevent wood from splitting,

If the wall crumbles when you drill into it, mix up a cement-based plugging compound (available from DIY stores). Turn back the

Drilling Vertical Holes With a drill stand, not only will the drill bit be held vertical, but the depth is accurately controlled.

Freehand Drilling Guide When drilling it can be helpful to stand a try square alongside the drill to ensure accuracy.

Left Screw battens to unit sides, set back from front. Middle Hold scribing

fillet 25mm (1in) away from side wall at widest point and use pencil and block

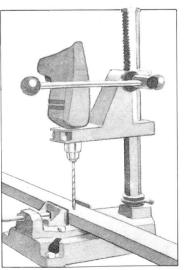

Techniques: Wall Fixings

120/121

screw about half a turn before the compound sets. When it is hard (in about one hour) the screw is removed and a heavy fixing made.

If your drill sinks easily into the wall once it has penetrated the rendering, and a light grey dust is produced from the hole, you are fixing into lightweight building blocks. In this case, special winged wallplugs should be used.

To make a quick, light-to-medium weight fixing, a masonry nail can be used. Choose a length that will penetrate the material to be fixed, and pierce an exposed masonry wall by 15mm ($\frac{5}{8}\text{in}$) or a rendered wall by about 25mm (1in).

Lath and plaster For a strong fixing, screw directly into the main vertical studding timbers to which the laths are nailed. You can find these studs with a metal detector (see Stud wall, below).

For a lightweight fixing you can screw into the wood laths. These can be located by probing with a pointed implement such as a gimlet. Then insert a twin-thread wood-

Above Drill a clearance hole and countersink it. Below Pilot hole is slightly less than screw length.

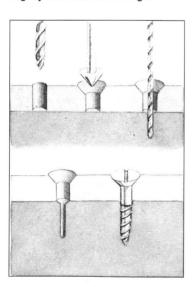

screw. For medium-to-heavyweight fixings into lath and plaster, drill between the laths and use a cavity-wall fixing suitable for lath and plaster, such as a spring toggle, gravity toggle or nylon toggle.

Stud wall For a strong fixing into a plasterboard-covered stud wall, make a screw fixing directly into the vertical timber studs. You can find these by tapping the wall to check where it sounds most dense, and then probing these areas with a pointed implement until a firm background is found. By drilling about 25mm (1in) to the farther side of this mark, the centre of the stud will be found and a screw can be inserted.

To avoid making unnecessary holes, a metal detector can be used. Move it over the wall to locate a pattern of nail fixings and mark this on the surface. Vertical rows indicate a stud. Alternatively, use an electronic stud and joint detector. This is moved over the surface to detect a change in density between the different construction materials. A change indicates a stud.

Skew Nailing for Strength Assemble frames by skew nailing (driving nails at an angle). The joint will not then pull apart.

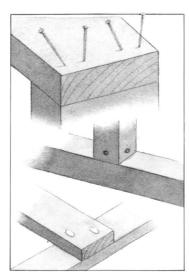

If a fixing cannot be made into a stud, a lighter fixing can be made into plasterboard by using a fitting designed for that material. Follow the manufacturer's instructions.

Cavity wall Cavity walls comprise a solid inner leaf of bricks or building blocks surfaced with plaster and separated from the outer leaf of bricks or stone blocks by a cavity about 50mm (2in) wide.

When tapped, a cavity wall sounds solid. For fixings, treat it as a solid wall (see page 120).

Finding verticals Use a plumb line to mark a vertical line on a wall. Tap a nail into the wall where you want the vertical to be, and tie the plumb line to it. When the line is steady, hold a scrap of wood on the wall so it just touches the string and mark the wall at this point. Repeat the procedure at a couple of other places. Alternatively, rub the plumb line with chalk. When it stops swinging, press it against the wall, then pluck the string to leave a vertical chalk line on the wall

Using a Nail Punch
For a neat finish, use a nail punch to
drive nail heads below the surface,
then fill indentation.

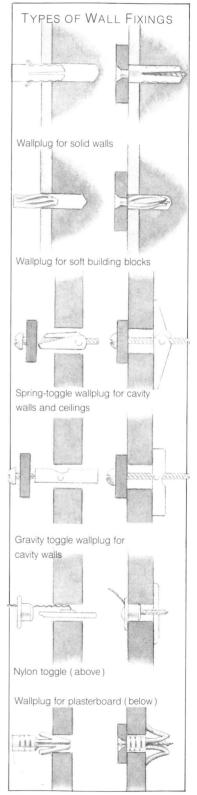

TECHNIQUES: HINGES AND CATCHES

HINGES AND CATCHES

Flush hinges These are simply screwed to the edge of the door and the frame, and require no recessing. However, they cannot be adjusted after fitting. Screw the inner hinge flap to the edge of the door, and the outer flap to the inner face of the frame (fig 1).

Fix the hinges at equal distances from the top and bottom of the door. With a tall or very heavy door, fit a third hinge centrally between the other two. Mark the hinge positions on the edge of the door with the hinge knuckle (joint) in line with the door front. Drill pilot holes and screw on the inner flap. Hold the door in place or rest it on something to raise it to the correct height, making sure that it is accurately aligned top and bottom, and mark the positions of the hinges on the frame. Remove the door and extend these lines using a try square. Hold the door against the frame in an open position, and screw the outer hinge flaps to match up to the guide lines.

Butt hinges These are conventional flapped hinges and are available in steel or in brass (better for high-quality work). They are fitted in the same way as flush hinges, except that the hinge flaps have to be recessed using a chisel or router.

Mark out the hinge positions as for flush hinges, making sure that the hinges are not positioned so that the fixing screws will go into the end grain of cross members.

Mark the length of the hinge using a marking knife. Then mark the width of the hinge and the thickness of the flap using a marking gauge. With a chisel held vertical and a mallet, cut down around the waste side of the recess, then make vertical cuts across the full width of the recess. Chisel out the waste, then pare the bottom of the recess flat using the chisel held with its flat side down (fig 2).

If you are careful, you can remove the bulk of the waste using a straight bit in a router set to the depth of the recess. The corners can then be finished using a chisel.

Catches With conventional flush or butt hinges, magnetic catches are popular. The magnet is fitted to the side of the cabinet and the catch plate is then positioned on the magnet. The door is closed on to the catch and pressed hard so that the catch plate marks the door. The door is opened and the catch plate is then simply screwed to the door.

Magnetic touch latches consist of a striker plate that is screwed to the door and a magnetic latch screwed to the frame. The magnet is attached to the end of a small spring housed in the latch; by pushing on the front of the door, it pulls away from the magnet and opens.

Ball catches are very neat devices. On the central edge of the door a hole is drilled to accept the body of the catch. The striker plate is then positioned to coincide with the centre of the ball.

Fitting a Flush Hinge
Flush hinges are very easy to fit.
Screw the outer flap to the frame
and the inner flap to the door.

The Stages in Fitting a Butt Hinge

Using a try square and a trimming knife, mark out the length of hinge. With a marking gauge mark width and thickness of hinge flap. With chisel vertical, cut round outline of hinge. Make series of cuts across width of recess. Pare out waste then check that flap lies flush. Screw the butt hinge in place.

Fitting a Butt Hinge
Butt hinges must be recessed into
the door and frame so that hinge
flaps are flush with surface.

Magnetic Cupboard Catch
A magnetic catch is screwed to the
inside face of a cabinet and the
catch plate is screwed to the frame.

Techniques: Wood Joints

122/123

WOOD JOINTS

Butt joint This is the simplest frame joint of all. The ends of the timbers to be joined must be cut square so that they butt together neatly. Corner and 'T' joints can be glued and nailed for strength.

Halving joint Also known as a half-lap joint, these may be used to join wood of similar thickness at corners or to T or X joints (fig 5). The joint is formed by cutting each piece to half its thickness. Use a try square to mark the width of the cut-outs and a marking gauge set to half the thickness of the wood to mark their depth. Be sure to cross-hatch the waste wood with a pencil so that the correct side is removed. To form a corner half-lap, hold the timber upright in a vice and saw down to the line, then place the timber flat and saw across the shoulder to remove the waste. To form a T or X half-lap, saw down each side of the T cut-out to the depth of the central gauge line, and then chisel out the waste wood.

Types of Halving Joints

Top A corner halving joint. Bottom

left A T-halving joint. Bottom right A cross halving joint.

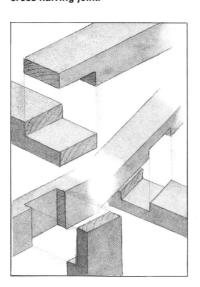

Housing joint Used mainly for shelving, this is basically a slot into which a shelf fits. The 'through' housing joint goes to the full width of the shelf, while a 'stopped' housing joint is taken only part of the way across the board (fig 7). Chisel the waste away from each side. In the case of a stopped housing, chisel the waste from the stopped end first. If you have a power router, it is easier to cut a housing joint by running the router across the board against a batten which is cramped tightly at right angles to the board.

Rebates Are L-shaped steps in the edge of a piece of timber.

By hand Use a marking gauge to mark the rebate width across the top face of the piece of work and down both sides. Mark the depth of the rebate accurately across the end and both sides.

Hold the timber flat and saw down on the waste side of the marked line to the depth of the rebate. Chisel out the waste one bit at a time along the end grain.

Types of Housing Joints

Top A through housing joint; Middle

Through housing joints on the side
of a central support; Bottom A

corner housing joint.

Stages in Forming a Through Housing Joint
Mark width of the housing according to thickness of wood being joined. Use a
trimming knife. Mark depth with marking gauge. Cut down sides with tenon
saw. Chisel out the waste, working from both sides to the middle.

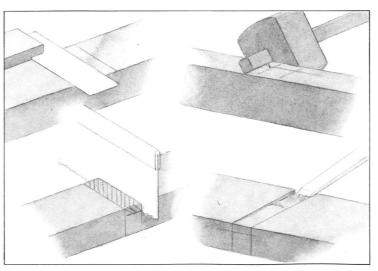

With a router It is not necessary to mark out the rebate unless you want a guide to work to. However, do practise on scrap wood to be sure of setting the router correctly.

If using a straight cutter, adjust the guide fence on the router so that the correct width is cut, then plunge and adjust the cutting depth so that the router will cut to the correct depth. When the router is correctly set up, simply hold it flat on the piece of work and move it against the direction of the cutter's rotation.

If you are using a cutter with a guide pin, simply adjust the depth of cut and then run the cutter along the edge of the wood to form the rebate. The cutter will follow irregularities in the wood, so make sure your wood is perfectly straight.

Mitre joint This is a type of butt joint, but the faces are cut at an angle (fig 8). A simple mitre joint is glued and pinned, a stronger one is made using dowels, or by sawing oblique cuts into which wood veneers are glued. Cut the joints at 45 degrees using a mitre box.

Forming Mitre Joints
Glue and pin together a simple mitre
joint. Reinforce joint with a corner
block, dowels or wood veneer.

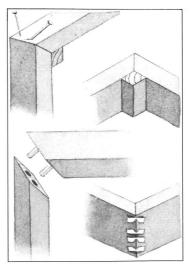

TECHNIQUES: WOOD JOINTS

Dowel joint Dowels are a strong, simple and hidden means of joining wood together (fig 1).

Use pre-cut grooved dowels with bevelled ends (see Materials, page 117). These range from 6mm $(\frac{1}{4}in)$ diameter by 25mm (1in) long to 10mm (3in) by 50mm (2in). The dowel length should be about one and-a-half times the thickness of the wood being jointed. If you need to use dowelling of a larger diameter (as used in the Painting Table project, page 58), cut your own from lengths of dowel. Cut grooves down the length of dowel to allow glue and air to escape, and chamfer the ends. When making your own dowels, their length can be twice the thickness of the wood.

On both pieces of wood, use a marking gauge to find the centre line, and mark with a pencil. Drill the dowel holes to half the dowel length with the drill held in a drill stand, or aligned with a try square stood on end. Drill the dowel holes in one of the pieces to be joined, insert centre points in the holes, then bring the two pieces of the joint together so

Types of Dowel Joint
Dowels can join panels edge to edge
and join frames at corners. They can
be hidden or have ends exposed.

they are carefully aligned. The centre points will make marks in the second piece of wood where the dowel holes should be drilled. Drill the holes to half the length of the dowels, plus a little extra for glue. Where dowels are used for location rather than strength, such as for joining worktops, set the dowels three-quarters into one edge and a quarter into the other.

Put adhesive in the hole and tap dowels into the holes in the first piece with a mallet. Apply adhesive to both parts of the joint; bring the pieces together and cramp them in position until the adhesive has set.

Using a dowelling jig A dowelling jig enables accurate dowel holes to be drilled. It is cramped over the workpiece above the pre-marked hole centres. A bush of the same diameter as the drill bit is selected and fitted on the jig. The bush holds the drill vertically as the hole is made. A depth gauge ensures that the hole is the required depth (fig 4). The jig is then set up on the matching piece of wood and the process repeated.

Dowels to Join Panels Right Mark dowel positions. Drill holes, insert centre points. Mark second piece. Dowel together.

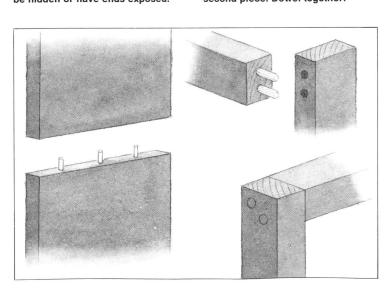

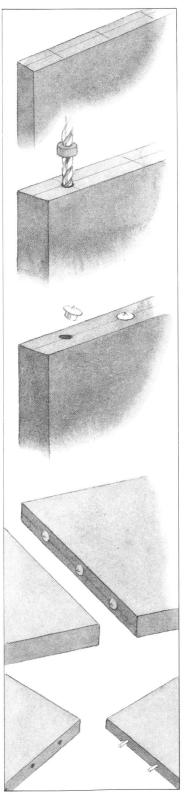

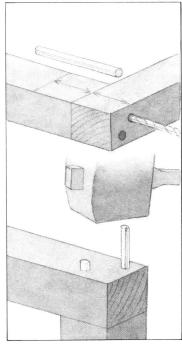

Making a Dowelled Frame If edge of frame will not be seen, drill holes for dowels after making frame. Hammer dowels home; cut ends flush after glue dries.

4 Using a Dowelling Jig
If dowels are to be hidden, a
dowelling jig makes it easy to drill
holes that align in both pieces.

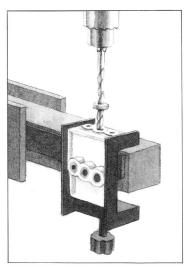

SAFETY

Hundreds of thousands of accidents occur in the home every year. Many of these are the result either of adults undertaking do-it-yourself tasks or of children playing in unsafe environments. Before making any of the projects in this book, always observe the following recommendations.

ADULT SAFETY

Never rush a woodworking or other kind of home improvement job: make sure that you know exactly what skills, tools and materials you will need *before* you start work. This means reading the project instructions, cross-referring to any techniques you are unfamilar with, and, if necessary, practising first on a piece of scrap wood. Check that you have the right tools, and that they are in good working order. If, for any reason, you are borrowing or hiring a tool, read the instructions carefully before you use it, and, again, practise first on a piece of scrap wood.

A clean, tidy work area will enable you to work more quickly and in greater safety: remove waste and clutter at regular intervals. Take special care when using power tools, and always unplug them from the mains electricity when they are not in use. Keep children away from your work area, and warn them that your tools and materials are not toys to be played with. The rule of never leaving tools lying around is a fundamental one to observe if there are children in the house. Try to keep your work area well-ventilated, especially when you are using paint, varnish or solvents.

Wear sensible clothing. Remember that clothes are likely to get torn or dirty. Choose something old, but also consider how you can best protect yourself. Depending on the job, you may need: goggles or safety glasses to protect your eyes; a mask to protect against dust or fumes; gloves to protect your hands when handling, for example, glass; and stout footwear for a firm footing. Overalls are often the safest and most comfortable choice of general clothing.

Paint, turps, varnish and many preservatives are toxic, so treat them with care. Any item being built for use in a child's room or to be played with by a child should be decorated using non-toxic paint and varnish – this is particularly important for the Crib project (pages 20–5). The lead content in these products is now limited by law (for this reason never use up paint that might have been lying around for years), but paints and varnishes labelled 'non-toxic' must not contain any heavy metals at all.

MATERIALS

When choosing your materials, always buy the best you can afford. It is not only much more difficult to make the projects in this book if the faces do not meet properly, it is also more difficult to mark and cut out joints accurately, and more time-consuming, since you will have to plane down all the faces to remove splinters etc.

CHILD SAFETY

Many children sustain serious injuries simply by falling over toys left lying around the house: storage solutions such as the Swing-door Wardrobe (pages 64–73) or the Storage House (pages 32–7) add a play element to tidying up, encouraging children to be as tidy as possible. Other accidents occur when children play with toys or items of furniture that have not been designed or made with children in mind. Make sure that a child is old enough to play with any given toy, and try to reduce the risk of accidents by throwing away any toys that are broken.

CONSTRUCTION

Corners and edges should be smoothed and rounded over wherever applicable: the edges of the panels in the Swing-door Wardrobe must be kept flat and square for the door to shut properly, whereas the exposed edges of the Rocking Chair (pages 26–31) can all be rounded over without the design being compromised. Screw heads should always be countersunk, and nail heads punched below the surface to reduce the risk of cuts or injury: use filler to cover the holes and, when it is dry, sand smooth with the surface.

Hinged items always present the risk of entrapment, usually of hands and fingers, feet and toes, but sometimes of a child's head: the latter usually occurs when very young children are holding on to a box with a hinged lid and are reaching inside. To minimize the risk, always make the space between the two hinged panels or surfaces either less than 5mm (in) or greater than 12mm (in). If you are hingeing a lid (a toy box, for example). bear in mind that a child may sustain additional injuries from the force and weight of the falling lid - in extreme circumstances, this has resulted in child fatalities. For this reason, always fit a support that will hold the lid open. Children have also been known to become trapped inside toy boxes, so it is an excellent idea to drill a couple of adequate ventilation holes in the sides.

Tools, Materials and Techniques

Safety

124/125

FURNITURE

Bear in mind that robust, active children climb up and over all manner of surfaces not really intended for such treatment. Even the most vigilant parent or guardian will be unable to provide wholly uninterrupted supervision, so you should take care to anticipate hazards and reduce the risk of injury.

Children will use shelves, tables, chairs and open drawers in chests of drawers as steps to climb up. In children's rooms, especially, try to keep as much furniture as possible low down, and always use angle brackets or wallplugs to anchor large pieces of furniture to the wall so that there is no chance of them tipping over and causing injury. Bear in mind the weight of the door in the Swing-door Wardrobe project, and make sure that enough magnetic catches are fitted to hold it shut. If you build the Shelf, Rail and Peg Storage (pages 38–41), think about the age of the child or children using the room when you are deciding upon the height at which to screw the backboards to the wall.

The Crib project has been built to carefully calculated dimensions for a new-born baby. If you want to make a larger crib for an older child, it is essential that you first investigate safety recommendations concerning spacing of slats, stability, and the risks of strangulation.

Toys

The younger the child, the more careful you must be about choosing toys: what is safe for a seven-year-old may well be hazardous for a child of eighteen months. A number of the projects in this book involve movement, and these have all been designed and tested for strength and stability. For this reason you should not attempt to modify the designs without first consulting safety legislation concerning toys: up-to-date copies of all safety recommendations can be found at most large reference libraries.

With common sense, many of the potential hazards such as sharp points or edges can be eliminated. Beware of small, detachable parts, which children might swallow or choke on, and pay particular attention to the size and construction of rattles. Inspect labels to check the lead content of any paints you might want to use to decorate toys: the level of lead is now strictly controlled, but paint sold for use on metal furniture still has a relatively high lead content and should therefore never be used to paint toys.

INDEX

abrasive paper, 115	climbing frames, 95	flush hinges, 122
adhesives, 116	climbing frame project, 96-103	four-poster beds, 42
annular ring-shank nails, 117	coach screws, 117	frames, dowelled, 124
	colours, 8	friezes, 47
babies, cribs, 12, 20-5	coping saws, 115, 119	
basins, 72	cots, 12	G-cramps, 115
baskets:	countersink bits, 114	games, round-the-houses golf, 112
Moses, 12	cradles, 12	gardening, 95
storage, 49	cramps, 115	gauges, 114
battens, 117	crates, storage, 49	glues, 116
bedrooms, 10-43	cribs, 12	golf, round-the-houses, 112
beds, 12	crib project, 20–5	1-1
painted decoration, 16–17	cross-cutting, 118	hacksaws, 115
storage, 14	cross-pein hammers, 115	halving joints, 123
beds, 12	cupboards, playrooms, 46	hammers, 115
crib project, 20–5	alcove storage project, 32–7	hand drills, 114
four-poster, 42	swing-door wardrobe project, 64–73	hand planes, using, 119
platform, 12	curtains:	hand tools, 115
bench stops, 114	bedrooms, 12–13, 14	hanging rails, 8, 14, 71–2
bevel-edge chisels, 114	puppet theatre, 88–9	hardboard, 116 hardwood, 116
bevels, sliding, 114	curves, cutting, 119	hinges, 122
bird-tables, 95	cutting, 118–19	holes, drilling, 120
bits, drill, 114	cutting tools, 114	hollow-wall fixings, 117
blackboard screen, 90	desks, 47	horses, rocking, 74–9
blinds, 14	truck desk, 91	houses:
block planes, 115	displays, 49	dolls' houses, 48
blockboard, 116 boards, 116	divan beds, 12	doll's house project, 52–7
bolts, 117	dolls' houses, 48	log cabins, 94
bookshelves, 49	doll's house project, 52–7	play houses, 95
borders, 47	doors, hinges and catches, 122	tree-houses, 95
bracing, 118	dowel bits, 114	housing joints, 123
brushes, paint, 115	dowel joints, 124	3,
bunk beds, 12	dowelling jigs, 114, 124	jigs, dowelling, 114, 124
butt hinges, 122	dowels, 117	jigsaws, 115
butt joints, 123	dressing-up boxes, 8	joints, 123–4
Suit joine, 120	drill stands, 114	,
carpets, 14, 46	drilling, 120	knives, marking, 114
carrycots, 12	drills, 114	
cart project, 104-11		ladders, rope, 94
castles, 94	easels, 49	lath and plaster walls, fixings, 121
catches, 122	equipment, tools, 114–15	lighting, 14
cavity walls, fixings, 121	expanding wall bolts, 117	log-cabin play houses, 94
chairs:		low-level shelves, 43
bedrooms, 14	fabrics, curtains, 12-13	
playrooms, 46–7	files, metal, 115	magnetic catches, 122
rocking chair project, 26-31	fillers, 116	mallets, 115
chalk, 114	finishes, 117	marking gauges, 114
chests of drawers, 8	firmer chisels, 114	marking knives, 114
chipboard, 116	fixings, 117, 120–1	marking square, 118
chisels, 114	flat bits, 114	masonry bits, 114
circles, cutting, 118–19	flooring:	masonry nails, 117 materials, 116–17
circular saws, 115	bedrooms, 14	MDF (medium-density fibreboard), 116
claw hammers, 115	playrooms, 46	MDI (Modium-density libreboald), 110

measuring, 118	power drills, 114	steel rules, 114
measuring tapes, steel, 114	power planes, 115	stencils, 47
metal files, 115	power routers, 115	storage, 8
mitre boxes, 114	power saws, using, 118, 119	alcove storage project, 32-7
mitre joints, 123	preservatives, wood, 117	bedrooms, 14
mobiles, 12	profile gauges, 114	low-level shelves, 43
mortise chisels, 114	punches, nail and pin, 115	playrooms, 46, 47–9
mortise gauges, 114	puppet theatre project, 80-9	shelf, rail and peg storage project, 38-41
Moses baskets, 12	in I from a man from J	swing-door wardrobe project, 64–73
	rail storage project, 38-41	straight-edges, 114
nail punches, 115	rebates, cutting, 123	stud wall fixings, 117, 121
nailing, 120	Rigot, Gérard, 17	surforms, 115
nails, 117	rip cutting, 118, 119	swing-door wardrobe project, 64–73
nesting boxes, 95	rocking chair project, 26–31	swings, 94, 95, 97, 102
nurseries, 8, 14	rocking horse project, 74–9	3WI193, 34, 33, 37, 102
	rope ladders, 94	tables, 46–7
orbital sanders, 115	round lost-head nails, 117	
oval brads, 117	round-the-houses golf, 112	painting table project, 58–63
574. 57446, 117	round wire nails, 117	truck desk, 91 work tables, 49
paddling pools, 95	routers, 115, 123	- Control (Control (C
padsaws, 115, 119	rugs, 14	techniques, 118–24
paint, 117	3 /	tenon saws, 115
paint effects, 47	rules, steel, 114	timber see wood
paint chects, 47	cofety 105	tongue-and-groove boarding, 116
painted decoration, 16–17	safety, 125	tool boxes, 49
painting table project, 58–63	in outdoor play areas, 94 sanders, orbital, 115	tools, 114–15
panel pins, 117		'torpedo' spirit levels, 114
panel saws, 115	sanding blocks, 115	toy boxes, 49, 72–3
paring chisels, 114	sandpits, 94, 95, 102	tree-houses, 95
pegboards, 49	sash cramps, 115	truck desk, 91
peg storage project, 38–41	sawing, 118–19	try squares, 114, 118
pigeon-hole units, 70	saws, 115, 118, 119	twin-thread screws, 117
pilot holes, 120	using, 118, 119	twist drill bits, 114
	screens, blackboard, 90	70
pin hammers, 115	screwdrivers, 115	vanity basins, 72
pin punches, 115	screwing, 120	varnish, 117
pinboards, 49	screws, 117	verticals, finding, 121
pine, 116	scribing blocks, 114	vices, 114
planes, 115, 119	scribing gauges, 114	
planing, 119	shape tracers, see profile gauges	wall anchor bolts, 117
planning, 8	sharpening, tools for, 114	wall fixings, 120–1
platform beds, 12	shelving, 8	wallpaper, 47
playrooms, 44–91	low-level, 43	wallplugs, 117, 121
blackboard screen, 90	playrooms, 49	wardrobes, swing-door project, 64-73
doll's house project, 52–7	shelf, rail and peg storage, 38-41	weather vanes, 113
equipment and furnishing, 46–7	slides, 94, 95, 102	webbing cramps, 115
painting table project, 58–63	sliding bevels, 114	wheels, cart, 104, 111
puppet theatre project, 80-9	smoothing planes, 115	wildlife, 95
rocking horse project, 74–9	softwood, 116	wood, 116
storage, 46, 47–9	solid wall fixings, 117	floors, 14
swing-door wardrobe project, 64–73	spanners, 115	joints, 123–4
truck desk, 91	spirit levels, 114	preservatives, 117
plumb bobs, 114, 121	spokeshaves, 115	wood screws, 117
plywood, 116	stains, wood, 117	work tables, 49
portable workbenches, 114	steel measuring tapes, 114	workbenches, portable, 114

ACKNOWLEDGMENTS

The publisher would like to thank the following for their help:

For their ideas, contributions and general assistance:

Hilary Bird; Bridget Bodoano; Joanna Bradshaw; Michelle Clark; Judith Harte; David Jenkens; Madeleine O'Shea; Sean Sutcliffe, Wendy Jones, Kevin Adams, Terry Bartholomew, Jon Cook, Leigh Harrhy, Mark Hinton, Steven Huzzey and Steve Stonebridge at Benchmark Woodworking Limited; Servis Filmsetting; and Will Webster.

For lending props used in the special photography on pages 18–41 and 50–89:

Alvin Ross/Alfie's Antique Market, 13–25 Church Street, London NW8; The Conran Shop, Michelin House, 81 Fulham Road, London SW3; Decorative Living, 55 New Kings Road, London SW6; Judy

Greenwood Antiques, 657 Fulham Road, London SW6; Meaker & Son, 166 Wandsworth Bridge Road, London SW6; Mothercare UK Ltd; The Nursery, 103 Bishop's Road, London SW6; Papers and Paint Ltd, 4 Park Walk, London SW10; The Puffin Children's Bookshop, 1 The Market, Covent Garden, London WC2; Gail Rose; The Singing Tree, 69 New Kings Road, London SW6; The Tintin Shop, 34 Floral Street, London WC2.

For taking part in the special photography: Rory Higham; Ellie and Sam Johnson; and Lily Whitfield.

Finally, the publisher would like to thank the Royal Society for the Prevention of Accidents for their help and advice about safety in the design and manufacture of toys and children's furniture, and for checking the projects in this book.

PHOTOGRAPHIC ACKNOWLEDGMENTS

The publisher thanks the following photographers and organizations for their kind permission to reproduce the photographs in this book:

9 Peter Aaron/Esto; 11 Marianne Majerus; 12 Yves Duronsoy; 13 below left Yves Duronsoy; 13 right Christian Sarramon; 14 Lewis and Gould Architects, New York (Michelle Lewis); 16 above left Marianne Majerus; 16 below right Yves Duronsoy; 16 below left Yves Duronsoy; 17 Marianne Majerus; 44 left Mark Darley/Esto; 44 centre Tom Leighton; 45 Marianne Majerus; 46 right Mark Darley/Esto; 47 right Trevor Richards; 48 Dia Press; 49 left Camera Press; 49 right Jeremy Cockayne; 91 Camera Press; 92 left Gary Rogers; 92 centre Dia Press; 92 right Ron Sutherland/Garden Picture Library; 93 Pia Tryde; 94 Georges Lévêque; 95 left Marianne Majerus; 95 right Georges Lévêque; 112 Lars Dalsgaard; 113 Dia Press.

The following photographs were taken specially for Conran Octopus:

Richard Foster 1-7, 18-42, 50-90, 98-111

Shona Wood 8 left (wall units designed and built by Tim Rose), 8 right, 13 above left, 15, 44 right (designed by Georgina Godley), 10 left and right (John, Meryl and Rosie Lakin), 10 centre (conceived by Elizabeth Philian and built by Mark Vidler) 16 above right (furniture by Gérard Rigot, design and fittings by Simon Foxell), 43, 47 left (Paxton Locher Architects), 44 right, 46 left (Rebecca Langton).